THE COMPLETE

typographer

THE COMPLETE

typo

grapher

A manual for designing with type

WILL HILL

Prentice Hall
is an imprint of

A QUARTO BOOK

Published by Pearson Prentice Hall.
Pearson Education, Inc.
Upper Saddle River
New Jersey 07458

Editor in Chief: Sarah Touborg
Acquisitions Editor: Billy Grieco
Editorial Assistant: Theresa Graziano
Assistant Managing Editor: Melissa Feimer
Senior Operations Supervisor: Brian Mackey
Director of Marketing: Brandy Dawson
Senior Marketing Manager: Kate Mitchell
Marketing Assistant: Craig Deming

Cataloguing-in-Publication Data
is available from the Library of Congress.

Pearson Education Ltd.
Pearson Education Australia PTY, Limited
Pearson Education Singapore, Pte. Ltd
Pearson Education North Asia Ltd
Pearson Education, Canada, Ltd
Pearson Educación de Mexico, S.A. de C.V.
Pearson Education—Japan
Pearson Education, Malaysia, Pte. Ltd

Conceived, designed, and produced by
Quarto Publishing plc
The Old Brewery
6 Blundell Street
London N7 9BH

QUAR.TYB3

Project Editor: Diana Craig
Art Editor: Caroline Guest
Designer: John Grain
Picture Researcher: Sarah Bell
Proofreader: Blanche Craig
Indexer: Dorothy Frame

Creative Director: Moira Clinch
Publisher: Paul Carslake

Color separation by: Modern Age Repro House Ltd., Hong Kong
Printed by: 1010 Printing International Ltd., China

Prentice Hall
is an imprint of

10 9 8 7 6 5 4 3 2 1

ISBN-10: 0205759793
ISBN-13: 9780205759798

Contents

Introduction

For 500 years the printed word has been a crucial tool in the development of civilizations and cultures, the dissemination of knowledge, and the expression of human sensibility. A hundred years ago the setting of type was still a specialized craft within the printing industry. Twenty-five years ago quality typesetting was available only to professionals within graphic design and related industries. Today, however, typographic software and desktop publishing have permeated all areas of contemporary life, across visual communication, commerce, and recreational use. The capacity to utilize and manipulate a proliferating range of typefaces is now within the reach of the non-specialized user—the aspiring design student or the interested novice. More typefaces are now readily available to a wider public than at any time in the past.

The development of an individual typographic awareness begins with an understanding of the way in which type works. The chapters that follow are designed to provide a foundation for this awareness, giving a brief outline of the evolution of type, an introduction to the language and terminology of type and type setting, fundamental rules and conventions of professional practice, and key decisions on type selection and page layout. A directory of typefaces places the major type categories and typefaces into their historical context, introducing some key examples of excellence in contemporary type design as well as identifying the fundamental values that have sustained the continued use of classic typefaces over the last 500 years of print history. In this way, this book will provide a sound basis for the confident and informed exploration of a rich and vivid medium that continues to play a fundamental role in human communication.

ABOUT THIS BOOK

Chapter 1: History of Type

This chapter provides an informed historical grounding for the use of type. It gives an overview of the production of type and of the development of the printed word over a period of more than five centuries, and provides a basis for positioning typographic categories and styles within their historical context.

Chapter 2: Categories of Type

This chapter relates the history outlined in the previous chapter to an enhanced understanding of current typeface designs. Based upon the categories of the Vox system, each section outlines the historical origins and stylistic features of the category, and shows the typefaces in use through both historical and contemporary examples, followed by an in-depth analysis of key typefaces within the category.

Chapter 3: Working with Type

The preceding chapters provide an informed basis for making key decisions in the selection of typefaces. This chapter deals with the application of this knowledge to the design process itself. It introduces the fundamental concepts and specialist vocabulary of the subject. It then details the processes by which successive design decisions influence and develop the appearance and functionality of printed text, expressive display typography, and typography for the screen. Each section is supported by an explanatory glossary and a sequence of assignments.

Chapter 4: Catalog of Type

The *Catalog* presents a selection of useful, noteworthy, and distinguished typefaces in all major categories, selected for stylistic innovation, long-established use, historical significance, and recognition within the design profession. It clarifies the distinction between those faces designed for the setting of continuous text and those intended for display purposes. For this reason it uses an extended range of descriptive categories that goes beyond the limitations of the Vox system.

Endmatter

In support of the previous chapters, the book provides a section on usage—good typographic practice—a main glossary, useful contacts, bibliography, and an index.

Chapter 2: Categories of Type

Categories of Type continued

Chapter 3: Working with Type

Chapter 4: Catalog of Type

key features

alphabet settings shown in 30pt

sample text setting, shown in 14 on 18pt

glossary

assignment

sample text setting, shown in 9.5 on 11pt

key features

history

the history of type

For its first 400 years, the evolution of type
design was dominated by the history of print.
Most major developments in typography were
prompted by developments in print technology,
from the mechanization of punchcutting and
the invention of the Linotype and Monotype
systems in the 19th century to the introduction
of phototypesetting in the 20th century.
The development of typographic design as
a distinct profession is a 20th-century phenomenon
that itself reflects significant changes in reprographic
technologies. The arrival of computerized typography
revolutionized type design, bringing digital software
to the independent user and providing the type
designer with the means to design, market, and distribute
typographic products. At the same time, the requirements
of the Internet have created a major new area of typographic
practice. Where digital design initially focused on making
screen information resemble the final printed output, today's
typographic designers are developing design methods and
new typefaces specifically for the screen.

Early movable type

The first European book to be printed from movable type was Johannes Gutenberg's 42-line Bible, printed at Mainz in Germany in 1455. Gutenberg's achievement was to mechanize the production of what had previously been a uniquely crafted object, and his work marks the inception of book typography and typeface design.

■ THE ORIGINS OF TYPE

Gutenberg was not the inventor of printed type. There is evidence that printing was already established in China and Korea at this time, both in the form of "block books" and early forms of movable letter. The European alphabet was, however, more easily adapted to the concept of movable type than the more complex Chinese writing system, and the impact of print upon the culture was consequently more immediate and far-reaching.

Gutenberg's most significant innovation was neither in printing nor typesetting, but in the casting of type from a mold, allowing for the multiple production of identical metal letters from a single original design.

■ HAND-CUT PUNCHES

The details of Gutenberg's working methods were closely guarded during his life and remain the subject of speculation and research, but the casting of his type is likely to have followed a process that came to be widely adopted across Europe. The letters would first be cut in relief on the end of a cylinder of steel. This positive reversed form was known as a punch. The punch would then be struck into a softer metal, usually copper, to create an impressed right-reading form, known as a strike. This was trimmed to appropriate width to form the matrix. The matrix was fitted within the two halves of a mold, into which liquid metal could be poured to form the sort (the name given to the individual piece of type), giving a reversed relief letter that would create a right-reading impression when printed.

A separate punch would be made for every letter and punctuation mark in the font, for every size. While this process underwent considerable refinement between the 15th and 19th centuries, it remained at the core of typefounding for some 400 years.

■ OPTICAL AND PRACTICAL ADJUSTMENTS

Hand-cut punches show considerable variations of form between the smaller and larger sizes, reflecting adjustments and modifications made by the punchcutter to ensure the optical effectiveness of the type at each scale. At smaller sizes, fine details would be strengthened and counters opened up to aid legibility and prevent the risk of ink clogging, or "filling in." The cutting of punches in the larger sizes allowed for the fine details of the letters, and particularly the form of serifs, to be sharpened and refined.

The punchcutter was therefore a key craftsman, and punches and matrices became a crucial component in the development and dissemination of typographic knowledge, passing from hand to hand, and indeed from one country to the next, to be reused by successive generations of printers and typefounders.

■ CALLIGRAPHIC LETTERFORMS

The letters in Gutenberg's 42-line Bible were designed primarily to replicate the calligraphic Textura Blackletter forms used in German illuminated manuscripts of the time. This necessitated the casting of a large number of ligatures and alternate letters, to simulate the variations of typographic form used by scribes at that time. Analysis of the pages appears to show a font totaling over 300 characters. Neither type nor punches survive, giving rise to differing opinions about the exact number of characters cast. Recent research has questioned the extent to which movable type was used in the printing of the Gutenberg Bible. It is, however, clearly established that Gutenberg had instituted the process of printing from movable type at this time.

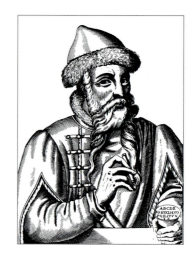

THE FATHER OF PRINTING
Johannes Gutenberg (1397–1468) is generally credited as the inventor of printing from movable type for the Western world. Originally a goldsmith, he was already knowledgeable in the casting of metals.

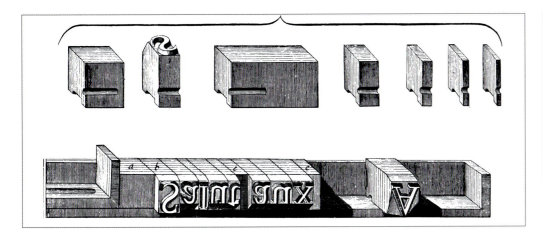

THE DEVELOPMENT OF WRITTEN FORMS

The history of the printed word is only part of the larger and even more complex history of written language itself. The development of the European alphabet can be traced back to Sumerian cuneiform, a form of incised writing on clay tablets that evolved in southern Mesopotamia around 3150 BCE. This marked the emergence of an abstract writing system out of a set of pictographic symbols, which were largely descriptive.

A phonetically based alphabetic system, in which the sounds of spoken language are represented by a scheme of abstract marks, was developed by the Phoenicians from 1500 BCE. The influence of the Phoenicians as a trading culture introduced the idea of a full, non-representational writing system across the Mediterranean and formed the basis for successive Greek, Etruscan, and Roman alphabets. As writing spread across medieval Europe, the square forms of the Roman alphabet gradually developed into rounder shapes, known as uncials and half-uncials. The many variants were standardized by the Emperor Charlemagne in the Carolingian edict of 800 CE. This established a consistent alphabet of 24 letters and gave its name to the Carolingian "minuscule" hand that is the basis for the lowercase letters in use today.

HAND COMPOSITION

Metal type and spaces were assembled on a composing stick before being locked into a metal frame, or chase, for printing. This example (above) from the 18th century is essentially identical to the methods used in Gutenberg's time.

EUROPE'S FIRST PRINTED BOOK

A page from Gutenberg's 42-line Bible, printed in 1455 (left). The condensed, angular qualities of the Textura Blackletter type create a powerful impact on the page, but make the text virtually illegible to modern eyes. The initial letters and borders, which were added by hand after printing, provide some visual relief.

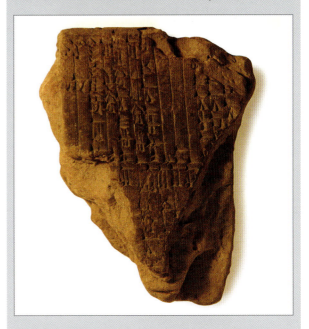

ORIGINS OF WRITING

This large fragment of a cuneiform tablet (above) dates from the third dynasty of Ur (2113–2006 BCE). Divided into columns and lines, it is a statistical account maintained by a temple, recording the amount of produce being deposited there.

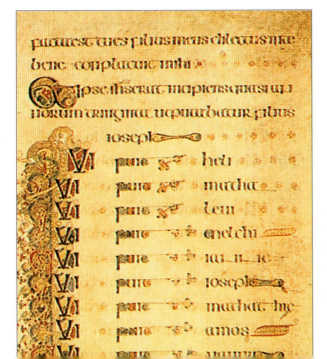

EARLY LOWERCASE

Celtic half-uncial script is used in the 8th-century Book of Kells (left). The beginnings of lowercase letters can be seen in the extension of the vertical strokes of letters such as b, d, and p.

The development of printing

Printing was introduced into Britain by William Caxton in 1476 and, as it spread across Europe, so styles of type developed to reflect regional preferences. The dense angularity of the Textura Blackletter was replaced in much of Europe by the Humanistic Roman forms, based upon the Carolingian minuscule, preferred in Italy and France.

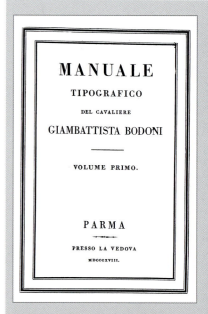

EARLY TECHNOLOGY
A wooden hand-press of a design that remained essentially unchanged through the 17th and 18th centuries (above).

■ THE EMERGENCE OF ROMAN TYPES

The Roman forms influenced the development of the early Humanist typefaces, and mark the emergence of the punchcutter's art, as type design developed beyond the simulation of handwritten forms and emerged as a medium with its own characteristics. However precise the punchcutting and casting, type remained at the mercy of the related technologies of printing and paper production. We can safely assume that the Renaissance punchcutter allowed for the spread of ink in absorbent paper and the mechanical imprecision of the printing process, cutting the punches considerably lighter than the intended letter to compensate for the subsequent coarsening of the printed result. Developments in print and paper technology in the 17th and 18th centuries created the conditions for letterforms of far greater delicacy, sharpness, and contrast.

■ DEVELOPMENT OF ALDINE AND OLD FACE

The types cut by Francesco Griffo for Aldus Manutius in Venice would form the basis for the further development and refinement of the Aldine form in the letters of Claude Garamond in France. After Garamond's death his punches and matrices were bought by Christophe Plantin, a French printer based in Antwerp who was later to commission work from Robert Granjon in France as well as the Dutch punchcutters Hendrik van Keere and Christoffel van Dyck, establishing the distinctive characteristics of the Netherlands Old Face or "Dutch taste."

■ THE TYPE CASE

The earliest typefaces included a large number of ligatures and alternate versions of letters. However, for practical reasons the character set was rationalized to comprise 24–26 lowercase letters (u and j were later additions to the standard alphabet), along with capitals and numerals. Each font of type was arranged in two cases, hence the terms "uppercase" to describe capitals, and "lowercase" to describe the minuscule letters.

■ TYPE SIZES

The sizes at which type was cast were not subject to a standard measurement until the 18th century. Prior to this, types had been given specific names at each size, including Great Primer, Double Pica, and others related to their intended use. French punchcutter Pierre-Simon Fournier (1712–68) first introduced a unified system of type sizes based upon the division of the inch into units, known as points. This marked the inception of a consistent language for describing type size, and led to the development of the point system adopted in mainland Europe, although this was different from the point system used in the US and UK (see pages 110–111).

■ DEVELOPMENTS IN PRESS TECHNOLOGY

Gutenberg had employed wooden presses using mechanical principles based upon agricultural machinery. The printer placed the paper face down upon the type, after which a screw was tightened to make the impression. While this process was refined over the next three centuries, the basic principle remained unchanged.

The iron hand-press was introduced to the UK by Lord Stanhope at the beginning of the 19th century, followed by the Columbian presses in the US, and the Albion presses in the UK. These presses used a lever mechanism, giving greater power of impression in a single movement, and thus allowing greater precision than was possible with wooden presses.

THE ENLIGHTENMENT LETTER
Title page (above) from Giambattista Bodoni's Manuale Tipografico (1818).

The industrialization of the printing process continued with the development of the cylinder press, invented in London by the German designers Koenig and Bauer. This carried the paper over the type on a rolling cylinder, a principle that lent itself readily to mechanization. One of the first steam-powered presses was installed at *The Times* newspaper in London in 1814. Mechanization quickly spread to most major newspapers, but book-publishing houses continued to make use of hand-presses throughout the 19th century.

■ HAND-SET TYPE

Although these developments increased the speed and efficiency of the printing process, the actual setting of type continued to rely upon the exacting and labor-intensive practice of hand composition. The individual letters would be assembled into lines of text in a composing stick, to be transferred to a tray, known as a galley, and finally locked into the metal frame known as a chase, that would be positioned in the press for printing.

NAMING BY SIZES

An extract from William Caslon's specimen sheet of 1734 (left). Names such as Great Primer and Double Pica were used to describe type by size before the advent of the point system.

VENETIAN HUMANIST

A paragraph from The Natural History of Pliny the Elder *(left), printed in Venice in 1476 by French typecutter and printer Nicholas Jenson (1420–80). Jenson's Roman letters are widely viewed as a definitive Humanist type.*

FROM OLD FACE TO MODERN

A page from John Baskerville's Virgil (1754) set in his own types (above).

BASKERVILLE: TECHNOLOGICAL ADVANCES

John Baskerville (1707–75) was responsible for a number of innovative developments within typography and printing. The typeface by which he is known has been successfully adapted to a range of technological changes and remains one of the most attractive and legible of text faces. It also reflects a number of innovations for which Baskerville was responsible, and embodies refinements of form that were to gain full expression in the Didone typefaces of Bodoni and Didot.

The clarity and definition of printed type in Baskerville's time was subject to the spread of inks into the paper surface, resulting in printed letters that were considerably heavier and less sharp than the metal type from which they had been created. Baskerville developed more concentrated inks, and introduced the use of "wove" papers that were hot-pressed after printing. These improvements allowed for finer printing and enabled the greater contrast of stroke widths that characterizes Baskerville's types, prompting the transition toward the highly refined hairlines of the Didone letterforms.

INDUSTRY, CRAFT, AND REVIVAL

The 19th century is generally viewed as a time of declining technical standards in printing as demand for mass publication increased. In Britain, it is true that few printing companies maintained high typographic standards in the face of a broadening but less specialized market. The designer, writer, and polemicist William Morris was concerned with both the decline in aesthetic standards and the erosion of craft skills brought about by the industrialization of printing. Morris commissioned the Chiswick Press, founded by Charles Whittingham, to publish two of his books of poems, and later set up the Kelmscott Press in 1891, with the intention of restoring standards of craft and quality in printing.

Equally significant was the work of Morris' associates Emery Walker and T. J. Cobden-Sanderson, who founded the Doves Press in 1900. The Doves Bible of 1905 used a Humanist face, the Doves Type, recognized as a far more sensitive interpretation of the 1476 Jenson model than Morris'.

Other private presses were founded in the early 20th century, notably the Vale and Ashdene Presses in England, and Daniel Berkeley Updike's Merrymount Press and Elbert Hubbard's Roycroft Press in the United States.

Although the phenomenon of the private presses represents a fairly specialized area of practice, its wider impact upon typographic awareness was considerable. The revivals of Humanist typefaces prompted a concern for the reform of typographic standards that was continued by Stanley Morison at Monotype and informed the development of type design in the 20th century.

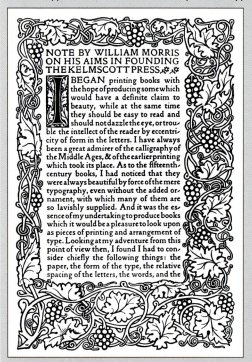

MEDIEVAL REVIVAL

An example of Golden Type (above) designed by William Morris (1834–96), reflecting the influence of medieval manuscripts.

THE BIBLE AS ART OBJECT

A page from the Doves Bible (above) printed in 1905 by T. J. Cobden-Sanderson and Emery Walker that used the Doves Type, which was a sensitive reinterpretation of the Venetian Humanist form.

■ LINOTYPE AND MONOTYPE

In the 1880s, two American engineers independently designed machinery to automate type composition. In both cases, this was achieved by assembling the matrices for casting text ready for printing. The process came to be known as hot metal, because the lines of text were created by fresh casting rather than the manual arrangement of pre-cast (cold-metal) type.

The Linotype machine, invented by Ottmar Mergenthaler and installed at *The New York Times* in 1886, was designed to cast type in whole lines. Known as slugs, these solid cast lines were easy to handle but impossible to correct, and the Linotype machine was widely adopted in newspaper production and other areas where speed of production was of greater significance than precision.

The Monotype machine, invented by Tolbert Lanston in 1887, was designed to cast a sequence of separate letters. Text was set from a keyboard that punched holes in a paper spool, through which compressed air was passed to position the matrix for casting each character in the correct order. The Monotype machine could be used both for setting text for the page and for casting type for hand-setting.

Both Monotype and Linotype systems allowed for the automated justification of lines, expanding the word spaces to fit a predetermined measure.

■ NEW TYPES FOR NEW TECHNOLOGIES

Machine composition was widely adopted for mass communication, but did not fully replace hand composition for books until after World War I. Initially the new typesetting manufacturers adapted existing foundry typefaces for hot-metal casting, but both Monotype and Linotype went on to commission new designs for the new systems. The format of the Monotype matrix case standardized the body widths upon which letters were cast, and the adaptation of foundry types to the new technology required subtle adjustments to the proportions of certain characters.

■ THE PUNCHCUTTING MACHINE

The invention, in 1884, of the punchcutting machine had a significant influence on 19th-century type design. Designed by Linn Boyd Benton, this traced the form of the letter through a pantographic apparatus to engrave a punch; the punch could then be created as a direct transcription of a drawing.

Though printers and designers had in the past made drawings for punchcutters to work from, this process had necessarily been a collaborative one,

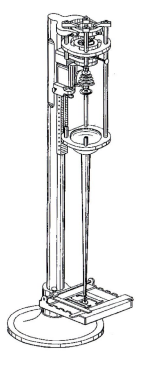

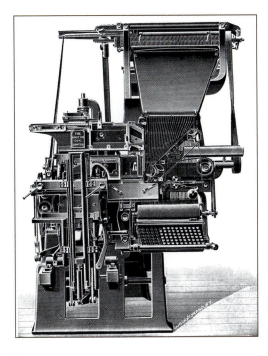

**AUTOMATED
PUNCHCUTTING**

*The punchcutting machine
(above), invented in 1884 by
Linn Boyd Benton (1844–1932),
was to revolutionize type design
and production.*

MECHANIZED TYPESETTING

*Ottmar Mergenthaler's Linotype machine (above) was the
first mechanical typesetting machine, and cast solid lines
of type for newspaper production.*

STANLEY MORISON: CONSERVATIVE INNOVATOR

Stanley Morison was one of the most
significant influences on the reform
of typographic standards in the early
part of the 20th century. From 1923
he was typographic advisor to the
Lanston Monotype Corporation,
and in the same year he founded
the typographic journal *The Fleuron*
with Oliver Simon. He was appointed
typographic advisor to the Cambridge
University Press from 1925, and his
book *First Principles of Typography* was
published in 1928. His achievements
at Monotype included commissioning
Eric Gill to design Gill Sans (1928)
and Perpetua (1932).

Although Morison collaborated with
Victor Lardent on the design of Times
New Roman (1932), his significance is
less as a designer than as an influential
commentator upon typographic
practice. His position within Monotype
and his standing in the worlds of
printing and publishing enabled him to
implement his concern for typographic
quality within an industry whose
standards had been undermined
by the pressures of mechanization.
While his concern for the integrity
of typographic form was based largely
in the qualities of traditional types,
this was not a retrogressive position.
In contrast to Morris and the private-
press movement, Morison did not
seek to return printing to an earlier
state of manual craftsmanship, but
rather to ensure that the printing
industry developed according to
appropriate aesthetic standards.

UNLIKELY COLLABORATORS

*Some of the most innovative designs for
mechanical typesetting arose from the unlikely
association between Stanley Morison (top) of
the Monotype Corporation and the lettercutter
and sculptor Eric Gill (above), who originated
key typefaces including Perpetua, Gill Sans,
and Joanna.*

reliant upon the skill and sensitivity with which
a punchcutter interpreted his client's or master's
intentions. Mechanical punchcutting allowed for
a range of sizes to be created from a single set of
master drawings. This process standardized some
of the subtle variations by which hand punchcutters
made optical adjustments to letters at different sizes.

As new typefaces came to be designed specifically
for mechanized punchcutting, however, the need for
all sizes to be based upon a limited number of master
drawings was absorbed into the designers' working
method. The design of new typefaces was no longer
an exclusive craft dependent upon the skills of the
punchcutter, and consequently became a less
specialized practice, embraced by designers,
illustrators, and architects. Linn Boyd Benton's son
Morris Fuller Benton (1872–1948) became one of
the most prolific of this new breed of type designers.

Offset lithography and photosetting

During the 20th century, two closely linked developments in printing and print origination radically altered working methods in type design and type use. The first was lithographic printing, in which the ink-retaining print areas are determined through the action of a light-sensitive emulsion coating a flat metal plate; the second was photosetting, the typesetting process in which letters are successively exposed onto photographic paper or film.

■ OFFSET LITHOGRAPHY

For 400 years, the printed word had been reproduced primarily through relief printing, a three-dimensional mechanical process in which the raised areas of type or image are inked and then impressed onto the paper. During the 20th century, this was superseded by the chemical process of lithography. Originally used for the multiple transfer of drawings made onto lithographic stone, lithographic printing was developed for mass commercial application through the use of flexible zinc plates that could be cylinder-mounted for printing via an inking roller. The process became known as offset lithography. As well as streamlining the printing process, it allowed for continuous printing onto a roll of paper or "web," a process known as web offset.

One of the major advantages of the lithographic process is that it does not require a raised print surface; until the development of photosetting, however, text type was available only in metal form. Pages of text to be printed lithographically had first to be typeset in metal, from which a proof copy was taken. This was then used to create the photographic negative from which the litho plate was made. The obvious inefficiencies of this procedure prompted the development of two-dimensional page composition and the emergence of phototypesetting.

■ PHOTOSETTING

In 1930 Edmund Uher designed a prototype photocomposition system. This used a master disk containing all of the characters of a typeface in the form of a photographic negative. A keyboard directed the rotation of the disk to select characters that were then exposed, in turn, through a lens onto photographic paper. The first commercial phototypesetters came into use in the 1950s, and the Linotype Corporation's Linofilm machine and Monotype's Monophoto machine were followed by many others, often developed by major foundries.

Photoset text and titling were assembled into layouts and photographed to create the negatives to which the lithographic plates were exposed. Sometimes described as cold composition, this process revolutionized not only the printing industry and the design of type but also the practice of graphic design. The increasing dominance of offset lithography and photosetting in the latter part of the 20th century moved typographic decision-making processes from the printing floor to the design studio. Photosetting completed the change in type design methods, since the design of faces for photosetting required no knowledge of relief print or punchcutting processes.

■ NEW FACES

Type designed for photosetting was usually drawn at large scale and cut from film before being photographed to create the master negatives of the font. In many instances, a single set of master negatives served for the setting of a range of sizes. The demand for typefaces for the new photosetting systems, and the relative ease with which such typefaces could be created, led to a proliferation of new faces of widely varying quality, and some questionable adaptations of faces from metal originals. It also prompted the widespread pirating of typefaces, adapted for new systems under different names and often inferior in form and detailing.

Photosetting uses the action of light upon photosensitive surfaces, which created particular problems for type designers because the concentration

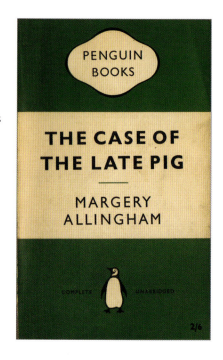

RATIONALIZATION AND DETAIL
In the late 1940s, Jan Tschichold was commissioned by Penguin Books to establish a set of consistent standards and guidelines for the typesetting and production of all their titles (above). The style instigated by Tschichold and further refined by Hans Schmoller was to remain in use over the following 12 years.

of light at areas such as the junctions of letters led to overexposure and a loss of definition. Some photosetting typefaces were designed with "light-trap" adjustments to the junctions to compensate for this.

■ DEVELOPMENTS IN PHOTOSETTING

The earlier and less sophisticated photosetting systems set single columns of type that were printed out as "galleys" and manually assembled ("pasted up") into the required layout, before being photographed to create the negative from which a lithographic plate could be made. The second phase of photosetting machines made increasing use of computerized information, allowing a page of set type to be viewed on a monitor screen. This enabled more of the page assembly to take place within the setting process, and meant that multiple columns and elements such as running heads, folio numbers, and subheads could be "set to page" on screen. In this, photocomposition anticipates some of the key characteristics of present-day digital systems.

■ INTERNATIONAL MODERNISM

A rigorous modernist aesthetic informed the postwar movement broadly described as Swiss typography, which developed in Zurich and Basel in the 1940s and 1950s, and which consolidated ideas first formulated by Jan Tschichold and Paul Renner in the 1930s. Characterized by strong asymmetrical grids, a rigorous use of Grotesque or Neo-Grotesque sans-serif type focused attention upon the underlying dynamics of composition. The deliberate choice of mechanical, undemonstrative typefaces, and the consequent lack of historical references or associative values, allowed this idiom to transcend national boundaries to become an effective international style.

■ TSCHICHOLD AND THE NEW TYPOGRAPHY

In his books *Die Neue Typographie* (1928) and *Typographische Gestaltung* (1935), Jan Tschichold (1902–74) formulated the principles of a new typography. The influence of the Bauhaus informs his early work, in which abstract modernist principles are applied to the practical problems of graphic design. The new typography was characterized by the use of sans-serif types, flush text, and an asymmetrical layout, a dynamic and explicitly modern idiom that was enthusiastically developed into a typographic ideology in Tschichold's early writings. His later career encompassed a much broader frame of reference, through distinguished work as a book designer and designer of typefaces, notably Sabon in 1967.

NEW TYPES, NEW LAYOUTS
The International Typeface Corporation's journal U&lc. (right) demonstrates the increased scope which photosetting provided both for the design of new faces and the flexible arrangement of type upon the page.

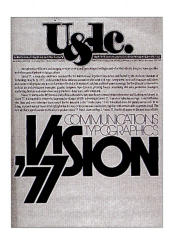

INTERNATIONAL MODERNISM
This design (right) utilizes many of the key characteristics of modernist typography. In its asymmetrical layout, its restrained scale of the type, and its emphasis upon the dynamic interaction of elements, it demonstrates how the international style has become a constant and recurring idiom in contemporary graphics.

The digital age

The development of typography from 1970 to the present day reflects the impact of digital technology throughout the type industry. During this period there has been an unprecedented growth in design and production that has profoundly affected everyone who works with type—designers, typographers, manufacturers, and—increasingly—the general public.

■ DESKTOP PUBLISHING

While professional photosetting systems had incorporated digital processes to become largely computerized by the 1980s, typesetting had continued to be a specialized service within the printing and reprographic industries. Compugraphic's use of the Apple Lisa personal computer to drive their MCS photosetters revealed the potential for typesetting to be incorporated within the designer's personal computer and prompted the emergence of desktop publishing.

The integration of detailed typesetting within an on-screen design process radically altered the working relationship between designer, typesetter, and printer. It also opened up the previously specialized world of typography and type design to a mass market of personal computer users. While it is now possible to see photosetting as having anticipated the development of digital typefaces, early desktop systems exposed the visual shortcomings of the emerging technology by comparison with the high standards that had been achieved in photosetting by the 1980s. Although partly attributable to the standards of resolution and screen display, this is also a result of some early attempts to translate traditional typefaces into digital form.

■ BITMAPPING

As with previous developments in type history, a period of experimentation determined the particular demands of the new technology before it could be assimilated into the working methods of type designers. Digital type on screen is formed from a grid of pixels, with all of the pixels that fall within the letterform appearing as positive. The resulting form is known as a bitmap. Type can also be recorded and stored in vector form. This maps the outline of the letter as a sequence of straight and curved lines, the mathematical formulae for which are then stored digitally. Both the screen information and the eventual printed output are then bitmapped.

■ INTEGRATING THE PIXEL

The perceived problems of digital type design were addressed with particularly incisive vision in the work of Zuzana Licko. Licko's early designs for Emigré incorporate the pixelated profile into the working method, rather than treating it as a visual interference. Designed to maintain their integrity of form under variable levels of resolution, Licko's early faces anticipate questions that later became fundamental to web typography and new media applications.

■ DIGITAL DESCRIPTION SYSTEMS

Digital type is created without mechanical processes, and each typeface is stored in the form of binary information. The shape of each character is composed upon a fine grid of pixels, and this character shape, along with coded information on the sidebearings, kerning, and hinting (a process to improve the alignment of type to the pixel grid), is stored as digital information in the font software.

Some of the most important developments in digital type technology concern the evolution of description languages: the means by which information is managed between digital file, screen, and printer. Early digital design programs allowed for only very approximate on-screen display, limited by the relatively crude pixel grid that is fixed at 72 dpi (dots per inch) on the Apple Mac and 96 dpi on PCs. Compared with the resolution of the output even of domestic digital printers at between 300 and 600 dpi, and professional imagesetters at up to 3000 dpi, this created noticeable

FROM PRINT TO SCREEN
Emigre *magazine was a key design journal in the 1980s and 1990s, and was central to the developing critical dialogue around the proliferation of new typefaces in the early phases of the digital age.*

TYPE, TECHNOLOGY, AND POSTMODERN DESIGN

During the late 1980s and early 1990s, digital technology broadened access to both graphic production and typeface design, providing unprecedented scope for radical graphic initiatives that questioned established views on the values, purpose, and nature of graphic design. Borrowing theoretical positions from postmodernism and critical theories of deconstruction, as well as the reappraisal of vernacular sources and "bad" design, innovative designers and design educators promoted confrontational work that questioned not only accepted aesthetic norms but also the social and commercial role of the designer. The grid-free and intuitive working methods of designers such as David Carson explored an integrated graphic language of type and image, developing an expressionistic idiom that permeated popular culture.

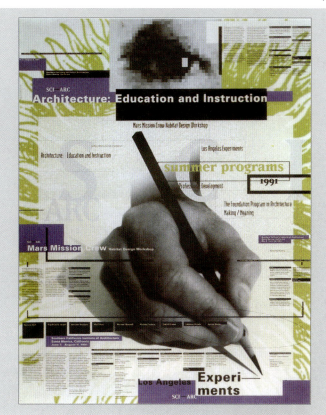

DECONSTRUCTING THE GRID

A complex multilayered design by April Greiman (left), combining formal grids with a loose asymmetrical arrangement of rules and titles, together with variations of weight, size, and color.

disparities between screen information and printed output. This problem was addressed through two different description systems: TrueType, developed by Apple; and PostScript, developed by Adobe. Both translated the character information from bitmap into vector form for display.

The information required for the digital output of type is stored in bitmap form. Since bitmaps cannot be scaled, this requires a separate set of bitmaps for each size. The image produced on screen was compromised by the irregularities of the pixel grid, and did not give a clear representation of the letter's profile or of the printed outcome. In order to address this problem and provide better screen information, Adobe developed fonts using the PostScript description language. These are known as PostScript fonts or Type 1 fonts.

■ POSTSCRIPT FONTS

A PostScript font consists of PostScript files and Bitmap files. PostScript files use the fixed-size bitmap file information to draw the characters on screen. This vector information can then be sent to the printer, which fills in the vector shape with pixels—a process known as rasterization. Adobe Type Manager scales information from the PostScript outline font to create appropriately sized bitmap letterforms on screen.

THE JOURNAL AS FOUNDRY

As well as producing a magazine of the same name (right)—which was one of the most important design journals of the emerging digital era and a forum for new ideas on emerging postmodern design philosophies— Emigre was one of the most influential digital foundries, publishing typefaces designed by the editors and contributors, as well as many of the key innovators in this developing medium.

EMIGRE No.70

The Look Back Issue

SELECTIONS FROM EMIGRE MAGAZINE #1 ~ #69

1984 ~ 2009

CELEBRATING 25 YEARS

In Graphic Design

Emigre

■ TRUETYPE

TrueType fonts, originally designed by Apple, were outline fonts in vector format, and are infinitely scalable. Both Mac and Windows operating systems include a TrueType rasterizer that converts the vector information into bitmap form for both screen drawing and print output. TrueType fonts are contained within a single file, which makes them more manageable than PostScript fonts.

■ UNICODE AND OPENTYPE

Unicode, a system developed in the 1990s for the description of a character set, allows for a single font to contain up to 65,000 characters or glyphs, instead of the limit of 258 which had in the past formed the basis for the "standard Western character set." This prompted the development of a new phase of font encryption that supersedes PostScript and TrueType.

The OpenType format was developed jointly by Microsoft and Adobe and is designed to the Unicode standard. OpenType fonts consist of a single file that can accommodate the extended number of characters/glyphs that the Unicode system defines. This allows for the font file to include not only all the alternate glyphs and diacritics required by different languages using the Western alphabet, but also to include further alphabets such as Greek and Cyrillic. Where, in the past, the development of non-Latin "extensions" was an inconsistent and selective process, limited to the more widely used faces and often carried out at a later date or independent of the original design, it is likely that, in future, many typefaces will be initially conceived for a number of alphabets. Several new OpenType faces currently offer extended multilingual character sets to support a wide range of languages including Hebrew, Arabic, Ethiopic, and numerous Oriental types.

■ FONT DESIGN SOFTWARE

Digital media broadened the availability of font design technology. Many early digital fonts were designed using the relatively specialized industry program Ikarus. More accessible and economical programs, such as the now defunct Font Studio, brought font design software within the reach of the individual user.

Macromedia's Fontographer became the leading type design tool through the 1990s, and Fontlab continued the development in relatively inexpensive, industry-standard software, now providing for the design of installable typefaces in OpenType format as well as TrueType or PostScript.

The accessibility of type design software to the less specialized independent user resulted in a proliferation of new faces of variable quality. More significant in the longer term, however, is the effect upon the economics of typeface production and distribution. As type developed from cost-intensive industrial hardware to digital software, a product that had previously required a major corporate infrastructure could be produced, marketed, and commercially distributed by its designer. Since the 1990s there has been a growth of independent, designer-led foundries, in addition to companies that manage the licensing and distribution of typefaces for individual designers. The Internet has been a key component in this development, providing designers with both a source of type information and a means through which fonts can be purchased and downloaded. The major foundries have developed comprehensive libraries of digital faces, investing in both the digitization of historic types in which they hold an interest and the commissioning of new faces.

■ TYPE AND THE INTERNET

The development of Internet communications from the late 1990s created a major new area of typographic practice, and set new challenges for both the website designer and the designer of typefaces. Earlier phases of digital design identified the need for screen information to resemble more closely the quality of final printed output, but with the growth of the Internet, it became necessary to view screen graphics not as an intermediate monitoring stage but as a final product. The visual quality of type on the screen therefore became increasingly significant.

This prompted the development of typefaces specifically designed for the screen. The process takes as its starting point the appearance of the type on the monitor, rather than in an intended printed outcome, and led to the design of faces in which there were no

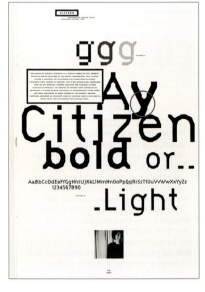

THE DIGITAL TYPEFACE
A page from the typographic journal Emigre *(above), featuring several of the early typefaces designed by Zuzana Licko to meet the new requirements of early digital publishing systems.*

TYPE MANIPULATION
This record sleeve design by Neville Brody (above) reflects a renewed interest in expressive and experimental typography in the 1980s, when the advent of accessible digital design software stimulated stylistic innovation.

print-based subtleties to be obscured or diminished when viewed on screen. Serifs were specifically designed for integration with the pixel grid, and detailed hinting ensured that letters were consistently aligned to pixels.

Although such a rationalization might be expected to result in crude, reductive letterforms, it has in fact informed the design of some distinguished typefaces, in which fitness for purpose is matched by exceptional aesthetic coherence. The work of Matthew Carter is particularly notable in this area, and his faces Tahoma (1995), Verdana (1996), and Georgia (1996), commissioned by Microsoft, were widely adopted for on-screen use.

◼ CONTEMPORARY TYPOGRAPHY

The late 20th century saw the most significant changes in communication technology since the days of Gutenberg. More recently the development of Unicode and OpenType, and the spread of Internet communications, signal a major cultural shift in type design. The fact that an OpenType font can contain a number of different scripts, as well as all the diacritics necessary for a wide range of European languages, marks a move away from the dominance of western Europe and the US, and the emergence of a more inclusive global awareness. Typeface designers are increasingly producing fonts to meet the needs of a number of different cultures, while the relative ease of distribution allowed by digital font software means that the availability of type is no longer limited to the industrialized world, or dependent upon the infrastructure of a Western printing industry.

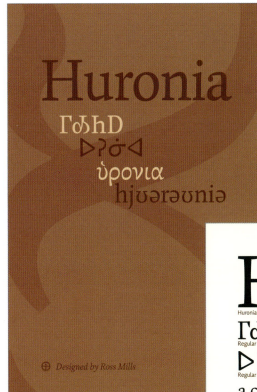

MULTILINGUAL TYPE

Designed by Ross Mills of Tiro Typeworks, Huronia (above and right) is a multiscript typeface which supports all extant Native American languages. In addition it provides for polytonic Greek and includes the necessary diacritics for all languages using the Latin alphabet.

categories of type

Almost all typefaces belong to a
recognized tradition, and in order to
make informed decisions about their
use, we need to locate them within
their wider historical context. The
classification of typefaces is, however,
a complex subject and continues
to be a matter of debate among
typographers and type historians.
Although widely recognized
terms are used to describe the
main categories of type, no entirely
comprehensive classificatory system
has yet been devised. The classification
that has attracted the broadest consensus,
despite its inevitable imprecisions, is the
Vox system, devised in 1954. The following
directory of typefaces is based primarily on
that system, introducing additional subgenres
where appropriate, and extending the nine
main Vox categories to a total of fourteen.

Typeface classification

In order to make informed decisions in the choice of typefaces, it is important to understand something of their background, history, and cultural context. Almost all typefaces belong to a recognized genre or tradition, and their characteristics and attributes can be more fully understood if we are able to locate them within the wider picture of typographic history. The classification of typefaces is, however, a complex subject and continues to be a matter of debate among typographers and type historians.

■ APPROACHES TO CLASSIFICATION

While widely recognized terms are used to describe the main categories of type, these continue to divide opinion, and no entirely comprehensive classificatory system has yet been devised. As with so many aspects of typography there is no single correct method or model; the manner in which we group type into categories will depend upon the purpose we wish such classification to fulfill. In the 19th century, the term "Old Face" was loosely applied to most historically established book faces, while in the early 20th century the term "Old Style" was sometimes used to describe those faces that were modern adaptations of these.

Some type historians devise their own personal modes of categorization, which may identify different relationships and affinities and give new insights into typefaces and their use. Others assemble classifications from elements of existing systems, retaining some categories and revising others.

Traditional terminology often proves imprecise, or is simply not equal to addressing the complexities of present-day type design with any consistency. The early sans serifs, for example, were described as Grotesques in the UK and Gothics in the United States. Gothic is, however, also used as a descriptive term for Blackletter, while the word "Humanist" has two quite distinct meanings: as a category of serif typefaces based on the Venetian model, and as a term for describing classically proportioned sans serifs.

■ THE HISTORICAL MODEL

A typographic genre can be identified by the historical period in which the type originated, but this is a less straightforward process than it sounds. Type design in the 20th century, in particular, has been a history of revivals and reinterpretations. Changes in print technology, design theory, and prevailing fashion over the last hundred years have prompted revisions of existing faces and the design of "new" typefaces inspired by historic examples. Some of these are faithful reconstructions of the original historic forms; others reflect the general characteristics of a particular tradition while applying them to a new typographic vision.

In addition, major changes in the technology of typesetting and printing have necessitated the modification of established type styles, and provided opportunities for the further refinement and development of classic forms.

■ FORMAL OR FUNCTIONAL ATTRIBUTES

An alternative method of grouping typefaces is according to formal characteristics—their overall shape, the form or absence of serifs, the proportion of the letters, or other visual features. Categories may also be defined by the tools used to design the letters —the pen, the chisel, the ruler and compass, or the pixel and the mouse—which are, in turn, reflected in the letterforms themselves.

■ THE VOX SYSTEM

Whatever the criteria for classification, the single most important feature of any classificatory system is that it should be widely recognized and thus form a basis for a shared understanding among professionals. The closest to a broad consensus on type classification

IDENTIFYING TYPE

In this promotional guide produced by the British Monotype corporation (facing page), some of the leading monotype faces are identified by their key characteristics. The use of such terms as "Old Face" reflects the loose and approximate classifications used by the printing trade before the introduction of the Vox system.

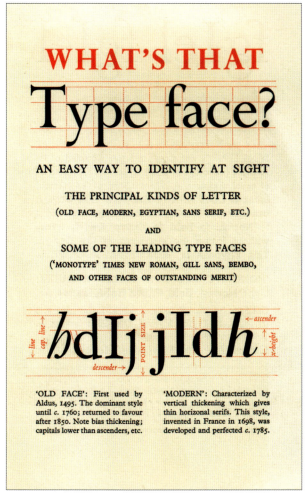

VOX CATEGORIES

The Vox system comprises nine main categories, incorporating some traditionally established terms alongside some new terminology. The first four Vox categories define type forms according to their historical period, mapping their development from the Venetian Humanist letter through the "Transitional" forms to the Didones. Subsequent categories are based upon the appearance of type forms: slab-serif and sans-serif types (termed Slab Serif and Lineale respectively), with some recognition of sub-genres within these categories. Finally, the terms Glyphic, Script, and Graphic are used to categorize a range of faces outside the typographic mainstream, according to the processes and tools that inform their design.

Like any attempt at an inclusive classification, the Vox system has many flaws and shortcomings. The invention of the term "Garalde" to encompass Aldine and Garamond, while more specific than the "Old Face" which preceded it, has no basis in usage or typographic tradition. The description of sans serif as "Lineale" carries the misleading suggestion that sans-serif faces are necessarily monoline. Each of these large categories in turn requires several sub-genres, while categories such as slab serif define a far smaller area of typeface design and type history.

I. HUMANIST *Aa* Centaur	**II. GARALDE** *Aa* Caslon	**III. TRANSITIONAL** *Aa* Baskerville
IV. DIDONE *Aa* Bodoni	**V. MECHANISTIC** *Aa* Rockwell	**VI. LINEAL (A) GROT** *Aa* Akzidenz Grotesk
VI. LINEAL (B) NEO GROT *Aa* Univers	**Aa** Clarendon	**VI. LINEAL (C) GEOMETRIC** *Aa* Futura
VI. LINEAL (D) HUMANIST *Aa* Gill Sans	**VII. INCISED** *Aa* Albertus	**VIII. SCRIPT** *Aa* Ex Ponto
IX. MANUAL *Aa* Mercurius	**X. BLACKLETTER** *Aa* Wilhelm Klingspor Gotisch	**XI. NON-LATIN** Geeza Pro

is the Vox system, devised by Maximilien Vox in 1954 and adopted by the Association Typographique Internationale (ATypI).

The organization of typefaces in this chapter is based on this system, with the addition of some sub-genres to create 14 categories in all. These include decorated and display types, which are addressed as a defined category; and the pragmatic term "Beyond Classification," which I have adopted from Lewis Blackwell to encompass not only the more eccentric products of digital type design, but also those typefaces that resist classification because they combine key characteristics of several genres.

Humanist

Humanist types, dating from the 1470s, represent the first major stylistic development in type design, and the emergence of print-based typographic forms distinct from handwritten letters. Whereas Gutenberg's type was designed primarily to replicate the formal Textura Blackletter of contemporary manuscripts, Humanist types drew upon the Roman book hand of their time, giving a greater openness of form. By comparison with later types, Humanist letters are characterized by a calligraphic quality, in which the inclined stresses and inflection of the strokes echo the forms created by a broad-nibbed pen.

◼ JENSON AND THE VENETIAN LETTER

The most influential exponent of the Humanist typeface was the French printer Nicholas Jenson, who worked in Venice in the 1470s. "Venetian" and "Jenson" have been used to describe Humanist revivals since the late 20th century. The Venetian Humanist idiom informed the design of William Morris' Golden Type, Morris Fuller Benton's Cloister Old Style, Frederic Goudy's Kennerley, and Bruce Rogers' Centaur. The term is derived from the Humanist book hand used for handwritten manuscripts in 15th-century Italy, and should not be read as "humanized."

◼ HUMANIST REVIVALS

Although they mark a significant development in typographic form, Humanist types occupied a very short period of type history (1470s–90s); they did not inspire an ongoing tradition or any real stylistic continuity, and their eventual revival took place after some 500 years of relative neglect. As a consequence, many of the Humanist revivals that appeared in the late 19th- and early 20th-centuries were, at best, imaginative reconstructions; at worst, they were rather questionable interpretations of an idealized antique form.

CHARACTERISTIC FEATURES

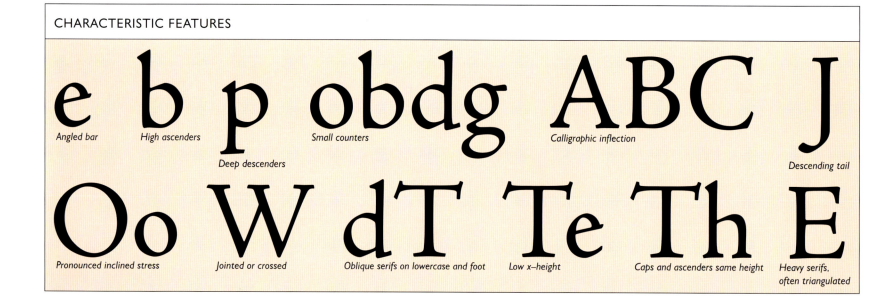

Angled bar | High ascenders | Deep descenders | Small counters | Calligraphic inflection | Descending tail

Pronounced inclined stress | Jointed or crossed | Oblique serifs on lowercase and foot | Low x–height | Caps and ascenders same height | Heavy serifs, often triangulated

GOLDEN TYPE

Designed for the books produced by the Kelmscott Press in the late 19th century, Morris' Golden Type was the first instance of a typographic "revival" design. It reflected his belief that Jenson's types from the late 15th century were innately superior to the commercial typefaces of his own time, and that Jenson had "carried the development of the roman letter as far as it can go."

Based on tracings rather than original types or punches from the 1470s, Morris' letters were then cut in steel by the punchcutter Edward Prince. As his printed examples had already been affected by the "ink-spread" characteristic of early letterpress, his designs are considerably heavier in stroke weight. His types were in turn subjected to the effects of letterpress printing, resulting in a much bolder letter than Jenson's.

The types produced by Morris for Kelmscott were highly influential but were intended for his exclusive use rather than commercial distribution. It is reported that when approached by the American Typefounders Association he told them to "go to hell," an exchange which may account for the title they gave to their derivative appropriation of his Troy type released in the early 20th century: "Satanick." Digital revivals of Morris' already oddly flawed revival reflect the differing approaches designers take in reviving historic type. David Nalle's "True Golden" is a rather literal reconstruction, retaining as "authentic" the irregularities of the printed form, while ITC Golden is a more rationalized and functional development from Morris' original.

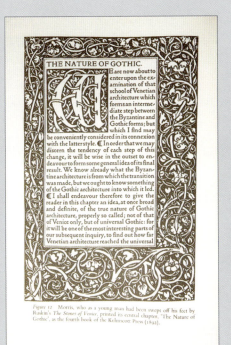

Figure 12 Morris, who as a young man had been swept off his feet by Ruskin's *The Stones of Venice*, printed its central chapter, 'The Nature of Gothic', as the fourth book of the Kelmscott Press (1892).

THE

HOLY BIBLE

Containing the Old and New Testaments : Translated out of the Original Tongues and with the former Translations diligently compared and revised by His Majesty's special Command

Appointed to be read in Churches

OXFORD
Printed at the University Press
1935

KELMSCOTT TYPES

The books designed by William Morris for his Kelmscott Press used his own typefaces, including the Humanist Golden Type (left). Based on drawings traced from enlargements of Jenson's pages, the resulting type is exceptionally heavy and dense. The even and balanced texture of the type is maintained by minimal word-spacing.

CLASSIC FORMS, 20TH-CENTURY METHODS

The Oxford Lectern Bible (above) was designed by Bruce Rogers and set in his Centaur face, based upon Nicholas Jenson's Eusebius. It showed the quality that could be achieved with Monotype machine setting, and the successful adaptation of a craft-based revival typeface to commercial production methods.

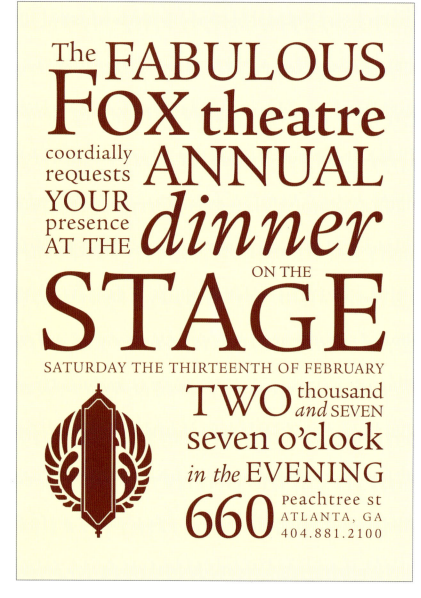

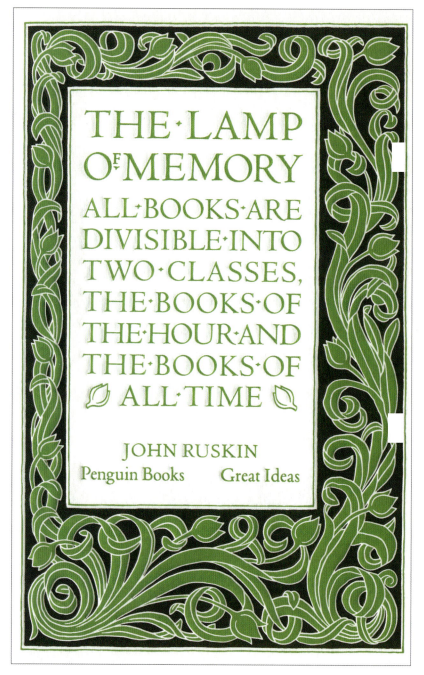

TRADITION AND MULTIPLICITY

Contemporary revivals of Humanist faces can reveal colorful qualities when used at display size, as demonstrated through the inventive mixture of size and case used in this invitation for a noted American theater (above).

REVIVAL AND DESIGN PHILOSOPHY

The Jenson revival Centaur is a contextually appropriate choice for this reprint of a key text by the 19th-century philosopher John Ruskin (above), whose ideas informed the thinking of William Morris and stimulated the Arts and Crafts Movement.

ITALIC TYPES

Renaissance typefaces did not include companion italics as a component of the face. While the Renaissance marks the emergence of classic italic typefaces, these were conceived as self-contained alphabets (usually with a roman uppercase). They were not originally paired with the upright, or roman, lowercase letters in the manner to which we have become accustomed. As a consequence, contemporary interpretations of Renaissance and early Aldine types frequently incorporate roman and italic letters originating from separate but broadly contemporaneous sources. Renaissance italics were designed for setting as continuous text, and therefore can be effectively used for this purpose.

Some Venetian revivals, such as Morris Fuller Benton's Cloister Old Style, appear to mimic the ink-squeeze of the original printed letters in the bluntness of their serifs and the lack of contrast in their stroke widths. In the case of William Morris, he based his Golden Type upon tracings from enlarged photographs of printed specimens rather than first-hand evidence of type or matrices from Jenson's time, thus incorporating the degeneration of print quality into a new generation of punches.

The enthusiasm with which Morris embraced the Venetian form was further developed in the work of T. J. Cobden-Sanderson and Emery Walker at the Doves Press in London in the early years of the 20th century. The adoption of the Humanist types by the private press movement, exemplified by the work of Morris and of the Doves Press, represents a conscious reaction against the aesthetically chaotic state of 19th-century printing, and the belief that earlier examples would provide a greater integrity of typographic form.

■ HUMANIST TYPES IN USE

Humanist typefaces have considerable character but limited practical uses. They are served better by the physical imprint of letterpress than the flat inking of lithographic printing; for commercial use there are advantages in using a typeface specifically designed in digital form, such as Robert Slimbach's Adobe Jenson, over the digitized forms of metal types such as Cloister or Centaur.

Humanist types are characterized by deep descenders, high ascenders, and a consequently low x-height, and generally require little additional leading.

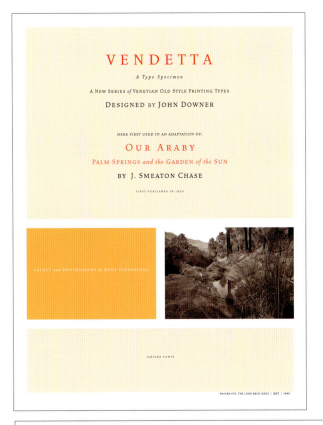

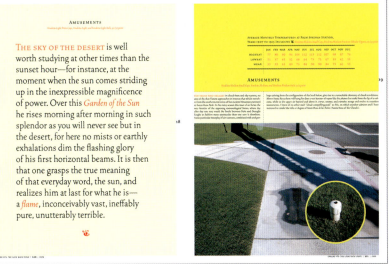

The relatively small size of the body, irregularity of outline, and small counters mean that they are not particularly legible at smaller sizes. They can be highly evocative in fine book work, display typography, and for evoking the historical associations of the Renaissance.

21ST-CENTURY VENETIAN

John Downer's Vendetta, based upon the Venetian Humanist letters of Jenson's contemporaries, is an explicitly digital reading of a classic form, published by Emigre. These pages from Emigre no. 50 (above) show it in layout with photography by Rudy VanderLans.

Adobe Jenson

ROBERT SLIMBACH 1995

ABCDEFGHIJKLMNOPQ
RSTUVWXYZ
abcdefghijklmnopqrstuvwxyz
1234567890 & ? (),:;'

Adobe Jenson is a highly rational reading of the Jenson model, adapted to the user expectations of the digital age. A delicate, angular face in four weights, it reflects the influence of Bruce Rogers' Centaur, but has the advantage of being better adapted to current print technologies. The italic is based upon the same sources as Frederic Warde's Arrighi italic, and is broader and more contrasted than the italic used in Centaur. Adobe Jenson Pro includes a full range of small caps, alternates, swashes, ligatures, and ornaments.

The typographer's first duty is to the text itself. An intelligent interpretation of the text will not only ensure readability, but will also reflect its tone, its structure, and its cultural context. The typographer's analysis illuminates the text, like the musician's reading of a score.

HELGA JORGENSEN, SIGRID ENGELMAN, ANDREW NEWTON 1989

ITC Golden

ABCDEFGHIJKLMNOPQR
STUVWXYZ
abcdefghijklmnopqrstuvwxyz
1234567890 & ? (),:;'

ITC Golden Type is a digital revival by URW of the first true typographic revival, the type used by William Morris to print *The Golden Legend*. Morris' working method resulted in a face that was much heavier than the Jenson Roman upon which it was based. The ITC version has extended the family into three weights—original, bold, and black— and added small caps. The design moderates some of the original irregularities of form into a more systematic face suitable for setting larger sizes of text.

The typographer's first duty is to the text itself. An intelligent interpretation of the text will not only ensure readability, but will also reflect its tone, its structure, and its cultural context. The typographer's analysis illuminates the text, like the musician's reading of a

Centaur

ABCDEFGHIJKLMNOPQ
RSTUVWXYZ
abcdefghijklmnopqrstuvwxyz
1234567890 & ? ();:;'

BRUCE ROGERS 1912–14

Rogers' sensitive and elegant interpretation of the Humanist letter, **Centaur** is based on Jenson's Eusebius type of 1470, and is paired with a companion italic based by Frederic Warde upon a chancery hand of the calligrapher Ludovico degli Arrighi from 1524. The relatively light weight can appear unassertive when printed lithographically, and the low x-height limits its use at smaller sizes. Centaur is therefore not an economical option for extended text setting, but it is an excellent luxury typeface for fine book work at a larger scale.

The typographer's first duty is to the text itself. An intelligent interpretation of the text will not only ensure readability, but will also reflect its tone, its structure, and its cultural context. The typographer's analysis illuminates the text, like the musician's reading of a score.

Californian

ABCDEFGHIJKLMNOPQR
STUVWXYZ
abcdefghijklmnopqrstuvwxyz
1234567890 & ? ();:;'

DAVID BERLOW 1938, 1994–9

A digital adaptation of Frederic Goudy's University of California Old Style, **Californian** has a brightness of contrast and very well-defined and open counters. Like many of Goudy's faces, it draws upon historical example without adhering absolutely to an historical model, combining many of the characteristics of the Venetian Humanist letter within a characteristically American homogeneity of style. The result is a warm and legible text face with a rich and even texture on the page.

The typographer's first duty is to the text itself. An intelligent interpretation of the text will not only ensure readability, but will also reflect its tone, its structure, and its cultural context. The typographer's analysis illuminates the text, like the

Garalde

The term Garalde is used within the Vox system to describe the period of type history that begins with the Aldine faces of Aldus Manutius (1450–1515) and those of Claude Garamond (1480–1561). It includes the work of Robert Granjon (1513–89) in the 16th century; of Jean Jannon (1580–1658) in the 17th century; and of William Caslon (1692–1766) in the 18th century. The long period covered by this category marks the continued development of typographic form away from the influence of the broad-nibbed pen, toward letterforms more explicitly informed by the developing craft and sensibility of the punchcutter.

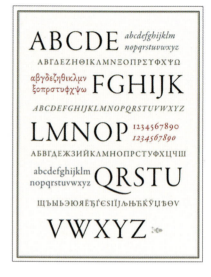

■ THE ALDINE LETTER

The origin of the Garalde form can be found in the typefaces of Aldus Manutius, cut by the punchcutter Francesco Griffo for the Aldine press at the end of the 15th century. Cardinal Bembo's *De Aetna*, published by Manutius in 1495, provides a key example of the genre as well as giving its name to one of its most distinguished 20th-century revivals, English Monotype's Bembo.

Two different approaches were adopted in pairing Griffo's forms with an appropriate companion italic. The Monotype Bembo italic is based upon Blado,

the italic cut of Monotype Poliphilus. This was a transcription of one of the italic typefaces designed by Ludovico degli Arrighi in 1526 and acquired for use by Antonio Blado of Rome. Griffo's letters also formed the basis for Giovanni Mardersteig's Dante.

■ REGIONAL DEVELOPMENTS

Whereas the Humanist types were largely superseded by the Garalde and passed into relative obscurity, Garalde types were refined and developed through subsequent centuries of typographic history, providing the inspiration for some of the most elegant and

ENHANCED FUNCTIONALITY
This promotional specimen for Adobe Garamond Premier Pro (above) demonstrates its classic visual qualities while offering a wide range of contemporary OpenType features across three scripts: Latin, Greek, and Cyrillic.

CHARACTERISTIC FEATURES

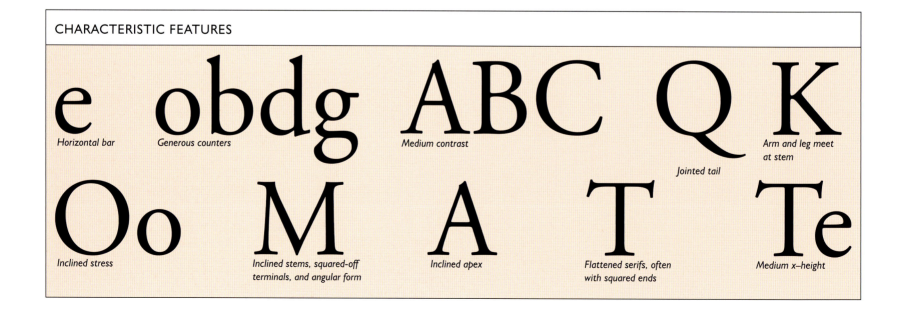

e — Horizontal bar

obdg — Generous counters

ABC — Medium contrast

Q — Jointed tail

K — Arm and leg meet at stem

Oo — Inclined stress

M — Inclined stems, squared-off terminals, and angular form

A — Inclined apex

T — Flattened serifs, often with squared ends

Te — Medium x–height

CONTEMPORARY REVIVAL

The Vienna type family by Andreas Pohancenik of Studio Zwei (above) is an example of a contemporary "superfamily" including a geometrically stylized Garalde text face alongside a range of related and compatible faces in differing idioms.

DISPLAY GARALDE

Matthew Carter's Big Caslon, based upon the distinctive, larger sizes of Caslon's types, enlivens this program design (above). The colorful alternate ampersand is especially characteristic of Caslon's work.

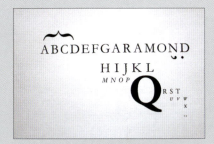
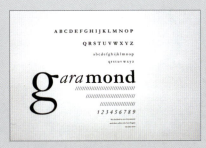

TYPOGRAPHIC POSTCARDS

This series of typographic postcards (above) explores both the functional and abstract features of the classic text typeface Garamond.

durable text typefaces in use today. The development of the Garalde form occurred across France, England, and the Netherlands. While there are some identifiable regional variations, this was also a period in which the exchange of typographic knowledge was developing internationally. The French type designer and punchcutter Robert Granjon, for example, worked in Paris, Lyon, Antwerp, Frankfurt, and Rome, influencing the development of typographic practice in key centers of learning.

■ CLAUDE GARAMOND

Garamond's historical significance changed when it emerged in the 1920s that the typefaces that had borne his name for some time were, in fact, the result of the work of the French punchcutter and printer Jean Jannon. Garamond's type is, however, the basis for the roman forms of Linotype Granjon, Berthold Garamond, and Robert Slimbach's Adobe Garamond.

■ DUTCH TASTE

Dutch "Old-style" letters include the work of Johann Fleischmann, Anton Janson, and Miklós Kis, and were the inspiration for Ehrhardt, one of the most effective book faces in current use. This was based upon Monotype Janson, a 1938 recut of the 18th-century Janson face, attributed to Janson, but actually cut by Kis, the Hungarian punchcutter based in the Netherlands in the late 17th century.

■ ENGLISH TASTE AND CASLON

The typefaces of William Caslon show the emergence of some of the characteristics of the later Transitional forms, having a near-vertical stress but also retaining many qualities of the Garalde. It has been noted that the strength and attractiveness of Caslon lies less in the inherent form of the individual letters than in the harmony and consistency with which those letters work together on the page. Caslon's types were popular in the United States, and were used for the publication of the Declaration of Independence in 1776.

Long favored for book work, Caslon remains a text face of unassertive grace, legible in its individual forms, and readable in the rhythmic relationships between letters. It has been both freely and faithfully reinterpreted for Monotype, photosetting, and digital form, with the consequence that a number of diverse typefaces carry the Caslon name. Adobe Caslon, redrawn by Carol Twombly from Caslon's 1738 specimens, is a sensitive reconstruction that shows the influence of Dutch Old-style faces but also has some characteristics of the Transitional forms that

CLASSIC CAPITALS
This book jacket design (right) makes sensitive use of Garalde capitals, carefully spaced and leaded to create a typographic rhythm which complements the photograph.

were to follow. Distinguished examples in current use include Justin Howes' Founder's Caslon, a meticulous reconstruction of several different sizes of the Caslon punches, and Matthew Carter's Big Caslon, a display face based upon the larger sizes of the original types.

■ 20TH-CENTURY GARALDES

Exemplary among 20th-century Garaldes is Jan Tschichold's Sabon, designed in the 1960s to work for hot-metal setting on both Linotype and Monotype machines, and as a hand-set type for the Stempel Foundry. One of the finest modern adaptations of the Garamond model, Sabon stands as the culmination of a hugely influential typographic career in which type design developed alongside book typography and critical writing. It is named for the punchcutter and type founder Jakob (or Jacques) Sabon of Lyons, who is credited with bringing Garamond into Frankfurt.

Sabon is, however, far more than a literal revival, since it incorporates characteristics drawn from the different sizes of the Garamonds to form one consistent and definitively 20th-century interpretation of the ideas that they embody. A digital version was

RENAISSANCE GARALDE

*Jonathan Hoefler's delicate Requiem, based
upon the letters of Ludovico degli Arrighi,
enhances this book jacket design (above).
The display version of this optically sized face
retains fine detailing and contrast at large sizes.*

issued by the Linotype library as Linotype Sabon, and
an improved version was designed by Jean-Francois
Porchez as Sabon Next in 2002.

Other distinguished 20th-century Garaldes include
Hermann Zapf's Palatino. Designed in 1929 and named
for the 16th-century calligrapher Giovanbattista
Palatino, Zapf's first text face is a highly functional face
in which the Garalde forms can be seen interpreted
through a calligrapher's sensibility. The face has a fairly
broad set, particularly in the capitals that reflect the
proportions of the roman inscriptional letter. The
calligraphic qualities of the face are more evident in
the angular strokes of the heavier weights, which evoke
the characteristics of broad-nibbed pen letters, while
maintaining the legibility of the best Garalde faces.

MISTAKEN IDENTITIES

The name of the 16th-century typecutter Claude Garamond
(or Garamont) has been associated with the stylistic
developments in French type design that immediately
followed the influence of Griffo's Aldine types. Garamond
was taught, or at least influenced in attitude and philosophy,
by Geofroy Tory, and his work shows a development and
refinement of form as well as a more systematic approach
to the constituent elements of the typeface. He established
himself as the leading French typecutter of his time, and his
roman is a technically highly accomplished development
from the Aldine letter, distinguished by a higher contrast
of stroke widths and tighter bracketing.

Garamond is credited with developing the sloped
capital forms of the italic letter, a genre previously limited
to lowercase, and thus creating the conditions for the
concept of the companion italic, which is widely attributed
to his younger colleague Robert Granjon. Many revivals of
Garamond's roman types partner these with italics based
upon those of Granjon.

For some time Garamond was thought to have been
responsible for the letters known as the Caractères de
l'Université in the Imprimerie Royale in Paris, which formed
the basis for revivals such as Morris Fuller Benton's ATF
Garamond, issued in 1918, Monotype Garamond, and
Frederic Goudy's 1921 Garamont.

In 1925 Beatrice Warde (writing under the pseudonym
Paul Beaujon) made detailed studies of a 1621 specimen
sheet that proved these types to be the work not of
Garamond but of the later typecutter Jean Jannon. Jannon
had cut the punches while working at the Protestant
academy in Sedan. They were subesquently confiscated
on the orders of Cardinal Richelieu and housed at the
Imprimerie Nationale. After being used for Richelieu's
memoirs in 1642 they had been forgotten until 1825,
when they were rediscovered and mistakenly attributed
to Garamond rather than Jannon. The italic letters of
the Caractères de l'Université were, in fact, the work
of Robert Granjon.

True Garamonds, based upon correctly attributed
source material, include Stempel Garamond, G.W. Jones'
Granjon, and Robert Slimbach's Adobe Garamond.

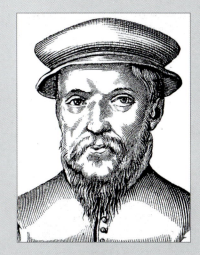

OLD STYLE FOUNDER

*Claude Garamond (above) was a highly
influential type founder, publisher, and
punchcutter, whose types have been widely
copied and are still in use today. His work
links Francesco Griffo's letters cut for Aldus
Manutius with the wider development
of the Old-Style letter across Europe.*

TYPOGRAPHIC RESEARCHER

*Beatrice Warde (above) was publicity
manager for the Monotype Corporation and
editor of* The Monotype Recorder. *In her
1926 article in Stanley Morison's journal*
The Fleuron, *she identified types
mistakenly attributed to Garamond as
the work of Jean Jannon.*

Bembo

ABCDEFGHIJKLMNOPQ
RSTUVWXYZ
abcdefghijklmnopqrstuvwxyz
1234567890 & ? (),.:;'

Letters cut by Francesco Griffo in 1495 were used by Aldus Manutius in the *De Aetna* of Cardinal Pietro Bembo, after whom Monotype named their adaptation of the Aldine model for mechanized typecasting. Despite a relatively low x-height, **Bembo** is an exceptionally legible face that reveals complexity of form when used at larger sizes. The slight angles to the initial stroke of the m and n are among the subtle details that serve to animate this classic 20th-century Aldine. Sadly, current digital forms of the face fail to match the vibrant qualities of the letterpress original.

The typographer's first duty is to the text itself. An intelligent interpretation of the text will not only ensure readability, but will also reflect its tone, its structure, and its cultural context. The typographer's analysis illuminates the text, like the musician's reading of a score.

Requiem

ABCDEFGHIJKLMNOPQ
RSTUVWXYZ
abcdefghijklmnopqrstuvwxyz
1234567890 & ? (),.:;´

Based upon the letters of the writing master Ludovico Degli Arrighi, **Requiem** is inspired by the handwritten forms of the Renaissance, which reflect a renewed interest in the classical roman capital. The italic is based upon the Chancery cursive for which Arrighi was best known. This exceptionally elegant and refined face includes a special range of ornaments and titling features. Though only designed in a single weight, the face is produced in a range of optical sizes, allowing for both text and display use.

The typographer's first duty is to the text itself. An intelligent interpretation of the text will not only ensure readability, but will also reflect its tone, its structure, and its cultural context. The typographer's analysis illuminates the text, like the musician's reading of a

MONOTYPE 1937

Ehrhardt

ABCDEFGHIJKLMNOPQ RSTUVWXYZ
abcdefghijklmnopqrstuvwxyz
1234567890 & ? (),:;'

Based upon the work of the Hungarian punchcutter Miklós Kis, mistakenly attributed to Anton Janson, **Ehrhardt** represents a 20th-century expression of the Dutch taste prevalent across northern European printing in the late 17th century. Ehrhardt is a regular and evenly proportioned face with a slightly condensed form, especially in the italic, that conserves space and promotes readability. Its resulting clarity and economy have made it a particularly popular choice for book setting.

The typographer's first duty is to the text itself. An intelligent interpretation of the text will not only ensure readability, but will also reflect its tone, its structure, and its cultural context. The typographer's analysis illuminates the text, like the musician's reading of a score.

ROBERT SLIMBACH 1989, 2004

Adobe Garamond

ABCDEFGHIJKLMNOPQ RSTUVWXYZ
abcdefghijklmnopqrstuvwxyz
1234567890 & ? (),:;'

The types of Claude Garamond have been adapted very freely to successive technologies, and even "true Garamonds" from the 20th century show considerable variations in form and x-height. Garamond was among the first type designers to design a companion italic. His letters show fairly low contrast and, as with many letterpress faces, they can look light on the page. Slimbach's **Adobe Garamond** is a characteristically efficient and pragmatic revival in a genre that has been the subject of misattribution and varied interpretation.

The typographer's first duty is to the text itself. An intelligent interpretation of the text will not only ensure readability, but will also reflect its tone, its structure, and its cultural context. The typographer's analysis illuminates the text, like the musician's reading of a score.

Galliard

ABCDEFGHIJKLMNOPQ RSTUVWXYZ abcdefghijklmnopqrstuvwxyz 1234567890 & ? (),:;'

MATTHEW CARTER, MIKE PARKER 1972

Based upon the types of Robert Granjon, ITC **Galliard** is not based upon a single Granjon face, but is a synthesis of the exuberant characteristics of his work. It is exceptional among 20th-century Garaldes for the coherence and integrity of its italic and roman forms across four weights— characteristics that do not feature in historic Garaldes, but are achieved through a sensitive contemporary interpretation of the tradition. Its forms are crisp yet fluid, with sharply defined angles, an inclined stress, and deeply bracketed serifs. The resulting face is both colorful and highly legible.

The typographer's first duty is to the text itself. An intelligent interpretation of the text will not only ensure readability, but will also reflect its tone, its structure, and its cultural context. The typographer's analysis illuminates the text, like the musician's reading of

HERMANN ZAPF 1950

Palatino

ABCDEFGHIJKLMNOPQ RSTUVWXYZ abcdefghijklmnopqrstu vwxyz 1234567890 & ? (),:;'

Palatino, Zapf's classic face, is less historically specific than many Garaldes, and its popularity may spring from the way in which he has imbued it with a distinctly human 20th-century personality, and revisited the genre from a calligrapher's perspective. The generous x-height makes Palatino an economical and highly legible face, while its calligraphic characteristics enliven the page when used at larger sizes. A lighter version of the roman produced in 1954 increased the range of weights to five.

The typographer's first duty is to the text itself. An intelligent interpretation of the text will not only ensure readability, but will also reflect its tone, its structure, and its cultural context. The typographer's analysis illuminates the text, like the

Sabon

ABCDEFGHIJKLMNOPQ
RSTUVWXYZ
abcdefghijklmnopqrstuvwxyz
1234567890 & ? (),:;'

Tschichold's well-proportioned and legible reinterpretation of Garamond's text face, **Sabon** is beautifully balanced across italic and roman in both its weights. It has a harmonious visual consistency and few obtrusive distinguishing features—an inclined stress, open counters, and a complementary interaction between characters. The OpenType era provided the conditions for the improved Sabon Next, developed by Jean-Francois Porchez, extending the family to five weights and including a generous complement of alternates and other OpenType features.

The typographer's first duty is to the text itself. An intelligent interpretation of the text will not only ensure readability, but will also reflect its tone, its structure, and its cultural context. The typographer's analysis illuminates the text, like the musician's

Adobe Caslon

ABCDEFGHIJKLMNOPQ
RSTUVWXYZ
abcdefghijklmnopqrstuvwxyz
1234567890 & ? (),:;'

A Caslon for the digital era, Twombly's **Adobe Caslon** is a practical and homogenous synthesis of William Caslon's text faces. It moderates the high contrast that is exaggerated in some Caslon revivals, but retains the exceptional crispness of the letters and the sharpness of the serifs. The colorful italic is distinguished by a pronounced angle and a very distinctive ampersand. Adobe Caslon Pro is designed in three weights and includes a full range of alternates, ligatures, superiors, small caps, non-lining figures, swashes, and ornaments drawn from the ornaments of the Caslon foundry.

The typographer's first duty is to the text itself. An intelligent interpretation of the text will not only ensure readability, but will also reflect its tone, its structure, and its cultural context. The typographer's analysis illuminates the text, like the musician's reading of a score.

Transitional

The term Transitional refers to the transition from the Garalde to the Didone or "Modern" letterforms of the late 18th century. One of the key influences upon this development was the typeface known as the Romain du Roi, designed in 1692 by Philippe Grandjean (1666–1714) for the Imprimerie Royale. These letters are based upon an underlying geometric structure, ensuring consistency in the stroke width and the form of the serif, and reflect a tendency toward a systematic rationalization of typographic form.

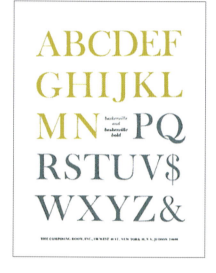

THE ESSENTIAL TRANSITIONAL
The capital forms of John Baskerville's types (above) demonstrate the key characteristics of the transitional form: an enhanced brightness of contrast and a geometrically consistent upright stress.

■ THE TRANSITIONAL LETTER

Transitionals are distinguished from Garaldes by a number of subtle but significant characteristics. The development toward a vertical stress completes the development of the wholly typographic letter, fully transcending the influence of pen lettering. The serifs are well defined but shallower and less triangulated than many of their predecessors. Though in most cases the serifs are bracketed, the bracket curve is often tighter, prefiguring the development of the unbracketed hairline serifs that feature in Pierre-Simon Fournier's letters and were to become a key attribute of the faces of Giambattista Bodoni and Firmin Didot.

■ CONTRAST AND "COLOR"

Transitionals are also characterized by a more dramatic variation in stroke width—a controversial development that prompted charges of impaired legibility in letters that were felt to be too "bright" to read comfortably. This refinement of form and detailing was itself made feasible by developments in printing technology. Taking advantage of these developments, John Baskerville (1706–75) was an innovator not only in the development of typographic form itself, but also in the use of hot-pressed papers and improved inks. These allowed for sharper definition and less ink-spread than ever before, and created the conditions not only for the

CHARACTERISTIC FEATURES

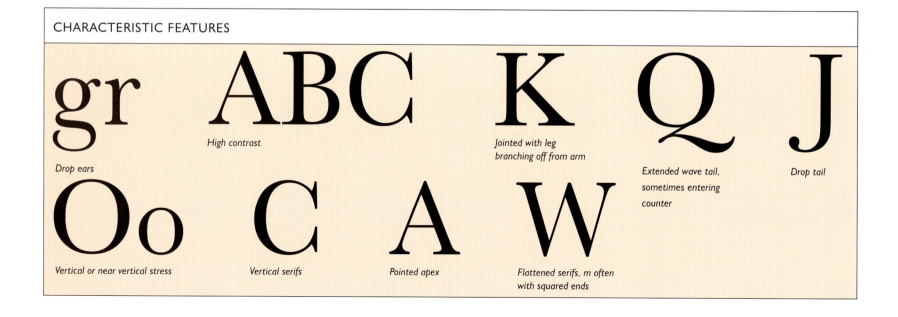

gr — Drop ears

ABC — High contrast

K — Jointed with leg branching off from arm

Q — Extended wave tail, sometimes entering counter

J — Drop tail

Oo — Vertical or near vertical stress

C — Vertical serifs

A — Pointed apex

W — Flattened serifs, m often with squared ends

heightened color of Baskerville's own faces, but also for the culmination of the vivid contrasted letterform in the Didones that were to follow.

■ THE DEVELOPING TRANSITION

As they mark the transition from the Old Style of Garaldes to the modern form of the Didones, different examples of the Transitional genre show greater degrees of affinity to the earlier or the later model. Baskerville's types may be compared to those of his contemporary and commercial rival William Caslon, whereas John Bell's Bell, recut by Monotype as Monotype Bell in 1931, clearly anticipates the Modern letter and might as readily be classified as an early Didone. The emergence of the genre is most clearly signaled in the work of Pierre Simon Fournier, whose letters have a minimal bracket to the serif and many of the defining Didone characteristics. William Martin's letters designed for the printer William Bulmer in 1790, and recut in the 20th century as Monotype Bulmer, similarly prefigure Bodoni in many key aspects. Type historians differ in attributing some of these faces either to the Transitional or the Didone category.

■ 20TH-CENTURY TRANSITIONALS

Twentieth-century examples of the Transitional model have provided a number of durable, robust, and functional types—notably the sensitive adaptation of Baskerville's letters, first for mechanical composition as Monotype Baskerville and later for photosettting and digital. American interpretations of the genre include Morris Fuller Benton's robust Century Schoolbook for ATF, and two distinguished typefaces designed by the hugely versatile designer W.A. Dwiggins: Electra and Caledonia. A recent addition to the Transitional genre is Zuzana Licko's Mrs Eaves, named for Baskerville's mistress and later wife, who went on to produce commercially successful typefaces after Baskerville's death.

EXPERIMENT IN GEOMETRY

Based on a geometric grid, the Romain du Roi letters produced for the sole use of Louis XIV's printers (below) represent a move from a craft aesthetic toward more systematic Enlightenment philosophies.

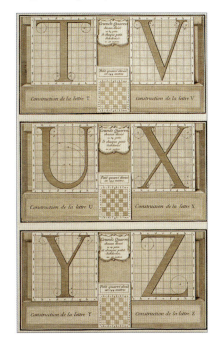

ABSTRACT FORM

In this booklet by a Spanish design group (below), the variation of scale and composition reveal the formal elegance of Baskerville's letters when viewed as abstract forms.

FOURNIER AND THE TRANSITIONAL LETTER

The most explicit expression of the Transitional spirit can be seen in the types of Pierre-Simon Fournier (1712–68). As the youngest son in a printing family, he was also known as Fournier le Jeune. He worked alongside his brother at the influential Le Bé Foundry in Paris. Established by Guillaume le Bé, the foundry had close associations with Claude Garamond and with Plantin in Antwerp.

While Baskerville's letters, with their increased contrasts and ordered structure, signal a new route out of the Old Face or Garalde idiom, it is Fournier's types that give the first signs of the stylistic tendencies to be later developed by Didot, Bodoni, and Walbaum. Fournier's work synthesizes some key influences: the narrow letters cut by Johann Fleischmann in Holland and the Romain du Roi of Philippe Grandjean. In 1742 Fournier published his first specimen book, the *Modèles de Charactères de l'Imprimerie*, which displayed a huge variety of faces and styles. This was prefaced by a detailed commentary upon the development of punchcutting and the printed word. The types show a sharpened contrast and an angular vitality, along with a minimal bracketing which prefigures the flat linear serifs of later Modern faces.

Fournier was among the many leading professionals to contribute to Diderot and D'Alembert's innovative *Encyclopédie* of 1751. His greatest achievements, however, were the two volumes of the *Manuel Typographique*, published in 1764, in which he wrote on the practice and art of punchcutting and typefounding, and showed a range of types including exotic alphabets, ornaments, and his distinctive italic faces.

In addition to his achievements as a punchcutter, Fournier is also an important figure in type history for his work in establishing a consistent system of interrelated type sizes, the *Table Générale de la Proportion*, which forms the basis for the point system (see pages 110–111).

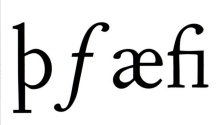

DEFINING CHARACTERISTICS

Current digital adaptations of Fournier's letters show their defining characteristics, notably the unbracketed serifs, varied and complex drop terminals and a vertical stress.

Bulmer

ABCDEFGHIJKLMNOPQ RSTUVWXYZ
abcdefghijklmnopqrstuvwxyz
1234567890 & ? (),:;'

ATF 1791–92, 1928

Based upon the types cut by William Martin for William Bulmer, this face reflects the increase in stroke contrast also seen in Baskerville and later in Bodoni and Didot. **Bulmer** was revived by Morris Fuller Benton for ATF in 1928, and later adapted to machine casting by Monotype in 1953. More condensed and upright than Baskerville, Bulmer can be used for both display and text setting. Digitally revived by Monotype under the supervision of Robin Nicholas, the current form offers lining figures as well as the original Old-style figures.

The typographer's first duty is to the text itself. An intelligent interpretation of the text will not only ensure readability, but will also reflect its tone, its structure, and its cultural context. The typographer's analysis illuminates the text, like the musician's reading of a score.

Baskerville

ABCDEFGHIJKLMNOPQ RSTUVWXYZ
abcdefghijklmnopqrstuvwxyz
1234567890 & ? (),:;'

MONOTYPE 1757, 1923

Prompted by Bruce Rogers while working at Cambridge University Press, the revival of John Baskerville's letters has provided one of the most elegant transitional text faces for 20th-century designers. Monotype interpreted the types cut for **Baskerville** by John Handy into a form suitable for mechanized production but retained the high contrast and rationalized form of the letters. Designed for letterpress printing, it can appear very light on the page under current printing methods. The italic is exceptionally refined, but the bold and bold italic are an unsuccessful compromise. A Greek extension was designed by Matthew Carter in 1978.

The typographer's first duty is to the text itself. An intelligent interpretation of the text will not only ensure readability, but will also reflect its tone, its structure, and its cultural context. The typographer's analysis illuminates the text, like the musician's reading of a

Mrs Eaves

ABCDEFGHIJKLMNOPQR
STUVWXYZ

abcdefghijklmnopqrstuvwxyz

1234567890 &? (),:;'

ZUZANA LICKO 1996

A contemporary interpretation of Baskerville's legacy, **Mrs Eaves** is named after Baskerville's partner and is often described as a revival. However, Licko's design emphasizes the characteristic "warmth" of letterpress rather than Baskerville's radical contrasts, and is perhaps most notable for features which have no precedent in Baskerville's time, such as the highly inventive set of ligatures across both upper- and lowercase letters. The family is completed by Mrs Eaves Sans, a quirky and stylistically anomalous sans serif counterpart, and the display face Mrs Eaves XL.

The typographer's first duty is to the text itself. An intelligent interpretation of the text will not only ensure readability, but will also reflect its tone, its structure, and its cultural context. The typographer's analysis illuminates the text, like the musician's reading of a score.

Fournier

ABCDEFGHIJKLMNOPQ
RSTUVWXYZ

abcdefghijklmnopqrstuvwxyz

1234567890 & ? (),:;'

MONOTYPE 1742, 1925

Monotype's **Fournier** design is based on the influential types cut by Pierre-Simon Fournier in 1742. His letters show a greater variation of axis than Baskerville's, and prefigure the work of Didot and Bodoni later in the 18th century. They are among the earliest of the Transitional style of typeface, showing greater vertical emphasis than the Old-style types, an increased contrast between thick and thin strokes, and minimal bracketing on the serifs. Fournier is an economical text face, giving an even color and a light and vibrant appearance on the page.

The typographer's first duty is to the text itself. An intelligent interpretation of the text will not only ensure readability, but will also reflect its tone, its structure, and its cultural context. The typographer's analysis illuminates the text, like the musician's reading of a score.

Didone

This category of types, also known as "Modern," is based upon the typefaces produced in the late 18th and early 19th centuries in Italy by Giambattista Bodoni (1740–1813); in France by Firmin Didot (1764–1836); and in Germany by Justus Erich Walbaum (1768–1839). Didones are characterized by a pronounced contrast in weight between the vertical strokes and the horizontal hairlines, which serves to emphasize the vertical stress of the letters. These qualities allow for extended typeface families, incorporating a wide range of widths and weights, including both extended ultra-bolds and condensed faces.

TIMELESS QUALITIES
The formal elegance of the best Didone letters (above) has ensured their continued use throughout the 20th century, and their continued popularity evokes a flavor of 1950s sophistication in the digital age.

■ **TECHNOLOGICAL DEVELOPMENTS**
Advances in print technology and paper manufacture in the late 18th century created the conditions for a radical new genre of typeface design. Harder and less absorbent papers, denser inks, and more accurate presses allowed for increased precision in the printing process, and facilitated the design of typefaces in which both the contrast, or color, and the delicacy of the hairline strokes were far more pronounced than had previously been possible. These typefaces represented a radical shift in typographic form, characteristic of the Enlightenment period. Following the example of the Romain du Roi, Modern types reflected an increasing concern for mathematical symmetry and order.

■ **20TH-CENTURY DIDONES**
While the genre is primarily associated with Bodoni and Didot, the principles of Didone type have been applied to both contemporary typefaces and revivals.
Bodoni Reinterpretations of Bodoni's types by different foundries in both Europe and the United States have led to a wide range of variants of Bodoni's original forms. Among adaptations for photosetting and digital, Bauer Bodoni is widely viewed as the most

CHARACTERISTIC FEATURES

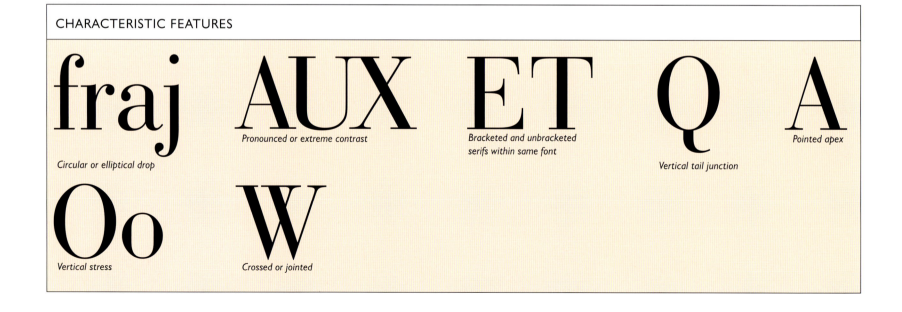

fraj
Circular or elliptical drop

AUX
Pronounced or extreme contrast

ET
Bracketed and unbracketed serifs within same font

Q
Vertical tail junction

A
Pointed apex

Oo
Vertical stress

W
Crossed or jointed

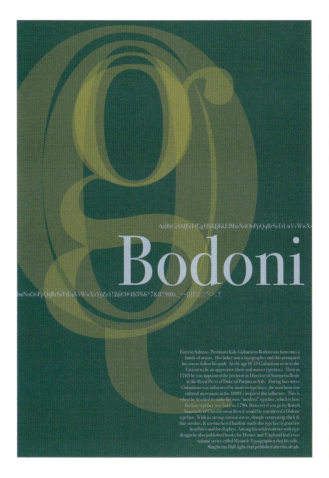

DEFINING CHARACTERISTICS

In this student poster project (left) the key characteristics of the Bodoni form are revealed through a multilayered composition which emphasizes the vertical stress and geometric basis of the genre.

ASSERTIVENESS AND AUTHORITY

The ordered, formal qualities of the Didone letter (right) are particularly suited to the visual rhetoric of the headline or display quotation, and the robust forms remain legible against a high-contrast background.

"MODERN LIFE DEMANDS, AND IS WAITING FOR, A NEW KIND OF PLAN, BOTH FOR THE HOUSE AND THE CITY."

DISPLAY MODERNS

The extreme bold weight of some Didone faces (left) has suited them exceptionally well to uses in poster design and publicity, defining a tradition which extends through the 19th century and into contemporary practice.

faithful to Bodoni's original, being closer to it than the Berthold and Monotype designs.

Berthold Bodoni may be the most complete modern synthesis, incorporating several generations of redesigns. While it has become established as a very widely used typeface under this title, its evolution has resulted in a design several times removed from Giambattista Bodoni's original.

Monotype Bodoni is a durable adaptation of the form that takes into account the constraints of mechanical typesetting systems.

Didot The first Didone typeface was cut in 1781 by François Ambroise Didot, whose son Firmin developed and refined the trademark characteristics that have come to be associated with the family name, culminating in the Didot of 1800, which has formed the basis of the genre.

Didots of 20th-century origin include Linotype Didot, drawn by Adrian Frutiger in 1991, and based on the fonts cut by Firmin Didot between 1799 and 1811. Frutiger also studied the Didot types in *La Henriade* by Voltaire, published in 1818.

Jonathan Hoefler's HTF Didot exemplifies the use of digital media to reinstate the optical variation characteristic of historic types of the modern period.

Walbaum Designed by Justus Erich Walbaum in the early 19th century, Walbaum is a German development of the Didone tradition established by Bodoni and Didot.

Walbaum now exists in two equally authentic versions based upon Walbaum's original matrices. Monotype Walbaum is based upon the smaller text sizes of the original, and is consequently heavier in weight than Berthold Walbaum, which is based upon the larger sizes. It was adapted by Monotype as a typesetting face in 1933, and subsequently redesigned by Günter Gerhard Lange for photosetting in the 1970s, using the original Walbaum matrices.

Walbaum Book and Walbaum Standard were issued in 1975–79, and included newly developed bold and small caps.

■ EXPERIMENTAL DIDONES

Bayer Type Herbert Bayer's Bayer Type was designed in 1931 as a monocase typeface using some features of the Didone style; a more conventional Didone was released by the Berthold Foundry under the title Bayer Type, in 1935; and the original monocase was digitized by The Foundry in the 1990s.

HIGH-CONTRAST FIGURES
The numerals of Didone typefaces are often particularly striking, as demonstrated in their use as a dominant design feature in this series of color-coded booklets (above).

SPACE AND CONTRAST
In contemporary display use, Didone faces can withstand tighter spacing and leading than would have been possible in their original metal form. This page spread (left) shows letters minimally spaced to form a visually cohesive title.

Ambroise Jean-François Porchez designed the Ambroise type family, a contemporary interpretation of various typefaces belonging to Didot's late style, issued by the Porchez Typofonderie in 2001. Each typeface is named after members of the three generations of the Didot family.

Filosofia Zuzana Licko's Filosofia is a characteristically irreverent and personal interpretation of the Didone idiom.

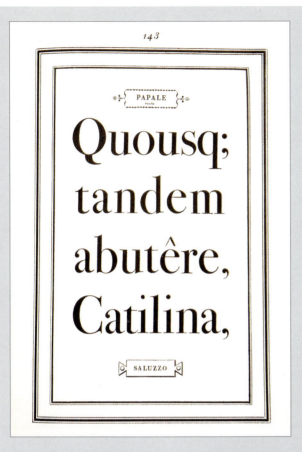

ORIGINAL SOURCES

The Manuale Tipografico *of Giambattista Bodoni (left) demonstrated an unprecedented refinement of clarity and contrast, consolidating his role as the pre-eminent printer and typographer of his time.*

TONAL LAYERING

Set on both a vertical and horizontal axis in this promotion for a collaboration between Portuguese and Italian artists (above), the robust geometry of the Didone form retains its legibility and definition when subjected to digital layering and variation of tonal values.

GIAMBATTISTA BODONI

The types of Giambattista Bodoni achieved a level of elegance unsurpassed in the development of the "Modern" letter of the late 18th century. Influenced by the innovations of both Baskerville in England and Fournier in France, Bodoni defined the characteristics of the emerging style: heightened contrasts of thick and thin strokes and a consistent geometric construction. The resulting letterforms serve to define the genre to the extent that the term "Bodoni" has at times been used more as a generic description than the attribution of a specific face. His roman of 1798 is perhaps the definitive example, forming the basis for an ongoing process of adaptation and revival which was to continue through the 20th century.

After working as a compositor for the Vatican Printing Office in Rome, Bodoni was appointed in 1768 as director of the Stamperia Reale in Parma, under the patronage of the Duke of Parma. This project was intended to enhance the Duke's prestige with the production of fine books, and as a consequence provided the opportunity for Bodoni to refine his typographic vision under conditions of the highest-quality presswork. The support of his patron allowed him the scope to operate without commercial constraints, and to demonstrate the highest levels of perfectionism in type design, page layout, and printing.

The resulting books are objects of uncompromised typographic beauty, conceived as luxury publications for an audience of connoisseurs. Set with a generous and dynamic use of white space and minimal ornamentation, Bodoni's pages demonstrate the vivid interplay of black and white, and exploit to the full the opportunities for high contrast and fine lines provided by improved printing technology.

Bodoni's first publications for the press used the types of Pierre-Simon Fournier, after which he created his own types, demonstrated in his specimen book of 1771. These include not only the formal upright letters for which he is best known, but also a wide range of ornaments, vignettes, exotics, scripts, and italics, including the upright cursive which was to inspire 20th-century faces such as Typo Upright and Linoscript. The final edition of his *Manuale Tipografico*, unfinished at the time of his death in 1813, was completed by his wife and published in 1818.

Monotype Bodoni

MONOTYPE 1922

ABCDEFGHIJKLMNOPQ
RSTUVWXYZ
abcdefghijklmnopqrstuvwxyz
1234567890 & ? (),:;'

Bodoni's original letters were cut with extreme contrasts of weight, which were individually moderated at each size. Adaptation of the Bodoni ideal to 20th-century technologies diminished this contrast, while resulting in types that were more durable in general use if less visually distinctive. **Monotype Bodoni** follows many of the characteristics of Morris Fuller Benton's revival for ATF in 1911, which introduced an unbracketed serif more reminiscent of Didot. While subsequent revivals have sought to recapture the more extreme optical contrasts between sizes, Monotype Bodoni remains a durable text face in its own right.

The typographer's first duty is to the text itself. An intelligent interpretation of the text will not only ensure readability, but will also reflect its tone, its structure, and its cultural context. The typographer's analysis illuminates the text, like the musician's reading of

Bauer Bodoni

HEINRICH JOST 1926

ABCDEFGHIJKLMNOPQ
RSTUVWXYZ
abcdefghijklmnopqrstuvwxyz
1234567890 & ? (),:;'

Bauer Bodoni is recognized as one of the most "authentic" 20th-century revivals, and the roman form is noticeably subtle in its tonal color, retaining the slight bracketing and taper of the serifs. Available in a range of weights and widths, it is a typeface of exceptional elegance that combines an ordered regularity of form with a vivid contrast of stroke widths. It is characterized by a vertical stress, emphasized by the contrasts between vertical and horizontal strokes, and a roundness of form echoed in the drop terminals.

The typographer's first duty is to the text itself. An intelligent interpretation of the text will not only ensure readability, but will also reflect its tone, its structure, and its cultural context. The typographer's analysis illuminates the text, like the musician's reading of a score.

Linotype Didot

ABCDEFGHIJKLMNOPQ RSTUVWXYZ
abcdefghijklmnopqrstuvwxyz
1234567890 & ? (),:;'

The upright and highly contrasted forms of the Didot alphabets are representative of the modern genre, and are quite similar to those designed by Bodoni around the same time in Italy. Characterized by a rigorous geometry and substantial bracketed serifs, Frutiger's **Linotype Didot** family, based on Firmin Didot, has 12 fonts and includes non-lining "Old-style" figures, a headline version, an "open" display face, and two fonts of ornaments.

The typographer's first duty is to the text itself. An intelligent interpretation of the text will not only ensure readability, but will also reflect its tone, its structure, and its cultural context. The typographer's analysis illuminates the text, like the

HTF Didot

ABCDEFGHIJKLMNOPQ RSTUVWXYZ
abcdefghijklmnopqrstuvwxyz
1234567890 & ? (),:;'

Jonathan Hoefler's **HTF Didot** exemplifies the use of digital media to reintroduce the optical variation characteristic of historic types of the modern period. Based upon the *grosse sans pareille* types of Molé le Jeune, the typeface was produced in seven optical sizes and three weights. The optical variants serve to maintain the extreme delicacy of the hairline strokes at display sizes, while retaining a sufficiently robust form and legibility in text. The typeface comprises a total of 42 fonts.

The typographer's first duty is to the text itself. An intelligent interpretation of the text will not only ensure readability, but will also reflect its tone, its structure, and its cultural context. The typographer's analysis illuminates the text, like the musician's reading of a

Walbaum

ABCDEFGHIJKLMNOPQ RSTUVWXYZ
abcdefghijklmnopqrstu vwxyz
1234567890 & ? (),:;'

MONOTYPE 1933

Because revivals of Justus Erich Walbaum's types in the 20th century have concentrated upon their use as a book face, **Walbaum** is one of the most practical of the Didones for text setting. Warmer and less programmatic than the quintessential modern faces of Didot and Bodoni, Walbaum's letters are generally broader, and the serifs more substantial. The bold weights have small counters that restrict their use at small sizes, but the regular weight gives a broad and even appearance when set as continuous text.

The typographer's first duty is to the text itself. An intelligent interpretation of the text will not only ensure readability, but will also reflect its tone, its structure, and its cultural context. The typographer's analysis illuminates

Scotch Roman

ABCDEFGHIJKLMNOPQ RSTUVWXYZ
abcdefghijklmnopqrstu vwxyz
1234567890 & ? (),:;'

RICHARD AUSTIN, A.D. FARMER 1809, 1904, 1907

Based upon the designs first cut by Richard Austin and cast by Alexander Wilson in Glasgow and William Miller in Edinburgh, **Scotch Roman** is a wide face characterized by generous bracketed serifs, short descenders, and large, strong capitals. Derived from the adaptation of the face by A.D. Farmer in 1904, the Monotype Scotch Roman is an effective and colorful text face, with a generous x-height and open counters but excessively bold capitals. Digital versions continue to be limited to a single weight, with an elegant and heavily angled italic.

The typographer's first duty is to the text itself. An intelligent interpretation of the text will not only ensure readability, but will also reflect its tone, its structure, and its cultural context. The typographer's analysis illuminates the text, like the musician's reading of a

New Caledonia

ABCDEFGHIJKLMNOPQ
RSTUVWXYZ
abcdefghijklmnopqrstuvwxyz
1234567890 & ? (),:;'

Less emphatic in its contrasts than the classic Didones, **New Caledonia** is the contemporary adaptation of Caledonia, a book face with a generous x-height and rather "bright" appearance. For many years, it has been an extremely popular face in American publishing. Though inspired by the Scottish types of the early 19th century, it is distinctly Dwiggins' own conception. Its refinement and vitality are particularly noticeable in the light curve at the base of the serif and stem terminals. A Greek version of the face is available.

The typographer's first duty is to the text itself. An intelligent interpretation of the text will not only ensure readability, but will also reflect its tone, its structure, and its cultural context. The typographer's analysis illuminates the text, like the musician's reading of a

Filosofia

ABCDEFGHIJKLMNOPQ
RSTUVWXYZ
abcdefghijklmnopqrstu
vwxyz
1234567890 & ? (),:;'

Reflecting an enthusiasm for the more rugged qualities of the smaller sizes of Bodoni, **Filosofia** is a text face with a less pronounced contrast than most Modern revivals. The letters have a noticeably geometric form and curved ends to the serifs. The text face is accompanied by a slightly condensed display face, Filosofia Grande, and a Unicase font. The face provides a full complement of OpenType features and language support including Central European and Turkish.

The typographer's first duty is to the text itself. An intelligent interpretation of the text will not only ensure readability, but will also reflect its tone, its structure, and its cultural context. The typographer's analysis illuminates the text, like the musician's reading of a score.

Marxism and Culture

Slab Serif

The slab serif is a form characteristic of a new industrial age, and reflects an emerging culture of promotion and packaging. Improved presses allowed for the printing of larger areas of black inking, and a commercial demand for heavier types prompted the development of the Didone form into the "fat face" alongside the emerging sans serifs or "Grotesques," and the slab-serif letter. Like the emerging sans-serif form, the slab serif had its origins in signwriting and architectural lettering from the 18th century.

■ ANTIQUE ROMAN

The first example of a slab serif or "Egyptian" type was Vincent Figgins' Antique Roman in 1817. It was a style that was to be widely adopted through the 19th century. The "antique" slab serif of Figgins's contemporary Robert Thorne was released under the name Egyptian, prompting the use of this term to denote an unbracketed slab serif. Slab serifs remain popular in advertising and promotional graphics.

■ EGYPTIAN AND ITALIENNE

Though a number of bracketed faces have been published under this name, Egyptians normally have an unbracketed slab serif of equal thickness to the main strokes, whereas the less familiar Italiennes are faces in which the slab serif is heavier than the stroke width. This style was widely used in poster designs at the end of the 19th century and in 1960s psychedelic posters.

■ CLARENDON

The name Clarendon was first used by Robert Besley of the Fann Street Foundry, London, to market a typeface designed by Benjamin Fox in 1845. It has since been adopted as a generic term for bracketed slab-serif types of the period and contemporary adaptations of this style. Clarendons enjoyed a revival of popularity in British graphic design during the period following World War II and into the 1960s.

MONOSPACED TYPEFACES

The letterforms developed for use in mechanical typewriters up to the 1970s and 1980s utilize a crude form of slab serif (see example above), in which the solidity of form and the stability given by the serifs compensates for inconsistencies of inter-character space. Each of the letters on a mechanical typewriter sits upon a body of uniform width, unlike metal type, in which width of the letter determines the width of the body. This influenced the design of certain letters, notably the exaggerated width of the serifs in both the capital and lowercase i. The suitability of slab serifs as the model for monospace typewriter faces led, in turn, to their use in monospace digital faces, such as Courier. Monospacing ensures consistent fit between the letterforms and the grid of pixels on the monitor screen. Recent designs in this idiom include Zuzana Licko's Base Monospace and Lucas de Groot's Consolas.

CHARACTERISTIC FEATURES

agr pg ET ET Q

Pronounced drop forms Short descenders Bracketed serifs with squared ends (Clarendons) Unbracketed serifs (Egyptians) Tail enters counter

Oo H

Vertical stress Low contrast

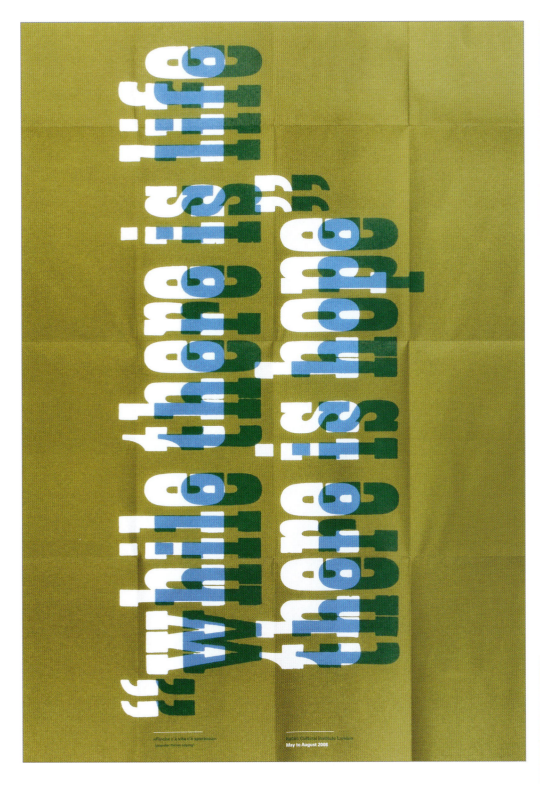

THE TACTILE IMPRINT

The origins of the slab serif as a 19th-century display face are reflected in the use of a distressed finish which evokes the variation and physicality of letterpress printing (above and below).

POSTER LETTERS

The robust form of a condensed slab serif withstands the deliberate visual disruption of overprinting an offset transparent color, set on a vertical axis in this poster design (above).

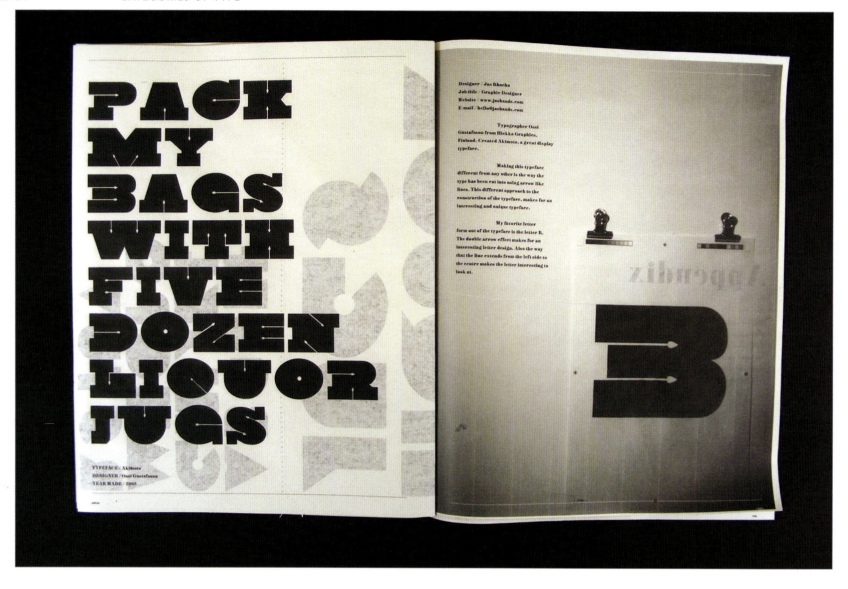

TYPEFACE / Akimoto
DESIGNER / Ossi Gustafsson
YEAR MADE / 2005

Designer / Jas Bhachu
Job title / Graphic Designer
Website / www.jasbands.com
E-mail / hello@jasbands.com

Typographer Ossi
Gustafsson from Hiekka Graphics,
Finland. Created Akimoto, a great display
typeface.

Making this typeface
different from any other is the way the
type has been cut into using arrow like
lines. This different approach to the
construction of the typeface, makes for an
interesting and unique typeface.

My favorite letter
form out of the typeface is the letter B.
The double arrow effect makes for an
interesting letter design. Also the way
that the line extends from the left side to
the centre makes the letter interesting to
look at.

■ RELIEF FORMS

Like the early Grotesques, slab-serif typefaces developed from large-scale display letters used in both woodblock letterpress printing and architectural lettering. The robust forms and substantial serifs of the Clarendons and Egyptians were perfectly suited to casting as relief forms in metal, and as a result they feature in many Victorian engineering projects as well as appearing in posters, playbills, and other promotional materials of the time. The broad and assertive serif provides an effective compensation for the irregularities of inter-character space.

■ MODERN FORMS

Slab-serif typefaces dating from the 20th century reflect a variety of influences and refer to a number of typographic traditions. While some can be seen as a development from the heavier weights of Didones or fat faces, the emergence of the slab serif owes as much to the early display Grotesques as to the mainstream of the serif tradition, and slab serifs continued to reflect historic developments in the sans-serif form.

Some 20th-century slab serifs appear to be serifed forms of sans letters, a reading confirmed in the design of faces such as Erik Spiekermann's Officina, in which the sans and serif versions share a common basic form. The historical basis for this idea is illustrated in Jonathan Hoefler's ingenious Proteus series: a set of four related faces based in the traditions of Victorian display lettering and designed to sit upon the same body, with the variants including a sans serif, a slab serif, and a triangular "Latin" serif.

MINIMAL COUNTERFORMS

In this example of the slab-serif genre (above), the counterforms of the letters are reduced to fine lines with arrow terminals. Despite this radical stylistic device, the letters remain forceful and well-defined, retaining many of the characteristics of the first slab-serif types.

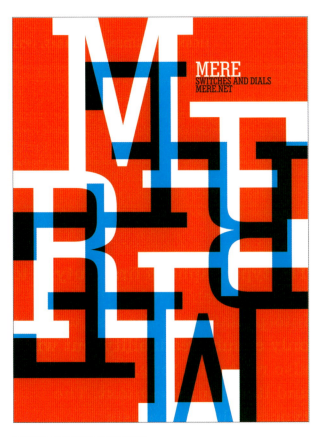

MERE
SWITCHES AND DIALS
MERE.NET

INTERLOCKING STROKES

In many slab-serif faces, the weight of the serif
is close or identical to that of the main strokes,
enabling links and linear patterns composed of
slab serif letters (above).

The forms of modern slab serifs frequently allude to developments in the sans-serif letter tradition. Gustav Jeager's Epikur, published by Berthold, has a wide set and a geometric construction reminiscent of Renner's Futura; Memphis, designed by Rudolf Wolf for Stempel, is also predominantly geometric. Frank Pierpoint's Rockwell, an unbracketed slab serif published by Monotype, suggests a serifed Grotesque.

■ TEXT SLAB SERIFS

Martin Majoor's Scala, designed in the 1980s for the Vredenburg concert hall in Utrecht in the Netherlands, is a text face with an unbracketed slab serif and a linear form that functions well under conditions of low resolution. It is essentially a slab serif on a Garalde form, and might be viewed as a more consistent realization of an idea previously attempted in Eric Gill's Joanna.

GUARDIAN EGYPTIAN

One of the most colorful and versatile expressions of the slab-serif form, the Guardian Egyptian type family was developed by Paul Barnes and Christian Schwartz as a central component of Mark Porter's redesign of the UK's *Guardian* newspaper in 2004–5. The face encompasses extreme variations of weight, for use from small text sizes through to very large-scale headlining in color.

Barnes had originally been commissioned to produce a revival of Neue Haas Grotesk, the earliest version of Helvetica, and a companion serif to be called Hacienda. However, Porter became unconvinced by the relationship between these faces, and Haas Grotesk was abandoned in favor of a wholly new sans serif.

At this point, Barnes explored the idea of the "Egyptian" as a route to a sans serif that would be compatible with a serif face, first creating a slab-serif face, then removing the serifs as a route to the new sans. Guardian Egyptian was originally conceived as a conceptual "missing link" between the serif and sans, a developmental idea that would not be used in the paper. However, as the design developed, it revealed a distinctive identity and versatility of form, and was finally adopted and developed for both headlines and text.

Influenced by the Egyptian faces cast by several London foundries in the mid-19th century, Guardian Egyptian has unbracketed wedge-shaped serifs, giving a more contemporary appearance. Eight weights were originally designed in both serif and sans. Schwartz describes the italic as "willfully bizarre; a Granjon italic dressed up as an Egyptian." Mostly used for pull quotes and headlines, it is designed to add another texture to the type palette. After five years as an exclusive *Guardian* face, Guardian Egyptian was made available for licensing in 2009.

MODERN LIFE IS RUBBISH
Greenwich
Admiral Benbow
Newham
Hammersmith & City
St. Bride

CONTEMPORARY EGYPTIANS

Barnes and Schwartz' type family (left)
comprises a colorful range of weights for use
in a newspaper noted for design innovation.

Clarendon

ABCDEFGHIJKLMNOPQ
RSTUVWXYZ
abcdefghijklmnopqrstu
vwxyz
1234567890 & ? (),:;'

Clarendon is among the most evocative and colorful of the Victorian faces. Although the broad width of the letters makes it relatively uneconomical for setting extended texts, the serifs are exceptionally durable and will retain their form under conditions of poor reproduction or screen resolution. The lighter weights are a later development that extends the functionality of the face, being more suitable for text setting than the bold form that is the basis of the genre.

The typographer's first duty is to the text itself. An intelligent interpretation of the text will not only ensure readability, but will also reflect its tone, its structure, and its cultural context. The typographer's analysis

Joanna

ABCDEFGHIJKLMNOPQ
RSTUVWXYZ
abcdefghijklmnopqrstuvwxyz
1234567890 & ? (),:;'

The letters of Gill's "no-nonsense text face," **Joanna**, reflect the influence of Robert Granjon in their underlying form, but interpret this through a 20th-century sensibility. They have a short, square, unbracketed serif, a moderate contrast, and capitals smaller than the ascender height. The italics are condensed, only slightly angled, and have some elements of the "sloped roman," while suggesting a modern reading of the Renaissance italic letter. Semibold, bold, and extra bold weights were added by Monotype in 1986.

The typographer's first duty is to the text itself. An intelligent interpretation of the text will not only ensure readability, but will also reflect its tone, its structure, and its cultural context. The typographer's analysis illuminates the text, like the musician's reading of a score.

Scala

MARTIN MAJOOR 1991

ABCDEFGHIJKLMNOPQ
RSTUVWXYZ
abcdefghijklmnopqrstuvwxyz
1234567890 & ? (),:;'

Scala and its companion book face Seria have become extremely popular text faces. The regular weight is fairly even in color, with a restrained contrast providing a dramatic comparison to the greater contrasts of the bold weight. Condensed forms and a full expert set of small caps complete a versatile and elegant face. Scala has a companion sans serif, Scala Sans, a balanced and harmonious monoline Humanist Sans that shares the same underlying skeleton and is available in four weights. There is also a set of display variants, Scala Jewel.

The typographer's first duty is to the text itself. An intelligent interpretation of the text will not only ensure readability, but will also reflect its tone, its structure, and its cultural context. The typographer's analysis illuminates the text, like the

Rockwell

FRANK PIERPOINT 1934

ABCDEFGHIJKLMNOPQ
RSTUVWXYZ
abcdefghijklmnopqrstu
vwxyz
1234567890 & ? (),:;'

Rockwell is a geometric face with well-defined slab serifs, a fairly high x-height, and noticeably short descenders. Available in four weights, the roman weight is monoline, with a serif of equal thickness, while the bold weight has slight contrast. The bar apex of the A and the deep serifs serve to reinforce the horizontal emphasis of the typeface. Its robust simplicity has made it an effective face for screen applications. It is also an effective display face. The italic is a somewhat undeveloped oblique form of the roman.

The typographer's first duty is to the text itself. An intelligent interpretation of the text will not only ensure readability, but will also reflect its tone, its structure, and its cultural context. The typographer's analysis illuminates

Grotesque

The early sans-serif "Grotesque" typefaces were developed in the 19th century and, like the slab serifs, emerged first in display type, signwriting, and architectural lettering. Though the unserifed letter has since that time been synonymous with ideas of innovation, its true antecedents can be found in classical forms revived in late-18th-century architecture. The Grotesque typeface was, however, a product of the machine age, and became emblematic of modernist design in the 20th century.

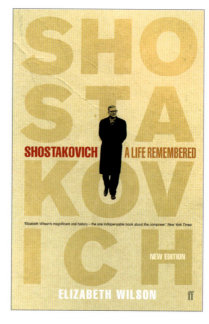

FOURSQUARE GROTESQUE
The assertive form of a generic Grotesque allows for its use at low contrast in this book jacket (above), in which the letters of the subject's name create a vivid background.

■ THE EMERGENCE OF THE GROTESQUE

The earliest recorded example of a commercial sans serif was the Two-line Egyptian produced in 1819 by the Caslon foundry in London. From the mid-19th century, the sans-serif capital became a feature of the expanding graphic vocabulary of display type. Though the unadorned "sans" came to denote modernity and a radical abandonment of historical associations, the unserifed form can be traced back to Hellenic sources and Roman Republican lettering, and it is likely that its introduction into the currency of 19th-century type design occurred by way of a revival of Hellenic references in architecture as well as the already established use of "block" letters by signwriters.

The display faces upon which the idiom is founded were often produced as capital fonts, without a lowercase or italic. Though simple and direct in overall form, the early Grotesques are not monoline faces, and the heavier weights, in particular, are characterized by marked variations of stroke width, with pronounced tapering and adjustments at junctions.

In the late 19th century, developments in mechanized punchcutting facilitated the development of more comprehensive sans-serif type families appropriate for text setting as well as display use.

■ AMERICAN GOTHIC

In the United States, the term "Gothic" was widely used to denote Grotesques or sans-serif letters in general. Morris Fuller Benton designed two of the most durable sans-serif faces of the 20th century in Franklin Gothic and News Gothic. Conceived as part of the

CHARACTERISTIC FEATURES

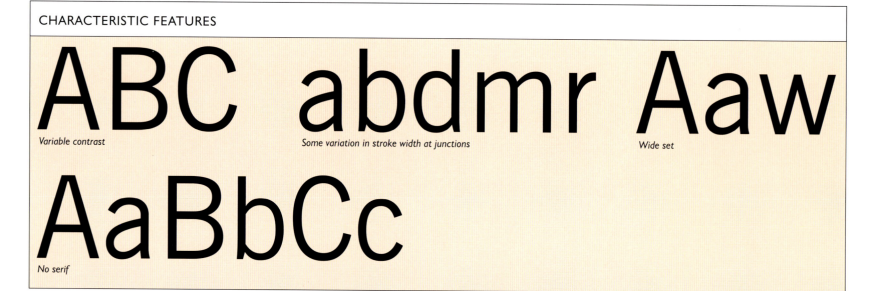

ABC abdmr Aaw

Variable contrast *Some variation in stroke width at junctions* *Wide set*

AaBbCc

No serif

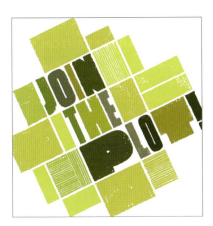

VARIANT GROTESQUES

*The Grotesque display types of the 19th
century developed into a wide range of weights
and widths. This poster for Greenpeace (above)
uses the wood type idiom in a modern context,
combining highly condensed forms with bold
extended letters to dramatic effect.*

process of modernizing 19th-century sans-serif styles, News Gothic is a classic American Gothic face that has remained in widespread use. A companion to Franklin Gothic, it has a regular form that is both lighter in stroke width and more condensed. The development of Franklin Gothic to include an extended range of weights and widths served to narrow the distinction between the two faces even further. Franklin Gothic was originally a display-weight face to which text-weight variants were added, while News Gothic was originated at a weight more suitable for text setting and has bold forms for display use.

Jonathan Hoefler has assembled two comprehensive families of historical Grotesques, first under the title Champion and later in the more extensive Knockout. Based upon commercial metal and wood types of the 1900s, the variations of weight and width in these faces are not mathematically derived, and the letterforms vary widely in their form and construction. They work together because they derive from a common historical source and context.

Comparison with Adrian Frutiger's Univers—another major family of sans serifs—reveals the unique qualities of Hoefler's approach, in which types are grouped by consistency of historical context rather than being designed as strict mathematical derivatives from a common template.

ORIGINS AND INSPIRATION

While 19th-century responses to the sans-serif letter were often critical, it is debatable whether this alone prompted use of the term "grotesque" as a generic description in the United Kingdom. Grotesque literally means "from the grotto," suggesting a primitive order of antiquity preceding the classical era and the Roman letter. In the United States, the even more confusing and historically inaccurate term "Gothic" was similarly widespread.

Such responses to a seemingly novel stylistic form have combined with the later history of the sans-serif letter as an emblem of modernity and typographic radicalism, to suggest that it was a wholly innovative, modernistic development. However, we should not infer that the sans-serif letter itself was unknown before the early 19th century. It had been in use by signwriters, letter-cutters, and architects in the 18th century, and it is by looking to this line of descent that we can trace the origins of the form.

The serif was a specific development within Imperial Roman letter-cutting, but Roman Republican letters, and the Greek and Etruscan letters which preceded them, were largely monoline and unserifed. Eighteenth-century architects such as Sir John Soane had imported a range of classical references into their work, and some of the earliest examples of the sans-serif letter appear in both architects' drawings and in projected inscriptions.

The early Grotesques were functional, commercial faces designed for high impact. Sans-serif letters developed gradually through the 19th century, but were seen only as a display style until the development of some key Grotesques and Gothics designed for text setting toward the end of the century. This may reflect the new thinking and new faces stimulated first by mechanized punchcutting and then by machine composition for Monotype and Linotype. The former opened up type design to designers from outside the specialist skill of punchcutting; the latter required the recutting of old types for new machines, and the origination of new forms.

CONDENSED GROTESQUE

These are historically associated with the letterpress printing from wooden type, and consequently lend themselves particularly well to the use of distressed and under-inked effects, as demonstrated in this page spread (above).

News Gothic

ABCDEFGHIJKLMNOPQ
RSTUVWXYZ
abcdefghijklmnopqrstuvwxyz
1234567890 & ? (),:;'

A condensed Grotesque, **News Gothic** was conceived as a family of sans serifs for text setting. Originally accompanied by a lightweight, Lightline gothic, bold weights were added in 1958. It has been revived by a number of different designers and foundries, in a number of different forms including Linotype's Trade Gothic. News Gothic remains a popular text face, combining legibility, economy, and an unobtrusive functional character.

The typographer's first duty is to the text itself. An intelligent interpretation of the text will not only ensure readability, but will also reflect its tone, its structure, and its cultural context. The typographer's analysis illuminates the text, like the musician's reading of

Akzidenz Grotesk

ABCDEFGHIJKLMNOPQ
RSTUVWXYZ
abcdefghijklmnopqrstuvwxyz
1234567890 & ? (),:;'

A broad and geometric Grotesque, **Akzidenz Grotesk** was ideally suited to the principles of the New Typography of the 1930s and later the typographers of the postwar Swiss school. Its continued influence is evident both in the development of new Grotesques and developments of its derivative, Helvetica. The broad form establishes a vivid horizontal emphasis, which is particularly valuable in asymmetrical layouts. While its wide set and low x-height make it a less practical text face than the later Neo-Grotesques, it has considerably greater visual interest and character.

The typographer's first duty is to the text itself. An intelligent interpretation of the text will not only ensure readability, but will also reflect its tone, its structure, and its cultural context. The typographer's analysis illuminates the text, like the musician's reading of

Franklin Gothic

ABCDEFGHIJKLMNOPQ RSTUVWXYZ
abcdefghijklmnopqrstuvwxyz
1234567890 & ? (),:;'

One of the most durable faces of its kind, **Franklin Gothic's** appearance of basic functionalism conceals delicate variations of form and stroke width, maintained across extremes of weight and width. Recuts for photosetting and digital have not diminished its vitality. Victor Caruso added book and medium weights in 1980, and David Berlow added condensed, compressed, and extra compressed versions in the 1990s. The resulting family offers a colorful range of weights and widths suitable for a variety of requirements from functional text setting to bold, emphatic display work.

The typographer's first duty is to the text itself. An intelligent interpretation of the text will not only ensure readability, but will also reflect its tone, its structure, and its cultural context. The typographer's analysis illuminates the text, like the

Knockout

ABCDEFGHIJKLMNOPQ RSTUVWXYZ
abcdefghijklmnopqrstu vwxyz
1234567890 & ? (),:;'

The **Knockout** family comprises 32 traditional Grotesques, organized by weight into seven series of five fonts, with a range of widths in each. The forms are drawn from the wood and metal types that were the stock-in-trade of jobbing printers from the late 19th century well into the 20th, as used in boxing and wrestling posters. Knockout is as much a stylistic anthology as a family, enlivened by many variations of form and construction between different fonts.

The typographer's first duty is to the text itself. An intelligent interpretation of the text will not only ensure readability, but will also reflect its tone, its structure, and its cultural context. The typographer's analysis illuminates the text, like the musician's reading of a

Humanist Sans

Within the context of sans-serif faces, the term "Humanist" refers to letters based on a classical model, in which the proportions of the uppercase are derived from the Roman capital letter and the lowercase from the Humanist writing hand. This reflects the historical dialogue between type design and the distinct but related traditions of letter-cutting and letter-writing, as well as the continued influence of the autographic letter on the industrial type form.

■ INTERPRETATIONS OF THE ROMAN LETTER

One of the most celebrated Humanist Sans faces, Gill Sans, designed by Eric Gill, was itself influenced by the alphabet created by Gill's mentor Edward Johnston for the London Underground. Johnston and Gill both came to type design from a background in the manual crafts of lettering. In both cases, the proportions of the classic Roman letter continued to inform the structure of the monoline letters they designed.

Gill Sans was commissioned from Gill by Stanley Morison of the London offices of Monotype. Though unique as a commercial typeface, Gill Sans is less an innovation than the stabilizing of a form of sans serif that had been in wide use within signwriting from as early as the late 18th century—a basic monoline

"block" letter that had not previously been expressed in the form of metal type. Its longevity and continued use serve to confirm its status as a pre-eminent Humanist Sans, in which the designer's own sensibility is applied through the knowledge of classical form, and refined by the skills of the Monotype drawing office.

Like the Johnston Underground letters which influenced it, Gill Sans was designed as a display face, but its clarity subsequently led to its adoption as a text face. It is a quintessential Humanist Sans: a monoline form based upon classical proportions.

■ AMERICAN HUMANISTS

The ideal of the Humanist Sans form has taken on a number of national accents. Its closest American

CHARACTERISTIC FEATURES

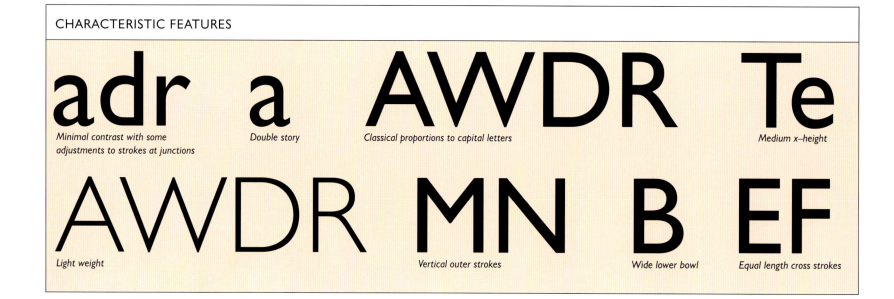

adr *Minimal contrast with some adjustments to strokes at junctions*

a *Double story*

AWDR *Classical proportions to capital letters*

Te *Medium x–height*

AWDR *Light weight*

MN *Vertical outer strokes*

B *Wide lower bowl*

EF *Equal length cross strokes*

EDWARD JOHNSTON

While it is uncertain who first applied the term "Humanist" to a sans with Roman proportions, the term clearly reflects the Humanist movement of the Renaissance—a period of renewed interest in the Roman letter. This is the only characteristic that links it to the Venetian Humanist serif faces. The term is also sometimes incorrectly thought to denote a less formal "humanized" style of sans serif. The designer with whom the concept of Humanist Sans originates was not directly associated with the type or printing industries. Edward Johnston (1872–1944), pictured left, was primarily a calligrapher, concerned with the aesthetics of a personal craft. However, in his emphasis upon craft values and enthusiasm for the Roman letter, he forms a link between the Arts and Crafts Movement and the modern types of Jan Tschichold, Rudolf Koch, and Paul Renner.

Johnston was commissioned by Frank Pick, the influential design director of London Transport, to create a typeface for use on the London Underground. His design of a sans serif was seen as a defining example of the genre that became known as the Humanist Sans Serif. The letters also refined a vernacular form of "block" letter widely used in signwriting and architectural lettering through the 19th century. Johnston brought to this quite flexible genre a refinement and stabilization of structure and proportion, based closely upon classical Roman forms. His assistant on the project was his pupil Eric Gill, whose Gill Sans owes much to Johnston's influence in the design of his innovative Gill Sans. Unlike Gill Sans, however, Johnston's Underground letters were not manufactured for commercial distribution but remained the exclusive property of London Transport.

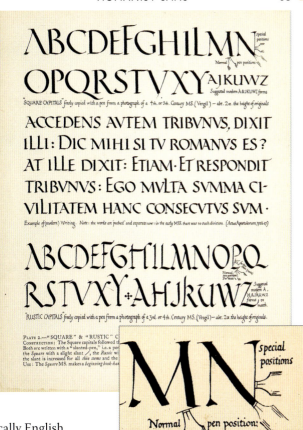

equivalent may be W.A. Dwiggins' Metro which, though described as a Gothic, has a closer affinity with Gill Sans than with the Geometric faces upon which it was designed to improve. Created in response to new German sans serifs such as Futura, Erbar, and Kabel, and released by Linotype in 1929, Metro is a Geometric type with some Humanist features. Although it was initially intended for display use, the addition of a lighter weight and subsequent revisions for photosetting have extended its functionality.

Frederic Goudy's Goudy Sans is a typically flamboyant contribution to the genre, with some quasi-medieval gestures and an effective italic. More recently Legacy Sans, designed by Ronald Arnholm for ITC, is an unserifed version of Jenson and thus a Humanist face in both of the senses of the term.

◼ EUROPEAN HUMANISTS

Hans Eduard Meier's Syntax is a Humanist Sans that incorporates a rich synthesis of influences into a coherent whole. Meier cites Jan Tschichold's Sabon as an influence, but one can also see references to pen lettering and to Hellenic letterforms in the right-angled terminals. Optima, designed by Hermann Zapf, is a more explicitly calligraphic form, broadly Humanist in proportion, and might equally be classified as a Glyphic in view of the spread of the slightly waisted strokes toward a broadening terminal.

◼ NEW GENERATIONS

Jeremy Tankard's Bliss is a characteristically English sans-serif family. Totaling over 160 fonts, it is designed in an extensive range of weights, including small-cap fonts at each weight. Reflecting the influence of Johnston, Gill, Meier, and Frutiger, it is at once a classic face in the English Humanist tradition and a definitive 21st-century design, making full use of the capabilities of digital type media.

THE CALLIGRAPHIC LETTER

This detail (above) is from a worksheet by Edward Johnston, whose sans-serif letters are informed by a calligraphic sensibility and form the basis for the Humanist sans-serif genre.

INFORMATIONAL HUMANIST

Combining the Humanist and Neo-Grotesque idioms, Adrian Frutiger's Frutiger type, designed for informational and wayfinding signage at Roissy/ Charles de Gaulle airport in Paris, demonstrates legible and user-friendly characteristics (right).

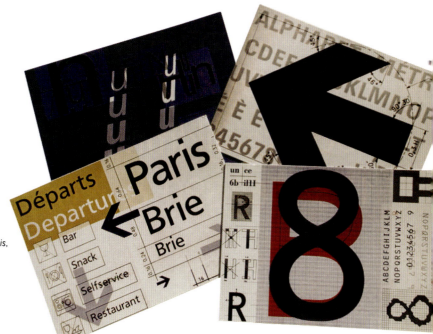

Gill Sans

ERIC GILL 1928

ABCDEFGHIJKLMNOPQ
RSTUVWXYZ
abcdefghijklmnopqrstuvwxyz
1234567890 & ? (),.:;'

A classic Humanist serif reflecting the influence of Edward Johnston's letters for the London Underground, **Gill Sans** is a largely monoline face moderated by a compensatory tapering of stroke widths toward the junctions. Initially designed in two weights, regular and bold, the typeface has a distinctive italic font with some cursive characteristics. The bold or semibold weight can also be effectively used for text setting, giving attractive weight and color on the page. The classical proportions of Gill Sans mean it can be paired with Garalde and Transitional faces.

The typographer's first duty is to the text itself. An intelligent interpretation of the text will not only ensure readability, but will also reflect its tone, its structure, and its cultural context. The typographer's analysis illuminates the text, like the musician's reading of a

Syntax

HANS EDUARD MEIER 1968

ABCDEFGHIJKLMNOPQ
RSTUVWXYZ
abcdefghijklmnopqrstuvwxyz
1234567890 & ? (),:;'

Syntax is a well-proportioned and robust yet visually lively typeface, with a subtle variation of stroke width and stress. There is a suggestion of Hellenic influences in the distinctive terminals. Syntax has a high x-height and a fairly narrow set. The capitals are shorter than the ascenders, and the face features special x-height figures. Produced in a range of five weights, Syntax is suitable for both text and display use. The face was developed as Linotype Syntax in six weights, with companion typefaces Syntax Serif, Syntax Letter, and Syntax Lapidar.

The typographer's first duty is to the text itself. An intelligent interpretation of the text will not only ensure readability, but will also reflect its tone, its structure, and its cultural context. The typographer's analysis illuminates the text, like the

Frutiger

ABCDEFGHIJKLMNOPQ
RSTUVWXYZ
abcdefghijklmnopqrstu
vwxyz
1234567890 & ? (),:;'

Designed for the signage of the Charles de Gaulle Airport in Paris, **Frutiger** is a well-balanced and highly legible sans-serif face, designed in five weights and two widths. The original Linotype typeface has since been expanded to include 14 weights, expanding its functionality beyond signs and large type. It has been adopted internationally for both headlines and body texts in magazines and other contexts. The italic is a "sloped" version of the upright letter.

The typographer's first duty is to the text itself. An intelligent interpretation of the text will not only ensure readability, but will also reflect its tone, its structure, and its cultural context. The typographer's analysis illuminates

Bliss

ABCDEFGHIJKLMNOPQ
RSTUVWXYZ
abcdefghijklmnopqrstuvwxyz
1234567890 & ? (),:;'

Based on an intention to "create the first commercial typeface with an English feel since Gill Sans," Tankard's **Bliss** reflects the influence of Johnston's London Underground letters, as well as Gill Sans and Meier's Syntax. The italic is a judicious mixture of cursive forms with sloped versions of the roman. As a digital Humanist Sans face, Bliss is more effective across a wider range of contexts than any of its distinguished ancestors. It can be used for display and text, and is also effective as an on-screen font, holding its readability under conditions of low resolution.

The typographer's first duty is to the text itself. An intelligent interpretation of the text will not only ensure readability, but will also reflect its tone, its structure, and its cultural context. The typographer's analysis illuminates the text, like the musician's reading of a

Neo-Grotesque

The term Neo-Grotesque describes a second generation of Grotesques, designed in the 1950s, which formed a key component of Swiss typography and the international modernist style. Neo-Grotesques appear more mechanical than the earlier Grotesques, with less variation of stroke width, a wider set, and a noticeably higher x-height.

■ THE ORIGINS OF THE NEO-GROTESQUE

The foundation of the Neo-Grotesque genre is the 18th-century Grotesque typeface Akzidenz Grotesk, produced by the Berthold Foundry in 1896. Revived in the postwar years and reissued under the name Standard, this face was favored by typographers of the Swiss typographic school, and strongly influenced the design of Max Meidinger's Neue Haas Grotesk in 1957.

■ HELVETICA: ICONIC NEO-GROTESQUE

To capitalize on its association with modernist design in Basel and Zurich, Neue Haas was later renamed Helvetica (after *Confoederatio Helvetica*, the Latin name for Switzerland). Sharing many of the characteristics that had made Akzidenz Grotesk a popular choice in pre- and postwar modernist

graphics, Helvetica differs from the latter primarily in having a much greater x-height and a slightly narrower set, both of which make it a more practical and economic face. Widely adopted as synonymous with Swiss typographic style, it remains the ideal of a stylistically neutral, "transparent" type, and became one of the most widely used typefaces of the 20th century. Largely devoid of nuance, it has acquired an authoritative voice through familiarity and repetition.

■ IMPORTANT NEO-GROTESQUES

Similar characteristics are found in Folio, designed by Konrad Bauer and Walter Baum. Univers, designed by Adrian Frutiger for Deberny & Peignot, is a Neo-Grotesque systematically designed across an extended family of weights and widths. Avoiding the

ADVENT OF THE NEO-GROTESQUE
This promotional specimen produced by the Haas foundry in 1957 (above) is the first incarnation of the typeface that was later to be renamed Helvetica, a landmark in the development of modernist type design.

CHARACTERISTIC FEATURES

Oo
Little variation of stroke width

on
Slightly condensed form

Te
High x–height

ABC
Minimal contrast

Q
Well-defined counters

FLEXIBLE FUNCTIONALISM

The robust qualities of Neo-Grotesque types retain impact and legibility even when used as transparent overlay or set on curved baselines, as shown in Dominic Lippa's design for the journal of the Typographic Circle (above and right).

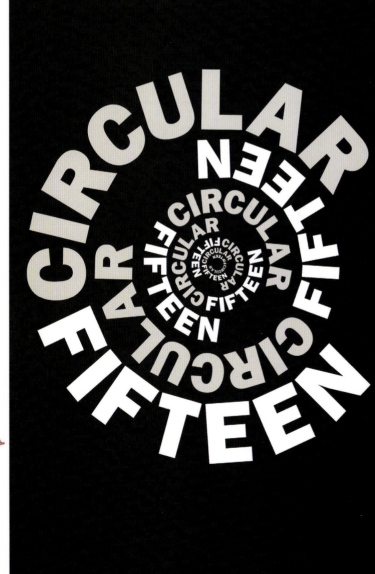

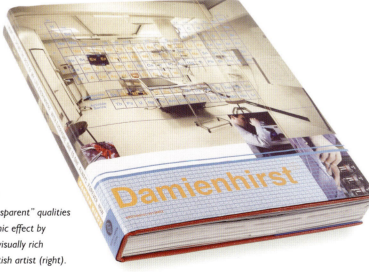

IRONIC NEUTRALITY

The informational and "transparent" qualities of Helvetica are used to ironic effect by Jonathan Barnbrook in this visually rich monograph on a leading British artist (right).

variations of form that enliven some earlier typeface families, or the peculiar compromises that occur when different weights are developed after the original, the entire Univers family derives from the original concept of this typeface, all being mathematical variants of a common model. The result is impressive in its consistency, if somewhat characterless.

Matthew Carter's Bell Centennial was originally commissioned for the telephone directories of the Bell Company in the United States. The earlier Linotype face, Bell Gothic, had been used for this purpose since the late 1930s, but it had suffered a decline in print quality in the transition from metal to photosetting. Designed to address the problems of small type printed on low-quality paper, Centennial marked a significant advance in both legibility and economy of setting.

■ NEUTRALITY AND TRANSPARENCY

It is a frequent criticism of Neo-Grotesques in general, and Helvetica in particular, that these letters are anonymous or mechanical in their appearance. It is true that they show less character than most other faces. This is both their weakness and their greatest strength. In many ways, they exemplify the ideal of type as a carrier of meaning; an ideal of transparency summarized in Beatrice Warde's analogy of type as a crystal goblet, providing the minimum of visual interference between the reader and the text. They refer to no particular regional or decorative tradition, though their adoption as a key element of Swiss typographic modernism means that they are strongly associated with the design philosophies of their time.

■ THE NEO-GROTESQUE IN DIGITAL TYPE

Erik Spiekermann's Meta is representative of a new generation of sans-serif faces developed in the 1990s. Initially designed as an alternative to the widely used Helvetica, it is perhaps best understood by reference to the dominant influence of the Neo-Grotesques of the 1950s. Like other late 20th-century sans serifs, it retains and enhances the functional characteristics of the Swiss school while introducing a distinctive individuality of form. It is available in an extensive range of weights, widths, and alphabets, including Greek and Cyrillic versions.

Arial, adopted as the default font by Microsoft, is a digital derivative of Helvetica. Though widely viewed as inferior in form by many typographers, it benefits from an exceptionally thorough process of hinting, ensuring a consistency of form and readability on screen across all sizes, maintaining its legibility under conditions of low resolution.

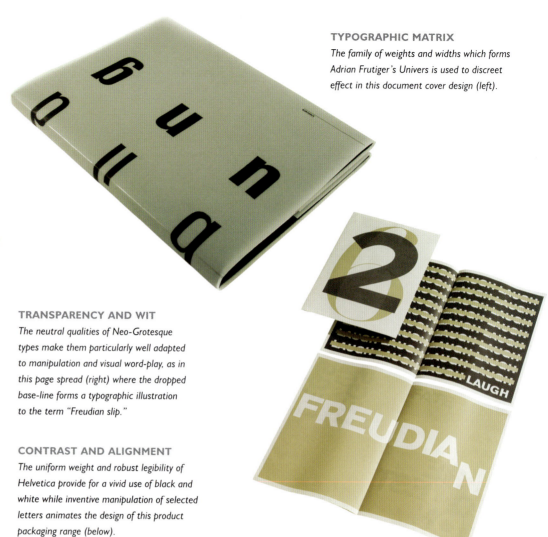

TYPOGRAPHIC MATRIX
The family of weights and widths which forms Adrian Frutiger's Univers is used to discreet effect in this document cover design (left).

TRANSPARENCY AND WIT
The neutral qualities of Neo-Grotesque types make them particularly well adapted to manipulation and visual word-play, as in this page spread (right) where the dropped base-line forms a typographic illustration to the term "Freudian slip."

CONTRAST AND ALIGNMENT
The uniform weight and robust legibility of Helvetica provide for a vivid use of black and white while inventive manipulation of selected letters animates the design of this product packaging range (below).

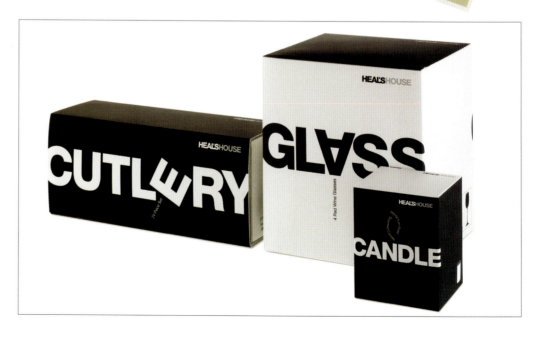

ADRIAN FRUTIGER

As the originator of Univers, Adrian Frutiger (1928–) occupies a leading position in the development of the Neo-Grotesque letter. His work has been closely related to key developments in type-production technology, and Univers was one of the first new types designed specifically for photosetting systems that were beginning to gain widespread use in the 1950s. The type family was designed as a new sans serif for the Lumitype/Photon photosetting machine at the Fonderie Deberny et Peignot, a Paris foundry.

Born in Switzerland, Frutiger studied at the Kunstgewerbeschule in Zurich, one of the key centers of the postwar modernist typography that was to become known as the Swiss style, and that was characterized by the widespread use of sans-serif types such as Akzidenz Grotesk. When Frutiger embarked upon the Univers project,

he had been working as art director for two years at Deberny and Peignot.

Like Paul Renner's Futura, which had also been considered as a possible sans serif for the new system, Univers was conceived as a system encompassing a range of weights. Frutiger extended the idea of the systematic family further by then applying this range of weights across five different widths. The numeric system used to describe the variant fonts reflects a fondness for systematic method and a reluctance to use relative terms such as "bold" or "light."

The family is designed for setting continuous text as well as display. It exemplifies the trend toward higher x-heights, reducing the contrasts between lower- and uppercase, which was to be a key feature in the update of Akzidenz into Neue Haas Grotesk and Helvetica. Alongside the systematic machine aesthetic, Frutiger's work is based in a refined

awareness of positive and negative form, reflecting his early love of sculpture. This was to be demonstrated later in his life in the series of abstract graphic works titled Form and Counterform.

Digital recuts of the face as Linotype Univers extended the range to a total of 63 fonts. Frutiger was to design more than 20 other distinguished typefaces, and has said that many of these have Univers as their skeleton.

LATE NEO-GROTESQUE

Less geometric and more complex than the Swiss Neo-Grotesques, Erik Spiekermann's Meta has an informal authority (below). The bold weight provides a direct, modern, and highly legible style for a series of typographic covers.

FLUID ALIGNMENTS

Neo-Grotesque types are particularly well suited to layering and tonal variation. This poster design (right) makes dynamic use of multiple alignments, anchored by an underlying modernist sensibility reflected in the ranged information at the base.

Helvetica

ABCDEFGHIJKLMNOPQ RSTUVWXYZ
abcdefghijklmnopqrstuvwxyz
1234567890 & ? (),:;'

The iconic modernist typeface, **Helvetica** is a highly legible face, as much because of its familiarity as the inherent clarity of the letterforms. It has a prompted a number of derivatives, notably Geneva and Arial. The original form can be distinguished by the horizontal finials, which have been moderated in many of the later typefaces. It is available in a large number of weights and variants, including rounded and outline faces. It continues to function well for the setting of text and as a deliberately neutral or minimalist choice for display setting.

The typographer's first duty is to the text itself. An intelligent interpretation of the text will not only ensure readability, but will also reflect its tone, its structure, and its cultural context. The typographer's analysis illuminates the text, like the

Bell Centennial

ABCDEFGHIJKLMNOPQRSTUVWXYZ
abcdefghijklmnopqrstuvwxyz
1234567890 & ? (),:;'

Bell Centennial is a condensed face designed for maximum economy and high legibility at small sizes. The design is distinguished by the introduction of notched junctions, designed to counter the distortion caused by the spread of light in photoset letters, and the spread of ink in printing on absorbent papers. This has subsequently been adopted as a stylistic feature by designers using the face at display sizes. The original face was named for its functions within the directory: Bell Centennial name and number and Bell Centennial address were accompanied by the slightly wider Bell Centennial sub-caption.

The typographer's first duty is to the text itself. An intelligent interpretation of the text will not only ensure readability, but will also reflect its tone, its structure, and its cultural context. The typographer's analysis illuminates the text, like the musician's reading of a score.

Univers

ABCDEFGHIJKLMNOPQ RSTUVWXYZ
abcdefghijklmnopqrstu vwxyz
1234567890 & ? (),:;'

Univers represents the first modular type family. Systematically designed across an extended family of weights and widths, it comprises 21 faces, coded by number, including 5 weights, and 4 widths. Compared with Helvetica it has a greater variation of stroke width and shows less affinity to the early 20th-century Grotesques, such as Akzidenz Grotesk. It was less widely adopted into the graphic vocabulary of the Swiss school, but it is a more original and ambitious face that can prove particularly useful when a wide range of differentiation is required.

The typographer's first duty is to the text itself. An intelligent interpretation of the text will not only ensure readability, but will also reflect its tone, its structure, and its cultural context. The typographer's analysis illuminates

Meta

ABCDEFGHIJKLMNOPQ RSTUVWXYZ
abcdefghijklmnopqrstuvwxyz
1234567890 & ? (),:;'

Designed to replace Helvetica in the graphics of the German postal service, **Meta** is representative of a new generation of sans-serif faces. The complex curves and right-angled terminals are particularly noticeable in the c and s, and create a greater openness in the partially enclosed forms of these letters. Meta is available in five weights and two widths. It includes Greek and Cyrillic fonts, and extensive language support. Meta is a highly legible text face with a distinctly modern character, which reveals additional levels of visual interest and variation when used for display purposes.

The typographer's first duty is to the text itself. An intelligent interpretation of the text will not only ensure readability, but will also reflect its tone, its structure, and its cultural context. The typographer's analysis illuminates the text, like the

Geometric Sans

Also part of the broader sans-serif category, Geometric typefaces reflect the idea that type can be reduced to simple geometric units and cleansed of all historical associations. They are characteristic of the modernist design ideology dominant in Europe from the late 1920s into the 1950s. Rather than achieving universal currency and widespread use, these faces came to symbolize a historic ideal of universality; a notion of modernity that already belongs to the past.

■ THE GEOMETRIC IDEAL

The modernist Geometric genre stands in direct contrast to the revivalist craft-based tradition that inspired William Morris' Humanist revivals, and instead asserts the integrity of the machine and the irreducible qualities of geometric form. The assertion of geometric principles reflects a determination to eliminate from type design any symbolic value or reference to past tradition.

Herbert Bayer's "Universal" Bauhaus lettering, designed in 1925, stands as the embodiment of the Geometric ideal, and its iconic status is reinforced by its use on the facade of the Bauhaus. A monoline display face, it is composed almost entirely of simple geometric units: straight lines, circles, and arcs. It is the rigorous application of this reductive principle that ironically gives it its character: the contrast between the ill-defined counters of the e and the full circular counters of the b; the truncated finial of the e; the unresolved reference to a hybridized capital form in the g; and the a which appears largely inconsistent with the geometry of the other letters.

At a similar time, just a year later in 1926, Jan Tschichold attempted a similar project with his own Universal. Recently revived as a digital face by The Foundry, it reflects a sensitivity characteristic of the graphic awareness that Tschichold brought to all of his work. It is a less rigorous expression of Geometric principles than Bayer Universal, and is a considerably more attractive typeface.

CHARACTERISTIC FEATURES

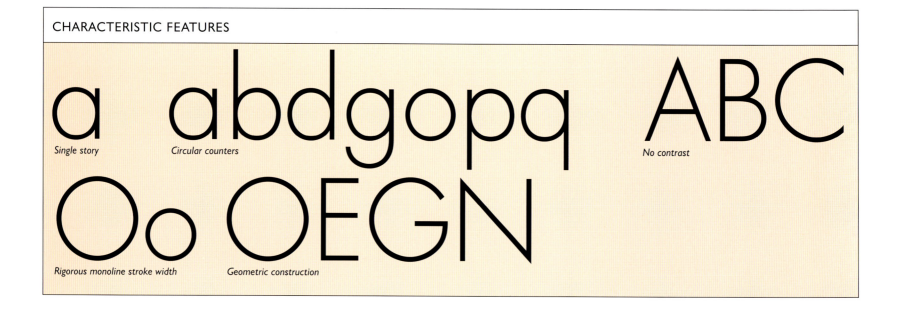

a — Single story

abdgopq — Circular counters

ABC — No contrast

Oo — Rigorous monoline stroke width

OEGN — Geometric construction

ANGULARITY AND DYNAMISM

The distinctive features of Rudolf Koch's Kabel typeface are developed in this logo (left and center left) for a leading contemporary design group. The angle of the e crossbar and finials form the basis for a design in which the original letters are further cropped and modified.

EXPERIMENTAL GEOMETRY

The challenge of reducing letterforms to a limited range of geometric elements (below left) continues to engage contemporary designers and students, producing quirky and idiosyncratic results.

GEOMETRIC ICON

The letters designed by Herbert Bayer for the Bauhaus in 1925 (below) were not developed as a production typeface in his time but have influenced and inspired a genre of types based upon geometric principles.

ROMILLY WINTER
Cast typeface
Poster

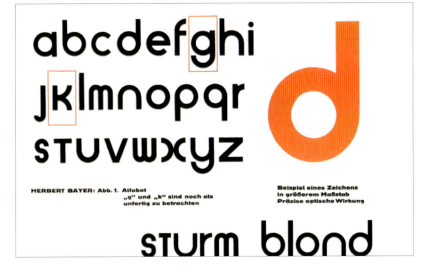

HERBERT BAYER: Abb. 1. Alfabet
„g" und „k" sind noch als
unfertig zu betrachten

Beispiel eines Zeichens
in größerem Maßstab
Präzise optische Wirkung

sturm blond

Bayer's Universal letters were redrawn for each successive use and were never fully developed or marketed as a working face. They have, however, influenced many other attempts at Geometric type, and have continued to have some limited use, most notably in Paul Rand's logo for the American Broadcast Corporation (using a more consistent and stabilized lowercase a). In 1991, Matthew Carter redrew Universal as a digital face.

ITC Bauhaus has been described as a redrawing of Universal, but is actually a distinctive development in the solutions it finds to the problems of Geometric monoline, introducing line breaks to resolve the cumbersome junctions of unadjusted strokes.

■ HUMANIST GEOMETRY

Kabel, designed by Rudolf Koch for the Klingspor Foundry in 1927–30, was radically redrawn for ITC in 1986 with a noticeably greater x-height. It is a colorful face with slightly more of a Humanist flavor than other Geometrics, enlivened by angled finials and some unexpected letter constructions. The sloping bar of the e makes an unexpected allusion to Humanist letters, or possibly to a Hellenic model.

■ A CLASSIC GEOMETRIC

Futura was designed by Paul Renner and issued by the Bauer Foundry in Frankfurt. Recent research has examined the disputed originality of Renner's initial designs, but his major achievement lies less in specific innovations of form than in the skill with which he developed an emerging modernist idiom into a durable, functional typeface. The radical design ideology of the Bauhaus and the principles of the New Typography were sensitively interpreted by Renner to produce a face that has become a 20th-century classic.

Futura is essentially a Geometric modernist typeface, and embodies the emerging typographic principles of Bayer and the Bauhaus. However, this geometry is tempered by refinements of detail and proportion that make it far more harmonious than many more rigidly Geometric faces. It is particularly notable among early 20th-century type families because it maintains its coherence across an extended range of weights. Though not all of these were originated by Renner, it is a reflection of the integrity of his original letterforms that they provided such a clear foundation for development.

■ DISPLAY GEOMETRIC

Avant Garde was designed by Herb Lubalin as a display face while he was art editor for the magazine of the same name. It was originally designed as a titling face and incorporated an ingenious range of capital ligatures to maintain the very tight setting for which it was designed. It is a fully Geometric face, with very few of the adjustments to junctions seen in Renner's Futura. The Geometric rigor provides for a dramatic set of capital forms and a rather less satisfactory lowercase. Avant Garde proved ideally suited to digitization, since its simplicity of form requires fewer bitmap points, and therefore less memory, than most faces. As a consequence it became a popular mainstream digital face, and a severely reduced version of the original design is widely available.

■ THE GEOMETRY OF THE SQUARE

The term Geometric should also include those typefaces constructed upon a square model, in which the use of curved strokes has either been minimized or removed completely. These are predominantly display faces, though the proportion of the square informs the design of more comprehensive faces, such as Eurostile. An important historic model can be found in the square letters designed by Theo van Doesberg in 1928, and revived in digital form in the 1990s by The Foundry as Architype Aubette.

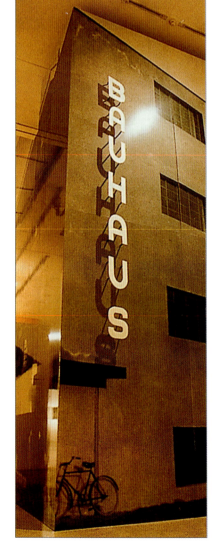

A LANDMARK RECREATED
Herbert Bayer's lettering for the Dessau Bauhaus was reconstructed in this exhibition design (right). The letters are all designed to a single common width, which makes them unusually well-adapted for vertical setting.

A CLASSIC GEOMETRIC

This promotional specimen for Paul Renner's Futura (right) vividly demonstrates the geometric structure of this monoline typeface. The double-dot diacritic is used to inventive effect beneath the centered G.

ECLECTIC GEOMETRY

Rudolf Koch's Kabel typeface (right) is a Geometric monoline face enlivened by some unexpected features such as the angled finials and sloped crossbar. The unusually low x-height was revised in later adaptations of the face.

CUSTOM GEOMETRIC

In this custom typeface designed for a youth orchestra (top), the use of a dot in place of a bar makes a subtle allusion to musical notation.

3-D GEOMETRY

Paul Renner's classic Futura (above) is enhanced by three-dimensional treatment in primary colors in the signage for an interactive venue in London's Science Museum.

Bernhard Gothic

ABCDEFGHIJKLM

NOPQRSTUVWXYZ

abcdefghijklm

nopqrstuvwxyz

1234567890 & ? (),:;'

Bernhard Gothic was designed for ATF as a response to the popularity of European Geometric faces, but has a more expressive, organic quality than its modernist contemporaries. The face has a low x-height characteristic of pre-war Geometric faces, and a distinctive italic form. The angled terminals suggest a glyphic quality that is further developed by the alternate forms of the e and s. These evoke classical inscriptional lettering and add to the distinctive personality of an unusually colorful Geometric face.

The typographer's first duty is to the text itself. An intelligent interpretation of the text will not only ensure readability, but will also reflect its tone, its structure, and its cultural context. The typographer's analysis illuminates the text, like the musician's reading of a score.

Futura

ABCDEFGHIJKLMNOPQ

RSTUVWXYZ

abcdefghijklmnopqrstu

vwxyz

1234567890 & ? (),:;'

A Geometric face moderated through a Humanist sensitivity, the monoline strokes of **Futura** are balanced by a compensatory tapering, a quality also found in Gill Sans. The proportions of the letters are determined largely by their own Geometric characteristics but allude subtly to the classical proportions of Humanist Sans type. Futura is notable among early 20th-century type families in that it maintains its coherence across an extended range of weights. It can be used for setting limited amounts of text, alongside its primary role as a display or subhead face.

The typographer's first duty is to the text itself. An intelligent interpretation of the text will not only ensure readability, but will also reflect its tone, its structure, and its cultural context. The typographer's analysis illuminates the text, like the

Kabel

ABCDEFGHIJKLMNOPQ
RSTUVWXYZ
abcdefghijklmnopqrstuvwxyz
1234567890 & ? (),.:;'

RUDOLF KOCH 1927–30, 1986

Kabel is an idiosyncratic monoline face with a number of distinctive features. Koch's original had a low x-height that was dramatically revised in the ITC version, improving legibility but compromising the Geometric proportions of the original. Kabel is currently available in five weights. Many of the more obtrusive aspects of the original are moderated in the demi weight, which has a more balanced form and is better suited for setting continuous text than the lighter weights, which emphasize the rigorous geometry of the face and are best reserved for display purposes.

The typographer's first duty is to the text itself. An intelligent interpretation of the text will not only ensure readability, but will also reflect its tone, its structure, and its cultural context. The typographer's analysis illuminates the text, like the musician's

Eurostile

ABCDEFGHIJKLMNOPQ
RSTUVWXYZ
abcdefghijklmnopqrstuvwxyz
1234567890 & ? (),:;'

ALDO NOVARESE 1962

Eurostile is a square monoline face with a high x-height and a distinct 1960s period flavor. Like Novarese's earlier Microgramma, it is based around a rigid and unvarying geometry, and both capital and lowercase letters are fitted to uniform widths. Primarily a display face, it may be used for the setting of small amounts of continuous text, and although the broad square form is not economical, its high x-height ensures reasonable legibility in the lowercase letters. Its mathematical consistency also makes it an effective face for screen use.

The typographer's first duty is to the text itself. An intelligent interpretation of the text will not only ensure readability, but will also reflect its tone, its structure, and its cultural context. The typographer's analysis illuminates

Glyphic

The term Glyphic is used to describe carved or inscribed types with origins in both the history and the contemporary practice of letter-cutting, and its main exponents have been equally distinguished in the letter crafts. The category includes those letters based upon classical, incised forms, but applies in particular to faces based upon relief letters, in which the surrounding background has been carved away. It also encompasses those categories of type sometimes known as "flare serif" in which the stem broadens toward the terminal, suggesting a vestigial serif form.

■ GERMAN TYPES

Some key characteristics of the genre can be seen in Rudolf Koch's Neuland. This was punch-carved by the designer from steel rods in a bravura display of subtractive letter-making.

A defining example of the Glyphic letter is Albertus, designed by Berthold Wolpe for Monotype. A natural expression of Wolpe's work as a lettering artist, this is typical of the Germanic tradition of Glyphics, also evident in the typefaces of Koch, with whom Wolpe studied.

The heavier Glyphics allow for a complex interplay between positive and negative forms that has been a characteristic of German and Eastern European display typography. Although the forms are Roman, this sensitivity to color and the interrelationship of positive and negative space reflects the vivid contrasts of the 20th-century Blackletter, a graphic vocabulary in which both Koch and Wolpe were proficient. Some Glyphic forms allude specifically to Blackletter tradition, whereas many others take their form and proportion from the Roman letter while retaining a Blackletter accent in their contrast and dynamics.

Poppl Laudatio, designed by Friedrich Poppl for Berthold 1982, is a Glyphic with a high x-height and generous counters that make it more suitable for the setting of text than most Glyphics.

TYPE AS TEXTURE

In this typographic print (above), Rudolf Koch's Neuland typeface is used to create a uniform surface evoking the inscriptional relief lettering that informed the original design. Variations of color and tone are used for emphasis and small glyphs separate words without interrupting the typographic rhythm.

CHARACTERISTIC FEATURES

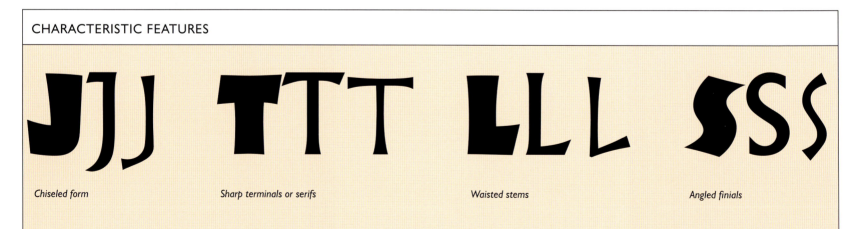

Chiseled form *Sharp terminals or serifs* *Waisted stems* *Angled finials*

ÜBER DEN WOLKEN IST SONNE
ABOVE CLOUDS IS THE SUN

GLYPHIC HUMANIST

Varied sizes of capitals are used in this promotional card for a new release of Hermann Zapf's Optima (above), revealing the subtle glyphic features of the face. The letters have both Glyphic and Humanist characteristics.

THE CLASSICAL CAPITAL

The historical associations of Carol Twombly's Trajan have made it a popular choice for works of historical scholarship or fiction (right). The absence of lowercase letters requires the introduction of a complementary Didone italic.

BOOKS AND THE SCIENCES IN HISTORY

EDITED BY
Marina Frasca-Spada and Nick Jardine

CONTRASTING GLYPHICS

This identity for a theological training college (below) contrasts the vigorous lowercase letters of Berthold Wolpe's Albertus with the delicate, incised letters of John Peters's Castellar.

▣ CLASSICAL FORMS

Twombly's Trajan is a faithful and sensitive transcription of the letters on Trajan's Column in Rome, and is widely used in book jacket design. Its combination of visual elegance and the gravitas implied by its classical origins have made it a favored choice in the packaging of contemporary literary fiction.

A noticeably more informal use of classical letterforms can be seen in Adrian Frutiger's Rusticana, based upon early Mediterranean letters, while Matthew Carter's Mantinia is based upon the inscriptional lettering on Italian painter Andrea Mantegna's *The Entombment* from the 1470s. It includes an extensive and beautifully considered range of alternates, tall caps, ligatures, and superiors.

Ridley Hall CAMBRIDGE

RUDOLF KOCH 1923

NEULAND

ABCDEFGHIJKLMNOPQ
RSTUVWXYZ
ABCDEFJIKLMNOPQRSTU
VWXYZ
1234567890 & ? (),:;'

Neuland is a bold and vivid face with suggestions of both Fraktur and early Roman forms. Koch cut the punches for this face without preliminary drawings, and some of this spontaneity is retained in the digital version, though the different sizes of punch have been standardized to a single set of masters. Koch's awareness of the graphic contrasts of Blackletter informs the design of his display faces. Variations in the angle of finials and the base strokes of letters animate a heavy form, in which the relationships of positive and negative space are dramatic but highly readable.

THE TYPOGRAPHER'S FIRST DUTY IS TO THE TEXT ITSELF. AN INTELLIGENT INTERPRETATION OF THE TEXT WILL NOT ONLY ENSURE READABILITY, BUT WILL ALSO REFLECT ITS TONE, ITS

BERTHOLD WOLPE 1935

Albertus

ABCDEFGHIJKLMNOPQ
RSTUVWXYZ
abcdefghijklmnopqrstuvwxyz
1234567890 & ? (),:;'

Albertus is the typographic expression of a letter-cutter's sensibility, reflecting Wolpe's awareness of carved relief letters and calligraphic form. The Glyphic flare serif animates the imposing Humanist letterforms, while the inclined stress and calligraphic inflection introduce subtle modulations of width into the curves. It has a lowercase that can be used for setting short texts, but it is primarily a display face, frequently used for its capitals alone. Available in two weights, it has a distinctive and exceptionally lively condensed italic which can be effectively used for the setting of continuous text.

The typographer's first duty is to the text itself. An intelligent interpretation of the text will not only ensure readability, but will also reflect its tone, its structure, and its cultural context. The typographer's analysis illuminates the text, like the musician's

LITHOS

ABCDEFGHIJKLMNOPQ
RSTUVWXYZ
1234567890 & ? (),:;'

CAROL TWOMBLY 1989

Lithos has a pronounced Hellenic flavor and makes colorful use of the characteristics of the early Mediterranean letter. It is animated by a slight forward incline to the stems, squared terminals, and the tensile curves of the C and G forms. It has a small cap version in place of a miniscule or lowercase. Designed in five weights, it includes Greek as well as Latin characters.

THE TYPOGRAPHER'S FIRST DUTY IS TO THE TEXT ITSELF. AN INTELLIGENT INTERPRETATION OF THE TEXT WILL NOT ONLY ENSURE READABILITY, BUT WILL ALSO REFLECT ITS TONE, ITS STRUCTURE, AND ITS CULTURAL

RUSTICANA

ABCDEFGHIJKLMNOPQ
RSTUVWXYZ
1234567890 & ? (),:;'

ADRIAN FRUTIGER 1992

The squared finials and waisted stems of **Rusticana** reflect the influence of 1st-century Roman vernacular lettering rather than imperial inscriptions, and the face is an evocative and colorful contrast to the formality of the classic Roman form. Rusticana is a companion to Frutiger's Herculanum and Pompeiana. Produced in a single weight accompanied by a font of geometric borders, it has no lowercase and is suitable for display purposes rather than continuous text.

THE TYPOGRAPHER'S FIRST DUTY IS TO THE TEXT ITSELF. AN INTELLIGENT INTERPRETATION OF THE TEXT WILL NOT ONLY ENSURE READABILITY, BUT WILL ALSO REFLECT ITS

Perpetua

ABCDEFGHIJKLMNOPQ RSTUVWXYZ

abcdefghijklmnopqrstuvwxyz

1234567890 & ? (),:;'

Cut by Charles Malin from Gill's drawings, **Perpetua** is a face that owes more to a letter-cutter's understanding of the Roman letter than to typographic tradition. The refined quality of the delicate serifs and the low x-height limit its functionality as a text face, and the digital version is best suited to large-scale use. The italic, originally called Felicity, follows Stanley Morison's preferred form of the "sloped Roman" rather than any cursive characteristics. A set of titling capitals complements the main font.

The typographer's first duty is to the text itself. An intelligent interpretation of the text will not only ensure readability, but will also reflect its tone, its structure, and its cultural context. The typographer's analysis illuminates the text, like the musician's reading of a score.

TRAJAN

ABCDEFGHIJKLMNOP QRSTUVWXYZ

1234567890 & ? (),:;'

Trajan is a sensitive transcription of the letters of the Trajan Column in Rome, probably the most influential and definitive example of the Roman inscriptional capital. These would have first been drawn with a brush before being cut into stone with a chisel. True to its origins, the typeface has no lowercase forms, substituting instead a slightly smaller set of capitals. It is available in two weights. Trajan has long been established as a popular choice in publishing and the film industry.

THE TYPOGRAPHER'S FIRST DUTY IS TO THE TEXT ITSELF. AN INTELLIGENT INTERPRETATION OF THE TEXT WILL NOT ONLY ENSURE READABILITY, BUT WILL ALSO REFLECT ITS TONE, ITS

MANTINIA

MATTHEW CARTER 1993

ABCDEFGHIJKLMNOPQ
RSTUVWXYZ

ABCDEFGHIJKLMNOPQRSTUVWXYZ

1234567890 & ? (),.:;'

Conceived as a display companion to the popular Galliard, **Mantinia** is based upon inscriptional letters in Andrea Mantegna's painting *The Entombment* from the 1470s. Characterized by a broad set and crisp, well-defined serifs, it includes a vivid and extensive range of alternates, tall caps, nested letter pairs, and ligatures, providing the user with a wide range of decorative options.

THE TYPOGRAPHER'S FIRST DUTY IS TO THE TEXT ITSELF. AN INTELLIGENT INTERPRETATION OF THE TEXT WILL NOT ONLY ENSURE READABILITY, BUT WILL ALSO REFLECT ITS TONE, ITS STRUCTURE, AND ITS CULTURAL CONTEXT. THE TYPOGRAPHER'S ANALYSIS ILLUMINATES

SOPHIA

MATTHEW CARTER 1993

ABCDEFGHIJKLMNOPQ
RSTUVWXYZ

1234567890 & ? (),:;'

Inspired by hybrid alphabets of incised letters from 6th-century Constantinople which blend elements of Roman, Uncial, and Greek, **Sophia** features a set of special "joining characters" that link with others to form ligatures. There are alternate forms of several letters. The letters are monoline with a fine incised serif terminal; the flattened curve of the C, G, and E suggest Hellenic influences. In keeping with the traditions from which it is derived, Sophia has no lowercase letters.

THE TYPOGRAPHER'S FIRST DUTY IS TO THE TEXT ITSELF. AN INTELLIGENT INTERPRETATION OF THE TEXT WILL NOT ONLY ENSURE READABILITY, BUT WILL ALSO REFLECT ITS TONE, ITS

Blackletter

Based upon the Germanic manuscript hand of the 15th century, Blackletter is the term used to describe the letterforms used by Johannes Gutenberg in the first books to be printed from movable type. While the use of Blackletter for text setting was quickly superseded by the early Humanist faces across most of Europe, it has continued and developed in more specialized contexts to the present day.

POLITICAL UNDERTONES
The continuing association of Blackletter with the iconography of Nazi Germany is evoked in this cover design for Arendt's book on the holocaust (above).

◼ NATIONALIST ASSOCIATIONS

Blackletter has a distinct and particular history in Germany, where its significance as an expression of national identity politicized its continued use through the first half of the 20th century. In the rest of Europe, Blackletter evolved largely as a display idiom, particularly adapted for use in liturgical contexts or as a consciously archaic form intended to evoke a sense of the past.

The adoption of Blackletter as the graphic voice of Nazi militarism was abruptly reversed by edict in 1941, but has continued to color public perceptions of the Blackletter tradition. Relatively few Blackletter faces were adapted from metal to digital, and the majority of examples available today are original or sometimes radical reinterpretations of the Blackletter form. The interrupted development of Blackletter has created the conditions for some imaginative reappraisals of a tradition that was interrupted by the events of World War II and a typographic vocabulary that had to some extent fallen into disrepute.

◼ BLACKLETTER FAMILIES

The term Blackletter encompasses four major families: Textura, Fraktur, Bastarda (also known as Schwabacher), and Rotunda. Textura is the Blackletter used in the Gutenberg bibles: a close-set, vertical form. It is a characteristic of early Blackletter that the weight of the stroke-width generally exceeds the white space of both counters and inter-character spacing, providing a dense and rhythmically even texture. It was followed, though not superseded, by the Rotunda form cut by

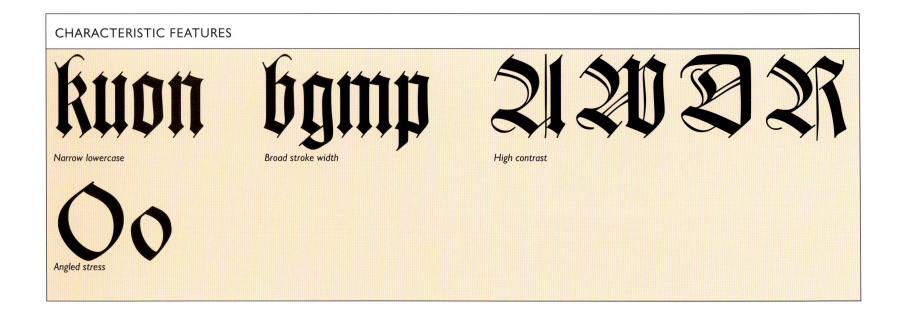

CHARACTERISTIC FEATURES

Narrow lowercase

Broad stroke width

High contrast

Angled stress

TEXTURA AND PATTERN

This page from Albert Kapf's 1955 Deutsche Schiftkunst *(above) demonstrates the even repetition of vertical strokes characteristic of the textural letter, offset by decorative scrollwork and calligraphic flourishes.*

POSTMODERN BLACKLETTER

In this poster-format annual report (right), blackletter types are used in a playful and ironic manner to set the title "Transformation," reflecting the long association of Blackletter with religious and devotional contexts.

OUTSIDER TYPE

The negative associations of Blackletter have prompted its re-emergence as a subversive or counter-cultural style in the 21st century. This piece of custom lettering (below) combines historical letterforms with digital manipulation of color, surface, and dimensionality.

printers in Switzerland and Italy. After 1480 the Schwabacher types, based upon local Bastarda traditions, appeared in Bohemia, Germany, and Switzerland. Fraktur developed from imperial chancery hands during the reign of Maximilian I (c.1493–1519). Its name refers to the broken curves that characterize this form of Blackletter.

Both Schwabacher and Fraktur came into common use between 1493 and 1522 when New High German, on which modern German is based, was becoming established. While the early Textura forms reflected a widespread manuscript tradition, Schwabacher letters in particular came to be seen as the visual embodiment of German national identity, Protestant thinking, and the German language.

Wilhelm Klingspor Gotisch

ABCDEFGHIJKLMNOPQ
RSTUVWXYZ
abcdefghijklmnopqrstuvwxyz
1234567890 & ? (),:;'

An ornamental Textura, **Wilhelm Klingspor Gotisch** is a vivid, animated face. The weight of the capitals is enlivened by a decorative second stroke, and the angular verticality of the lowercase is relieved by subtle curves in the d and z, and the hairline spurs that accent the diagonals. Incorporating the regular vertical intervals of the Textura form, with elements of differentiation and visual interest, the face is rhythmically consistent but colorful. The repetiveness of the condensed lowercase limits the readability of the face, which is primarily suited to display or titling functions.

The typographer's first duty is to the text itself. An intelligent interpretation of the text will not only ensure readability, but will also reflect its tone, its structure, and its cultural context. The typographer's analysis illuminates the text, like the musician's reading of a score.

Duc de Berry

ABCDEFGHIJKLMNO
PQRSTUVWXYZ
abcdefghijklmnopqrstuvwxyz
1234567890 & ? (),:;'

Duc de Berry is a Bastarda which reflects French Blackletter traditions. The o is characteristic of the open and curvaceous Bastarda form, and the face is alive with detail and color. The capitals are embellished with hairline strokes ending in rectangular terminals, while the vertical emphasis of the lowercase is moderated by concave strokes on the m and n, and the dramatic ascender of the d. Less dense than many Blackletter faces, it shows a greater Roman influence, and is reasonably legible for limited amounts of text setting. It includes a small number of historic Blackletter forms and ligatures.

The typographer's first duty is to the text itself. An intelligent interpretation of the text will not only ensure readability, but will also reflect its tone, its structure, and its cultural context. The typographer's analysis illuminates the text, like the musician's reading of a score.

Clairvaux

ABCDEFGHIJKLMNOPQ
RSTUVWXYZ
abcdefghijklmnopqrstuvwxyz
1234567890 & ? (),:;'

Clairvaux is a Bastarda that embodies many references to the Carolingian miniscule, particularly noticeable in the lowercase a. It may as a consequence be more legible to non-German readers than many other Blackletter faces. The title refers to the Cistercian abbey of Clairvaux, and the calligraphic qualities of the face reflect the manuscript tradition in a face that might equally be defined as a script. Its simplicity of form is in marked contrast to the more dramatic Blackletter faces, and it would be feasible for setting limited amounts of running text.

The typographer's first duty is to the text itself. An intelligent interpretation of the text will not only ensure readability, but will also reflect its tone, its structure, and its cultural context. The typographer's analysis illuminates the text, like the musician's reading of a score.

Fraktur

ABCDEFGHIJKLMNOPQ
RSTUVWXYZ
abcdefghijklmnopqrstuvwxyz
1234567890 & ? (),:;'

Fraktur is a highly colored, dramatic face with a vivid contrast of angled and curved strokes. Several historic Blackletter forms and ligatures are included in addition to the standard character set. The numerals are Roman rather than Germanic in form, and show the affinities between this phase of Blackletter and the late Didone or fat-face display types in their wide set and pronounced variation of stroke width.

The typographer's first duty is to the text itself. An intelligent interpretation of the text will not only ensure readability, but will also reflect its tone, its structure, and its cultural context. The typographer's analysis illuminates the text, like the musician's reading of a score.

Script, Italic, and Chancery

While the historical evolution of type shows a move away from calligraphic forms toward letters specifically informed by the technologies of the printed letter, a concurrent tradition has maintained the influence of the written hand through the design of Script, Italic, and Chancery typefaces. These range from highly formal and disciplined letterforms, based in many cases upon the historical example of noted writing masters, to animated, gestural faces from the 20th century, encompassing a range of highly personal approaches to the arts of pen- and brush-lettering.

■ ITALIC AS A PRIMARY FACE

While it is now an established convention that any text face should have a matched italic or italic version, the Renaissance origins of italics are as wholly distinct typefaces, designed for the setting of continuous text. This tradition is continued in the form of freestanding Italic and Chancery faces. Delphin, designed by Georg Trump, is characteristic of the Renaissance italic in having an upright roman capital that is substantially lower than the ascenders of the explicitly script-based italics. The capitals have a wide set and may also be used to set whole words. Designed by Imre Reiner, Mercurius and Matura are contemporary Italic faces.

■ CHANCERY

The Chancery hand originated as a formal mode of writing during the Renaissance and exists today as a form of unlinked script. One very widely known example is Hermann Zapf's Zapf Chancery, while Robert Slimbach's Poetica is an extensive Chancery typeface that includes a range of ornaments, swashes, alternates, ligatures, and variant forms.

■ LINKED SCRIPTS

Matthew Carter's Snell Roundhand is a linked Script face that vividly translates the example of

DIDONE SCRIPTS

As well as their elegant, modern roman letters, both Bodoni and Didot designed manual faces (like the Bodoni example above) which applied the characteristic high contrasts of the time to an upright linked script.

CHARACTERISTIC FEATURES

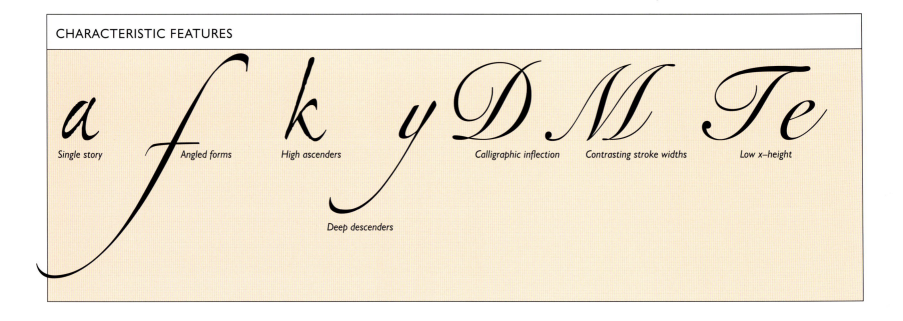

a — Single story *f* — Angled forms *k* — High ascenders *y* — Calligraphic inflection *DM* — Contrasting stroke widths *Te* — Low x-height

f — Deep descenders

the 17th-century writing master Charles Snell into typographic form. Initially drawn for photosetting on the Linofilm system, it was later digitized by Carter. Snell's work was characterized by a concern for restraint and regularity of form, which is why it is not diminished by translation into type. Individually formal, the letters are vibrant and animated when linked.

◼ DIGITAL TYPES AND VARIABILITY

In the past, many Script typefaces have lacked the vitality and spontaneity of original hand calligraphy, since the design of a typeface involves stabilizing and standardizing letterforms that remain fluid and responsive when applied by the calligrapher. All but the most rigidly formal of written letters will be animated by subtle variations in form, according to the letters that precede or follow them, particularly in the case of fully linked scripts.

Typographic standardization of Script characters may compromise or flatten the vitality of letters and their relationships. However, digital typeface design offers the possibility of extended ranges of variant letters, ligatures, swashes, and alternates. Whereas economic considerations would have made it impractical to cast so many letters in metal, a digital font can comfortably accommodate enough variant forms to humanize and animate Script type. A key example of this capability can be found in Hermann Zapf's Zapfino, in which the permutation of four different alphabets, coupled with an extensive range of ligatures, alternates, and terminal letters, allows the designer to replicate much of the scope for variation enjoyed by the calligrapher.

COMMERCIAL VERNACULARS

The traditions of informal script letters that characterized American publicity and advertising in the mid-20th century are colorfully evoked in this advertisement for a digital script typeface (above).

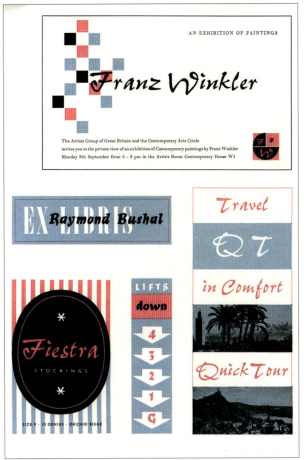

DISTRESSED SCRIPT

The overprinting of two layers of slightly contrasting script faces deliberately disrupts expectation of clarity and formal perfection in this calendar design for the Academy of Fine Arts in Poznan (above).

POSTWAR SCRIPT FORMS

Three new script typefaces by Imre Reiner are featured in this specimen (above) produced by Monotype in the late 1950s to promote Pepita, Mercurius, and Matura.

Snell Roundhand

ABCDEFGHIJKLMNO
PQRSTUVWXYZ
abcdefghijklmnopqrstuvwxyz
1234567890 & ? (),.:;'

Based upon the work of the 18th-century writing master Charles Snell, **Snell Roundhand** is a linked script face in two weights. The letters have well-defined counters and clear differentiation, with the result that it is a comparatively legible face that can be used in the setting of limited amounts of continuous text. As a linked face, Snell should always be set at default letter spacing, since any modification will break or compress the complex linking strokes that join the letters to one another.

The typographer's first duty is to the text itself. An intelligent interpretation of the text will not only ensure readability, but will also reflect its tone, its structure, and its cultural context. The typographer's analysis illuminates the text, like the musician's reading of a score.

Shelley

ABCDEFGHIJKLMN
OPQRSTUVWXYZ
abcdefghijklmnopqrstuvwxyz
1234567890 & ? (),.:;'

Designed as a new script typeface for photo-typesetting machines, **Shelley** was conceived as a script family that would offer a range of variant letterforms within a single face. It comprises three different variants: Allegro (in the style of Kuenstler Schreibschrift); Andante; and the more expressive Volante. The three versions can be used together to create greater calligraphic variation and color.

The typographer's first duty is to the text itself. An intelligent interpretation of the text will not only ensure readability, but will also reflect its tone, its structure, and its cultural context. The typographer's analysis illuminates the text, like the musician's reading of a score.

RICHARD LIPTON 2000

Bickham Script

$ABCDEFGHIJKLMNOPQ$

$RSTUVWXYZ$

abcdefghijklmnopqrstuvwxyz

1234567890 & ? (),.:;'

Richard Lipton's **Bickham Script** is a formal script typeface based on the lettering of 18th-century writing master George Bickham. With large numbers of alternate letterforms in addition to its range of weights, it makes full use of current encryption technology to offer extended variations and glyph options within a single face. The most recent version, Bickham Script Pro, includes over 1,700 glyphs per font, providing a multitude of extra OpenType features, such as the automatic substitution of alternate characters or discretionary ligatures.

The typographer's first duty is to the text itself. An intelligent interpretation of the text will not only ensure readability, but will also reflect its tone, its structure, and its cultural context. The typographer's analysis illuminates the text, like the musician's reading of a score.

JOVICA VELJOVIC 1995

Ex Ponto

$ABCDEFGHIJKLMNOPQ$

$RSTUVWXYZ$

abcdefghijklmnopqrstuvwxyz

1234567890 & ? (),.:;'

A face based upon the designer's own calligraphic forms, **Ex Ponto** reflects exceptionally detailed use of digital technology in reproducing the qualities of a pen nib upon paper. Its rough edges occur along one side of the stroke, replicating the rough "feathering" created by the texture of paper. An extended range of alternates, ligatures, terminal letters, and a set of titling italics further enhance the typeface's scope for calligraphic variation. The light, regular, and bold weights retain their integrity of form and calligraphic color whether used separately or in combination.

The typographer's first duty is to the text itself. An intelligent interpretation of the text will not only ensure readability, but will also reflect its tone, its structure, and its cultural context. The typographer's analysis illuminates the text, like the musician's reading of a score.

Zapfino

ABCDEFGHIJKLMN
OPQRSTUVWXYZ
abcdefghijklmnopqrstuvwxyz
1234567890 @ ? (),:;'

Perhaps the most vivid example of the potential for digital media to offer extended calligraphic capability, **Zapfino** comprises four alternate alphabets and a wide range of variant forms, terminal and initial letters, and ligatures. This provides a vast choice of permutations, giving the designer a level of creative intervention and flexibility closer to the calligrapher's craft than was previously possible. Zapfino is primarily a display face, though the more restrained standard alphabet can be used for short sections of continuous text. A limited version is provided with Apple OSX system software.

The typographer's first duty is to the text itself. An intelligent interpretation of the text will not only ensure readability, but will also reflect its tone, its structure, and

Brioso

ABCDEFGHIJKLMNOPQ
RSTUVWXYZ
abcdefghijklmnopqrstuvwxyz
1234567890 & ? (),:;'

A strongly calligraphic, contemporary interpretation of the Humanist form, **Brioso** demonstrates the extended character range afforded by digital media, offering a comprehensive selection of options and variants. These include small caps, swashes, alternates, and ornaments. The typeface has four weights: light, medium, semi-bold, and bold, available in four optical sizes, for caption, regular, subhead, and display use. This range of options allows for practical use across a wide range of contexts. It is therefore better suited for text setting than most script faces.

The typographer's first duty is to the text itself. An intelligent interpretation of the text will not only ensure readability, but will also reflect its tone, its structure, and its cultural context. The typographer's analysis illuminates the text, like the musician's reading of a score.

IMRE REINER 1957

Mercurius Script

ABCDEFGHIJKLMNOPQ
RSTUVWXYZ
abcdefghijklmnopq
rstuvwxyz
1234567890 & ? (),:;',

A colorful hand-rendered face produced for Monotype by the noted Hungarian lettering artist Imre Reiner, **Mercurius Script** is part of a trio of display faces that also includes Matura and Pepita. The animated, angular letters were created with a bamboo pen, and have a vigorous and dynamic presence. Originally designed for hot-metal casting, the face has been successfully adapted, first to photosetting and then as a digital face. It is produced in a single weight, with a fairly limited glyph set.

The typographer's first duty is to the text itself. An intelligent interpretation of the text will not only ensure readability, but will also reflect its tone, its structure, and its cultural context. The typographer's analysis illuminates

GEORG TRUMP 1955

Delphin

ABCDEFGHIJKLMNOPQ
RSTUVWXYZ
abcdefghijklmnopqrstuvwxyz
1234567890 & ? (),:;'

Trump's innovative **Delphin** echoes the early Renaissance italics in pairing its distinctive chancery lowercase with an alphabet of Roman capitals. These are considerably smaller than the ascending lowercase letters, and have a rugged breadth and tapered leg forms. The lowercase h, k, p, and y are particularly distinctive. The typeface is produced in two weights: Delphin II and the semibold Delphin II. An additional font in each weight contains alternate versions of several letters. The set of eight fonts includes a full set of Central European glyphs and diacritics.

The typographer's first duty is to the text itself. An intelligent interpretation of the text will not only ensure readability, but will also reflect its tone, its structure, and its cultural context. The typographer's analysis illuminates the text, like the musician's reading of a score.

Decorated and Ornamental

Both these terms are widely used to describe the profusion of colorful display faces that emerged to meet the needs of a developing consumer culture in the wake of the Industrial Revolution. As a general but not universal rule, a Decorated face is based upon a recognizable face within or around which decorative characteristics have been added. In an Ornamental face, the form of the letter itself is determined by some decorative or figurative intention.

BOTANICAL TYPOGRAPHY
The extremes of floriated decoration found in Victorian display types are used to appropriate effect in the Penguin edition of Emerson's Nature *(above).*

■ AESTHETIC INFLUENCES

Decorated and Ornamental letterforms frequently reflect developments in architecture and the graphic arts. Victorian designers and architects drew upon a range of ornamental vocabularies, appropriating medieval, Egyptian, classical, and gothic references, and producing decorative typefaces in each idiom. The Ornamental face may be composed of foliage, rustic woodwork, the human form, or abstract elements. The majority of 19th-century Ornamental faces are capital only, and necessarily designed for use at larger sizes.

Associated with a decline in quality printing, and a supposed degeneracy in aesthetic standards, Victorian display faces have long been seen as representing a typographic dark age. This somewhat humorless view ignores both the imaginative bravado of Victorian display type, and its fitness for purpose in an emerging consumer society. These forms mark the development of advertising, brand identity, and promotion, and constitute a spirited response to the need for greater differentiation of products, services, and entertainments.

■ TYPE AND FASHION

The extravagant flowering of forms established a category of display type design that continued through the 20th century and up to the present: the ephemeral typeface. Each phase of design history has seen commercial demand for typefaces that capture some essence of the spirit of the time. The success with

CHARACTERISTIC FEATURES

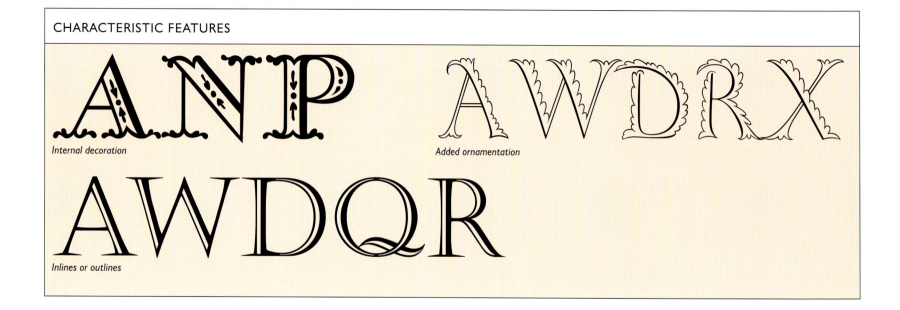

Internal decoration

Added ornamentation

Inlines or outlines

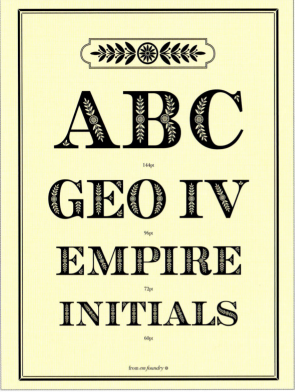

VECTOR AS ORNAMENT

This page spread by Marian Bantjes (above) reflects a sophisticated command of the developing tradition of decorative vector graphics, in which abstract curlicues develop out of the serifs and terminals of letters.

ORNAMENTAL REVIVAL

The floral inline detail is a distinctive feature of the Empire Initials (right), one of a series of historically informed typefaces by Jon Melton's Em Foundry.

VICTORIAN SONGBOOK

The typeface Marguerite (right) is a digital revival of the decorative faces often used in editions of 19th-century sheet music. A condensed form is enlivened by elaborate descenders and non-lining capitals.

which this is achieved is, in turn, reflected in the way that once-fashionable typefaces become unfashionable period pieces. This rejection subsequently prepares them for later reappraisal, as seen in the revival of Victorian display types in the 1960s.

Display typography is as volatile as fashion. Like fashion collections, some typefaces are not designed for widespread use but are expressions of the speculative or the fantastic, while others reflect classic values and demonstrate a durability that transcends the season's trends. Neither is better; they are simply appropriate to different contexts.

DECORATIVE REVIVAL

Bifurcated serifs, scroll-work, and drop-shadows evoke the 19th-century setting of this novel in a cover design by Two Associates (right).

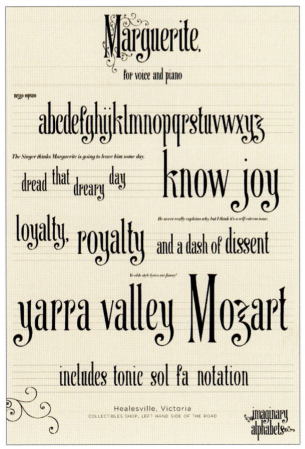

GILL FLORIATED

ABCDEFGHIJKLMNOP
QRSTUVWXYZ

ERIC GILL, 1937, 1995

Based on a single character drawn by Eric Gill as a decorated initial for a specimen setting of his Perpetua type, **Gill Floriated** is a rare example of an original early 20th-century ornamented face. Issued in 1937 for display casting, it was revived by Monotype in 1995 as a digital face. The floriated capitals are best used as dropped initials, and can be effectively combined with Perpetua. The typeface is limited by the absence of lowercase, accented characters, or figures.

THE TYPOGRAPHERS FIRST
DUTY IS TO THE TEXT ITSELF
AN INTELLIGENT
INTERPRETATION OF THE TEXT
WILL NOT ONLY ENSURE
READABILITY BUT WILL ALSO
REFLECT ITS TONE ITS

CASTELLAR

ABCDEFGHIJKLMNO
PQRSTUVWXYZ
1234567890 & ? (),:;'

JOHN PETERS 1957

Castellar is an "open" titling face of inline capitals, based upon the Scriptura Quadrata used in the first two centuries of the Roman Empire. It is a capital titling face with no lowercase, which can be particularly effective when combined with Humanist or Aldine text faces, but the limitations of the character set reduce the scope for its use.

THE TYPOGRAPHER'S FIRST
DUTY IS TO THE TEXT
ITSELF. AN INTELLIGENT
INTERPRETATION OF THE
TEXT WILL NOT ONLY
ENSURE READABILITY, BUT
WILL ALSO REFLECT ITS TONE,

KIM BUKER CHANSLER, CAROL TWOMBLY, CARL CROSSGROVE 1994

PEPPERWOOD

ABCDEFGHIJKLMNOPQRSTUVWXYZ

1234567890 &1? (),;;'

Designed for Adobe, **Pepperwood** draws upon late 19th-century wood-letter faces and the poster traditions associated with the American West. The letters are radically condensed and outlined, with decorative points at top and base and a jewel form at the center, reflecting ornamental Celtic letters from the 19th century. In an ingenious application of current technology to an historic idiom, the inner and outer forms are created as separate fonts, allowing for either to be used separately or for the two to be overlaid and independently colored.

THE TYPOGRAPHER'S FIRST DUTY IS TO THE TEXT ITSELF. AN INTELLIGENT INTERPRETATION OF THE TEXT WILL NOT ONLY ENSURE READABILITY, BUT WILL ALSO REFLECT ITS TONE, ITS STRUCTURE, AND ITS CULTURAL CONTEXT. THE TYPOGRAPHER'S ANALYSIS ILLUMINATES THE TEXT, LIKE THE MUSICIAN'S READING OF A SCORE.

GERT WEISCHER 1993

BODONI CLASSIC SHADOW

Weisher's **Bodoni Classic** collection is a large family of individual reinterpretations of Bodoni. Some of these echo or replicate decorative initials of Bodoni's time, while others are fanciful inventions. The decorative display faces include Bodoni Classic Bambus, Floral, and Shadow—a "Tuscan" with a bifurcated terminal. This is particularly reminiscent of the decorative letters of Bodoni's predecessor Fournier.

ABCDEFGHIJKLMN OPQRSTUVWXYZ

THE TYPOGRAPHERS FIRST DUTY IS TO THE TEXT ITSELF AN INTELLIGENT INTERPRETATION OF THE TEXT WILL NOT ONLY ENSURE

Beyond classification

An increasing number of typefaces resist categorization, either because they lack recognizable identifying characteristics or because they incorporate characteristics of more than one category. Some contemporary digital typefaces are designed to test the very limits of the term "typeface" in challenging accepted conventions of character recognition and legibility. The emergence of the experimental typeface, and of type design as a medium of creative inquiry, has produced a diversity of faces that may have limited application but serve to stimulate debate and challenge prevailing orthodoxies.

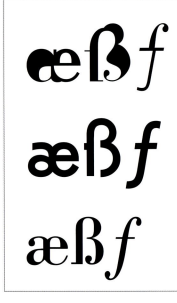

IRREVERENT HYBRID

Max Kisman's Fudoni (above) combines elements of two stylistically opposed and contrasting faces, Futura and Bodoni, in a face which resists conventional classification.

■ NEW TOOLS, NEW TYPES

The digital era has created the conditions for typeface design as an experimental or speculative medium, and for the release of typefaces designed to challenge conventional preconceptions rather than conforming to user expectations.

With the emergence of desktop font-design software in the 1990s, typographers discovered that they had new scope for the exploration of deconstructive postmodern ideas in typographic form. Even the fundamental classification of faces as either serif or sans serif was called into question; a typeface

such as Lance Hidy's Penumbra, for example, which was designed utilizing multiple master technology, offers a sliding scale of options within the face, ranging from sans to full serif.

■ HYBRIDIZED FACES

The 1990s also saw a number of hybridized faces, such as Max Kisman's Fudoni and Jonathan Barnbrook's Prototype, in which elements of two or more typefaces are combined. Both of these make use of revered canonical classic faces, Fudoni being a composite of Futura and Bodoni, and Prototype incorporating

CHARACTERISTIC FEATURES

INCONSISTENCY AND CONTRADICTION

This category of types (left) is defined by the absence of consistent defining features, but it is characterized by contradictory features, inconsistency of form, hybridization, and the abstraction of recognized letterforms.

DIGITAL FLEURONS

Marian Bantjes's Release Restraint (above) is described as an ornament font which happens to contain letterforms as well as "squiggly bits for making fantastic shapes and borders." The font may be used to create decorative surrounds to the letters, or wholly abstract patterns.

ECLECTIC HISTORICISM

Inspired by references from architecture, art, and type history, Jonathan Barnbrook and Marcus Leis Allion's Tourette (top right) is a playful postmodern face available in "normal" and "extreme" versions.

TYPE YOU CAN'T TRUST

Making subversive use of digital font technology, Just Van Rossum and Erik van Blokland originally programmed their controversial Beowolf and Beosans (right) to give unpredictable variations of form. Current releases offer more stablilized options.

elements of five traditional faces. They stand as a provocative demonstration of the potential of digital media to subvert preconceptions about typographic identity.

■ RESISTING CLASSIFICATION

Since the advent of digital media, the design of type has developed as a field of radical experimentation, a medium of creative play, and an expression of conceptual enquiry. It might be argued that the present conditions of digital type design make historical typographic classifications irrelevant.

Digitally designed faces may be defined by using the terminology of metal type, but explicitly contemporary typeface designs may draw freely upon a range of ideas and references, both from within type history and outside it. They may draw their inspiration from digital media rather than print; make a virtue of impermanence and unpredictability; and use deliberately playful or ironic allusions to the orthodoxies that they contradict.

Tijd @2009 Max Kisman
kismanstudio | Nieuwe Prinsengracht 39-4 | 1018 EG Amsterdam | 06 22 73 44 22 | maxk@kismanstudio.nl
Download gratis bij / free at: www.hollandfonts.com

PICTORIAL OVERPRINTS

This experimental typeface (above) revisits the Victorian "chromatic face," designed for two-color overprinting, and combines typographic and figurative elements in both of the fonts.

EMIGRE

Emigre, founded by Rudy Vanderlans and Zuzana Licko in 1984, began as an arts journal in the years immediately preceding the advent of digital media. As they developed its low-tech production methods to utilize early desktop-publishing technology, Licko's innovative work in the design of digital typefaces prompted the development of Emigre as a "foundry" for distribution of a new and distinctive generation of digital typefaces.

As a design journal, *Emigre* became a key focus of postmodern typographic discourse from the 1980s through to the end of the century, reflecting the influence of deconstruction and other aspects of postmodern critical theory upon a new generation of designers. Exploring the new capabilities of desktop design as a medium to critique the modernist values of the American design establishment, the large-format pages seldom conformed to a consistent grid and were frequently designed by their authors or a succession of innovative guest editors. As a forum for radical design ideas from leading American design schools including Cranbrook, Cal Arts, and Minneapolis Academy of Art, *Emigre* reflected the increasing engagement with critical theory that characterized much of the most innovative work of the period.

The increased accessibility of digital font-design software opened up a previously specialized field to a wider community of designers, and saw the emergence of typeface design as an experimental or polemical medium. Many of the designers who contributed to the journal also designed typefaces that were distributed as Emigre fonts. These included the work of Jeffrey Keedy, Ed Fella, Jonathan Barnbrook, and P. Scott Makela, as well as Licko's own increasingly influential types, which remained at the forefront of a medium that had been significantly redefined by her work.

Emigre ceased publication of its print journal in 2005 but continues to play an important role as an online resource as well as a leading type outlet. Combining within a single enterprise the production of typefaces and the dissemination of critical commentary, Emigre redefined the scope and possibility of the "foundry" for the digital age.

THE MAGAZINE AS FOUNDRY
*Current images from the Emigre website (right)
provide an update on recent developments and
faces that have become established favorites,
alongside critical writing and a growing range
of related merchandise.*

Mrs Eaves
A typeface designed by Zuzana Licko. *Introducing* Mrs Eaves XL Regular and XL Narrow. Licensed and distributed by Emigre.

ℍ𝕋𝔽 𝔉𝔢𝔱𝔦𝔰𝔥 𝟛𝟛𝟠

𝔄𝔅ℭ𝔇𝔈𝔉𝔊ℌ𝔍𝔍𝔎𝔏𝔐ℕ𝔒𝔓𝔔
ℜ𝔖𝔗𝔘𝔙𝔚𝔛𝔜ℨ
𝟙𝟚𝟛𝟜𝟝𝟞𝟟𝟠𝟡𝟘º & ? {},.:;'

JONATHAN HOEFLER 1995

Designed to parody the use of historical "fanciness," **HTF Fetish 338** is a deliberately eclectic display face that belongs to no single genre or category. The typeface evokes historical associations, but is in fact a synthesis of disparate styles, combining elements of Blackletter, Victorian, Byzantine, and Celtic. Though a fanciful invention, the resulting face has a balance and liveliness that equip it for a wider range of use than its experimental and argumentative origins might suggest.

THE TYPOGRAPHER'S FIRST DUTY IS TO THE TEXT ITSELF. AN INTELLIGENT INTERPRETATION OF THE TEXT WILL NOT ONLY ENSURE READABILITY, BUT WILL ALSO REFLECT ITS TONE, ITS STRUCTURE, AND ITS CULTURAL

P. SCOTT MAKELA 1990

Dead History

ABCDEFGHIJKLMNOPQ
RSTUVWXYZ
abcdefghijklmnopqrstuvwxyz
1234567890 & ? (),.:;'

Dead History is an example of the typeface as provocative gesture or polemic: a characteristically postmodern attack upon the reverence given to historical models and classification within type design. Juxtaposing a classic serif face with the mechanical face VAG Rounded, Makela deliberately undermined expectations of stylistic coherence. Like many experimental types from this period, its application is limited, but it functions well as a display face, ideally suited to expressing nonconformity and disregard for convention. It is available in two weights and includes a Cyrillic extension.

The typographer's first duty is to the text itself. An intelligent interpretation of the text will not only ensure readability, but will also reflect its tone, its structure, and its cultural context. The typographer's analysis illuminates the text, like the musician's

FF Fudoni

ABCDEFGHIJKLMNOPQ RSTUVWXYZ
abcdefghijklmnopqrstuvwxyz
1234567890 & ? (),:;'

FF Fudoni is a quintessentially unclassifiable typeface, being based upon a deliberate contradiction of typographic norms. It is composed of elements of two classic typefaces, Futura and Bodoni. To combine a 20th-century monoline sans and an 18th-century Didone might seem no more than a perverse joke, but the resulting face is colorful, irreverent, and witty. Fudoni exists in three versions: Fudoni One, Two, and Three. While these can be read as a range of weights, they also incorporate variations of form, combining elements of the two faces in different ways in each version.

The typographer's first duty is to the text itself. An intelligent interpretation of the text will not only ensure readability, but will also reflect its tone, its structure, and its cultural context. The typographer's analysis illuminates the text, like the musician's

PROTOTYPE

ABCDEFGHIJKLMNOPQ RSTUVWXYZ
1234567890 & ? (),:;'

Prototype is a unicase type which "samples" features from a range of classic serif and sans-serif faces. The rationalized single case references the "Universal" faces of Tschichold and Bayer, but addresses this concept from a characteristically postmodern perspective. The hybrid design evokes a variety of contradictory stylistic associations, while deliberately resisting all conventional classifications. The face includes a variant A designed for use at display sizes, and an alternate e.

THE TYPOGRAPHER'S FIRST DUTY IS TO THE TEXT ITSELF. AN INTELLIGENT INTERPRETATION OF THE TEXT WILL NOT ONLY ENSURE READABILITY, BUT WILL ALSO REFLECT ITS TONE, ITS STRUCTURE, AND ITS CULTURAL CONTEXT. THE TYPOGRAPHER'S

working with type

In talking about typography, we are talking
about the arrangement of positive shapes
from which we construct readable meanings.
Within these shapes, there is information about
the internal workings of language, about texts
and subtexts, about histories, systems, and cultures.
This discipline is an amalgam of several kinds of
knowledge. Effective typography depends as much
upon our awareness of design history as on a
mastery of technology, as much upon our
understanding of language as our sense
of visual aesthetics, and as much upon
problem analysis as upon creativity.
This chapter introduces the
terminology of typeface design,
the fundamentals of page layout,
the linguistic and grammatical
conventions of typographic usage,
and aspects of display, new media,
and environmental typography.

The typeface

The term "typeface" traditionally refers to any full set of standardized letterforms designed for reproduction through print. In recent years, this has also included faces designed specifically for digital screen use. Although the terms "typeface" and "font" are increasingly treated as interchangeable, a font is in fact one character-set comprising all uppercase and lowercase letters, numerals, and standard punctuation marks. A typeface may therefore include a number of separate fonts.

Æ æ
ß
Œ œ

COMBINED VOWELS
A digraph (above), also known as a digrave, is a single form that combines two vowel letters into a single form. Used largely for diphthongs —those letter pairs derived from classical Latin—the digraph denotes a phonetic value, whereas a ligature is designed to correct a visual inconsistency (see page 115).

■ FONTS WITHIN THE TYPEFACE

Typefaces designed for the setting of continuous text can be expected to include a regular or roman form, a bold, an italic, and a bold italic. Weights of type are normally described by the suffixes light, regular, and bold, but more extensive typefaces may include the more specialized designations demi, book, or semibold for intermediate weights; and extrabold, ultrabold, or black for weights darker than bold.

■ ITALICS

The relationships between the italic and the upright roman form vary considerably between one typeface and another. The idea that a typeface might include an italic form was not developed until the 16th century. The first italic types were designed as distinct alphabets; they showed a greater influence from handwritten script, and had a narrower set width.

Many 19th- and 20th-century typefaces in the Humanist or early Garalde idiom draw upon distinct but contemporary sources for their italics. By comparison, many sans-serif typefaces have an italic based upon an inclined version of the upright form. Notable exceptions can be found in the italic forms of Goudy Sans or the understated elegance of the Gill Sans italics, which show noticeable cursive characteristics despite their uniformity of stroke.

Although digital technology allows us to modify the angle of upright letters to create a false italic or oblique, this is no substitute for a true italic and should not be considered for professional work.

STRUCTURE AND CONTRAST
The four weights of Carol Twombly's Chaparral (below)—light, regular, semibold, and bold— reveal distinct characteristics of structure and contrast.

Light
Light Italic
Regular
Regular Italic
Semibold
Semibold Italic
Bold
Bold Italic

■ BOLD AND BOLD ITALIC

The idea that a typeface should include a bold version is primarily a product of the machine age. The development of mechanized typecasting and punchcutting allowed for the proliferation of bold types in the 19th century to be channeled into more systematic form, and it became a convention of 20th-century type production that faces were provided in a regular and bold version. The bold italic is a still later development, and has been an accepted requirement of type production only since the

20TH-CENTURY BOLD TYPE

*This specimen produced by the English
Monotype corporation in the 1930s to promote
Gill Sans (left) shows the development
of variant weights of type, in this case
a regular, bold, and light.*

COMPANION ITALIC

*Coordinating the design of the classic Aldine
Bembo for Monotype (below left), Stanley
Morison deliberated between two designs for
the companion italic, commissioning a new
letter from the calligrapher Alfred Fairbank
before substituting a revival based upon letters
by Giovanni Tagliente, which forms the basis
for the current digital version.*

CALLIGRAPHIC ITALIC

*Unlike the Grotesques and Geometrics,
the Humanist sans serif (below right) often
reflects calligraphic qualities in its italic letters,
which tend to be more distinct from the roman
in form and structure.*

THE GLYPH SET

The capacity of the first digital font was limited to
128 characters, then 256. Since the advent of Unicode
and OpenType it is now possible to contain several
thousand individual glyphs within a single font. Some
professional typesetting software includes a glyphs
window, which allows the user to view all the glyphs
in the font. This is invaluable in determining the
suitability of a typeface for a particular purpose.

In addition to the letters of the alphabet, ligatures,
diphthongs, figures, and punctuation marks, the
standard glyph set includes mathematical and scientific
symbols; printer's symbols such as the dagger, double
dagger, paragraph mark, and brace; currency symbols
for the major world currencies; and letters unique to
particular languages such as the Icelandic Thorn and
the German Eszett.

ABCDEFGHIJKLMNOPQRS
TUVWXYZ

abcdefghijklmnopqrstuvwxyz

*ABCDEFGHIJKLMNOPQRS
TUVWXYZ*

abcdefghijklmnopqrstuvwxyz

late 20th century. The bold and bold italic forms provided with historic typefaces are therefore a recent addition, achieved with varying degrees of sensitivity to the original.

The difference in weight between roman and bold varies considerably between one typeface and the next. Many recent adaptations of classic typefaces also include intermediate semibold weights.

■ TYPE FAMILIES

As well as including a number of fonts, a typeface may, in turn, belong to a larger type family, including condensed and extended versions and display faces. These are commonly seen as distinct but related faces. As a general but not universal rule, those variants that share a common width and proportion are seen as part of the same face, whereas related forms of differing width are more likely to be described as different faces within the same type family.

■ SUPERFAMILIES

The advent of Multiple Master technology and OpenType encryption has allowed for the development of "superfamilies," characterized by multiple weights and the inclusion of both serif and sans-serif versions within a common design.

WEIGHT AND WIDTH
The structure of Fred Lambert's Compacta (below) is such that its four weights are in effect also different widths.

REVIVAL FAMILY
Jonathan Hoefler's Knockout (bottom) is a colorful anthology of early 20th-century sans serifs, developed across a range of weights and widths. The letters vary noticeably in detail and are related more by their shared historical context than by a systematic principle or common structure.

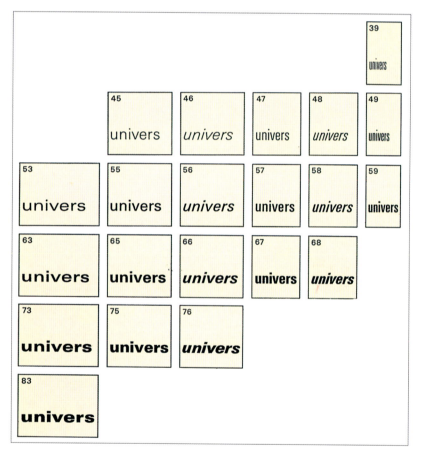

SYSTEMATIC APPROACH
Adrian Frutiger's Univers typeface (above) was conceived as a systematic family comprising an extended range of 21 weights and widths. These are identified by number.

Compacta light
Compacta roman
Compacta bold
Compacta black

Junior Flyweight Flyweight Full Flyweight Junior Bantamweight Bantamweight Full Bantamweight Junior Featherweight Featherweight Full Featherweight Junior Liteweight Liteweight Full Liteweight Junior Welterweight Welterweight Full Welterweight Ultimate Welterweight Junior Middleweight Middleweight Full Middleweight Ultimate Middleweight Junior Cruiserweight Cruiserweight Full Cruiserweight Ultimate Cruiserweight Junior Heaviweight Heaviweight Full Heaviweight Ultimate Heaviweight Junior Sumo Sumo Full Sumo Ultimate Sumo

DESCRIPTIVE LANGUAGE AND TERMINOLOGY

In order to make informed decisions in the observation, analysis, selection, and use of type, we need to understand something of the vocabulary used to describe it. This vocabulary reflects some 500 years of typographic history, and remains essential if we are to communicate observations, identify preferences, and provide accurate instructions in the use of type.

THE PARTS OF THE LETTER

An understanding of the letterform's basic anatomy (below and below left) allows us to describe its characteristics in detail and identify the defining features that distinguish one typeface from another. This provides the means for the recognition of typefaces and the vocabulary for describing their qualities.

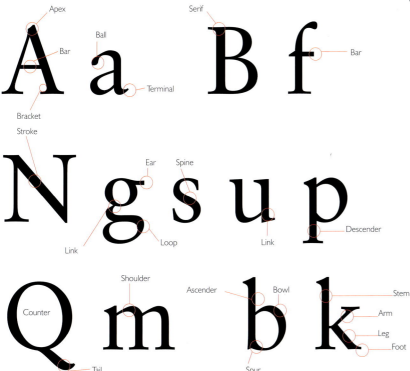

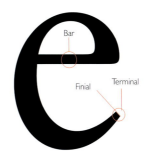

ASSIGNMENT
Select four typefaces, including both serif and sans serif, and set the same sentence in regular, italic, and bold. You may wish to use a pangram such as "The quick brown fox jumps over the lazy dog."

Study the differences between regular and italic. Study the differences between regular and bold. Compare the nature and extent of these differences in each face, and place the faces in order according to these characteristics:
• greatest contrast in form between regular and italic
• greatest contrast in weight between regular and bold

GLOSSARY
Font A single set of letters within a typeface
Italic Angled letters, originally based upon handwritten script
Lowercase Printer's term for "miniscule" letters, kept in a separate drawer or "case" of metal type
Mechanical typecasting Mechanical type production from the late 19th century
Punchcutting The traditional means of crafting type from the 5th to late 19th century
Typeface A set of standardized letters designed for mechanical or digital reproduction
Uppercase Printer's term for capital letters, kept in a separate drawer or "case" of metal type
Weight The thickness of stroke contributing to the boldness of the type

STRESS

The term "stress" is used to describe the angle of variation between thick and thin stroke width (below). It could be seen as equivalent to the angle at which the letterer or calligrapher holds a broad-edged pen or brush. Vertical or angled stresses are characteristic of certain categories of type. The move from an inclined to a vertical stress follows a steady historical progression from the Humanist types of the late 15th century, in which there is a pronounced inclined stress, to the Didones of the late 18th century, in which the stress is vertical.

COLOR

The term "color" describes both the tonal density and texture created by type when set as continuous running text upon the page (qualities also sometimes described in terms of gray value) and, more specifically, the degree of variation or contrast in weight between thick and thin strokes (see below). This variation ranges from monoline designs that have a consistent weight of line at all points, and thus minimal color, to the pronounced color resulting from the extremes of contrasting stroke width in the Didone faces of the late 18th century.

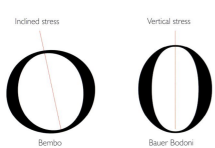

Inclined stress — Bembo

Vertical stress — Bauer Bodoni

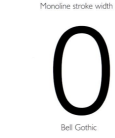

Monoline stroke width — Bell Gothic

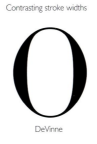

Contrasting stroke widths — DeVinne

Measurement

The size of type is measured in points. The historic differences between the European Didot system and the Anglo-American point system were effectively resolved in the decision by Adobe and Apple in 1985 to establish a point size of exactly $\frac{1}{72}$ in for the Adobe page-description language PostScript. This corresponds to the AppleMac screen, which has a resolution of 72 pixels to the inch.

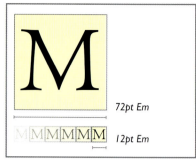

72pt Em

12pt Em

THE EM

The em (above) is a variable square measurement, equal in width to the body size of the type. An em in 72pt type is 72 points wide; an em in 12pt type is 12 points wide.

■ TYPE SIZE

Like most type terminology, the point system reflects the traditions of hand-set metal type. Point size originally referred to the size of the 'body' upon which the letterform was cast. This body was high enough to accommodate both the highest ascender and the deepest descender, and to leave some additional body clearance necessary to prevent ascenders and descenders from touching. For this reason, a 12-point (12pt) capital letter is not, in fact, 12 points in height. In addition, some typefaces may appear considerably larger than in others of the same point size, due to differences in x-height, body clearance and the relationship of ascender to cap height (for explanations of x-height and cap height, see diagrams opposite).

■ LEADING

As well as describing the size of type, the point system is used to specify the depth of space between lines (sometimes known as the pitch or line feed). Originally referring to the strips of lead inserted between lines of type, 'leading' is a term used to describe the measurement in points from one baseline to the next (see diagram opposite). This allows for both type size and leading to be combined within a single concise specification – for instance, 12pt type on 18pt leading, sometimes abbreviated to 12/18. This may also be described as 6pt leaded, referring to the amount of additional leading that has been used. Type set with no additional leading is described as 'set solid'.

Digital and photoset type may be set with less space between lines than would be created by the body height of the letters; this is described as 'minus leading'. When type is minus-leaded, ascenders and descenders may touch or overlap. Minus leading is therefore normally only used in display setting where individual adjustments can be made. It is specified in the same way as for normal text, but in these cases the leading will be less than the type size – 12/10 or 12/8, for example.

■ LINE MEASURE

The point system can also be used to specify line measure: the column width, or the maximum length of a line of type. This length is commonly expressed using the 'pica', a measurement of 12 points, or one sixth of an inch, also sometimes referred to as a pica em. While it is now increasingly common for column widths to be expressed in millimetres, pica ems remain in use as a system of line measure. The term 'cicero' was used to denote a 12-point measurement under the European Didot system and continues to be used in parts of Europe as an equivalent to the pica em.

■ VARIABLES – THE EM AND THE EN

The point and the 12-point pica are absolute measurements. When describing the measurements of the letter itself, it is necessary to use a relative or proportional measurement that can be applied to all sizes. Based upon the square proportions of a classical capital M, the em is a square measurement, equal in width to the body size of the type. This means that a 72pt em, for example, is 72 points in width; a 12pt em is 12 points in width.

Both the em (a measure equal to the body height) and the en (a measure that is half the body height) are used to describe the width of dashes and spaces.

■ THE UNIT

In order to specify in detail the individual widths of letters and the spaces between them, the em is subdivided into units. Until relatively recently, it was common for this to be expressed through division of the em into anything between 18 and 64 units. However, current PostScript technology uses a division of 1,000, giving 1,000 units to the em. This provides a means of accurately specifying the width of the letter and the inbuilt space or 'sidebearing' at its sides. These can be increased or decreased throughout the body of the text – through what is known as letter spacing – or adjusted between individual letters, by means of a process known as kerning (see page 112).

Like the em, the unit is not a fixed measure, but a proportional measurement derived from the size of the type used – 10pt type, for example, is measured in units of 1,000th of 10 points; 36pt type in units of 1,000th of 36 points. Any adjustment to unit values can therefore be applied consistently across a range of type sizes.

Letter spacing adjustments are specified in different ways by different typesetting systems, but the 1,000-unit em has allowed for unprecedented precision in the adjustment of letter spacing, kerning and word spacing.

X-HEIGHT

The "x-height" (left) refers to the height of the top of the lowercase letters—specifically, the height of the lowercase x. A typeface with a higher x-height and shorter ascenders provides for larger lowercase letters in relation to the body size and cap height.

CAP HEIGHT

The term "cap height" (left) refers to the height of the uppercase letters, which is frequently a little lower than the full height of the ascenders.

BASELINE

The baseline (left) is the line upon which the bases of the letters sit. Descenders will therefore extend below the baseline.

THE UNIT IN GLYPH MEASUREMENT

This letter has been drawn in professional font-creation software (above), which shows detailed measurements of the letter width and the sidebearings. These are expressed in units of 1/1000 of an em.

MINUS LEADING

In this image (right), the type has been "minus-leaded" with the leading set to a depth of fewer points than the type size.

VARYING THE LEADING

Adjustments to leading (right) will increase or reduce the amount of interlinear white space, and determine the density or texture of the print upon the page.

THE BODY

The point size describes the size of the body (right) upon which the type was cast—a height incorporating the tallest and deepest elements of letters in the font. Within this overall height a typeface will have a consistent baseline, x-height, and cap height.

9/10pt

As well as describing the size of type, the point system is used to specify the depth of space between lines. "Leading" is a term used to describe the measurement in points from one baseline to the next. This allows for both type size and leading to be combined within a single concise specification.

9/14pt

As well as describing the size of type, the point system is used to specify the depth of space between lines. "Leading" is a term used to describe the measurement in points from one baseline to the next. This allows for both type size and leading to be combined within a single concise specification.

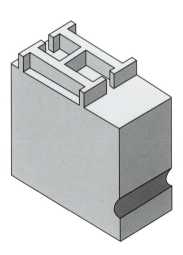

Brawer Architects & Hauptman

GLOSSARY

Anglo-American system American system of point measurement determined by the American Typefounders Association in 1886 at 72.27000072 to the inch

Ascender The part of some lowercase letters that extends above the x-height

Body height The overall height of the font, including descenders and ascenders

Cicero A European term for a 12-point unit, equivalent to a pica em

Descender The part of some lowercase letters that extends below the baseline

Didot system The European system of point measurement originated around 1770 by Firmin Didot at 67.55818249 to the inch

Em A relative or proportional horizontal measure equal to the body height of the type

En A measure that is half the length of an em, thus half the height of the body height of the type

Line measure The width of a column, determining the number of characters to the line

Pica (or pica em) A measurement of 12 points

Point The unit for measurement of type, now standardized at $1/72$in

Unit A division of the em into 1,000

Typographic space

Balanced and harmonious typesetting depends not only upon the design of the letterforms but also on the spaces between them. Professional typesetting programs allow the designer to make detailed adjustments to the space between letters, through letter spacing and kerning. The term "letter spacing" refers to modification of intercharacter space applied over an entire text, whereas the term "kerning" refers to separate adjustments in the spaces between individual pairs of letters.

KERN PAIRS

The pairing of certain letters (above) creates disproportionate amounts of white space between them, requiring the introduction of programmed kerning pairs in the design of the typeface. This process automatically introduces special adjustments to the sidebearings each time the pairing of these letters occurs in the text.

■ LETTER SPACING

Adjustments to letter spacing may be made necessary by a number of factors. Some typefaces tend to lose clarity of intercharacter space at smaller sizes, and an increase in the space around letters may make their form more easily readable. At larger sizes, the intervals between letters may be made more harmonious by a reduction in the spaces between them. Where whole words or sentences have been set in capitals, additional letter spacing is often necessary for optical balance and readability. Adjustments to letter spacing can radically alter the appearance of a body of text and the performance of a typeface, so they should be applied consistently throughout a document.

■ KERNING

The design of text faces incorporates automated adjustments to the spacing of particular letter pairs that would otherwise create disproportionate spaces: VA and Ta, for example. These are known as "kerning pairs." The attention to detail in the design of kerning pairs within a font is a characteristic of professional-quality typefaces. The necessity for kerning varies widely according to the stylistic qualities of the typeface. A monospace typeface, in which every letter is designed to sit upon a consistent body width, involves no kerning at all, whereas the digitization or adaptation of classic serif typefaces may require a great deal of kern adjustment and therefore a large number of kern pairs. Effective kerning ensures a consistent rhythm of intercharacter space, which enhances legibility and readability.

■ MANUAL KERNING

Manual kerning is the adjustment of individual intercharacter spaces to achieve a more consistently balanced spacing. Display type and titling, in particular, often benefit from the manual kerning of specific letter pairs. However, it would be impractical to apply this process to continuous text.

■ WORD SPACING

The space between words has traditionally been based upon a space equivalent to the body width of a lowercase i, or the interior counterform

SPACING FOR LEGIBILITY

The word spacing in the first example (below) has been reduced to the point at which differentiation becomes difficult but is still distinct. The middle example suits the width and openness of the type, while the lower is too wide, and interrupts the continuity of the text.

The spaces between letterforms contribute to balanced and harmonious typesetting. The majority of digital typefaces are designed with generous space between words, and the appearance and readability of text can in many cases be improved by adjusting the word spacing to give greater continuity and less interruption to the flow of the sentence.

The spaces between letterforms contribute to balanced and harmonious typesetting. The majority of digital typefaces are designed with generous space between words, and the appearance and readability of text can in many cases be improved by adjusting the word spacing to give greater continuity and less interruption to the flow of the sentence.

The spaces between letterforms contribute to balanced and harmonious typesetting. The majority of digital typefaces are designed with generous space between words, and the readability of text can in many cases be improved by adjusting the word spacing to give greater continuity and less interruption to the flow of the sentence.

of a lowercase n. This space can be adjusted manually for display and title setting. In text setting, it can be specified either as a constant—in the case of flush, or ranged, type—or as a maximum and minimum—in the case of justified type. The majority of digital typefaces are designed with generous space between words, and the appearance and readability of text can in many cases be improved by reducing the word spacing, giving greater continuity and less interruption to the flow of the sentence.

ZOOLOGY ZOOLOGY

Typography

INCREASED LETTER SPACE

Increasing the letter spacing (left) serves to balance the irregularities of a Geometric face and the otherwise intrusive effect of the large counter of the circular O.

DECREASED LETTER SPACE

When using text faces at display size (left), reducing letter spacing improves cohesion and visual unity.

ASSIGNMENT

The following words each contain typical kern pairs—combinations of letters that require special adjustment when they occur together. Some typefaces are fully programmed to make these adjustments.

AVARICE

ZOOLOGY

HALVAH

Talkative

Set these words in at least ten different typefaces on your system, and compare the extent to which the space has been balanced around the letter pairs AV, VA, OO, LV, Ta, and ve.

LIGATURES

A ligature is a single glyph incorporating two or more letters that might otherwise touch or overlap. Ligatures can benefit the evenness of letter spacing and avoid the unsightly collision of overhanging letters (typically the combinations ff, fl, fi, ffl, ffi). This typographic refinement can be seen in the earliest printed books, and continues to be incorporated within professional-quality typefaces. While successive phases of mechanical typesetting reduced the use of ligatures up to the late 20th century, digital type design has allowed for the design of typefaces with far more extensive ligature sets.

STANDARD LIGATURES

Many serif text typefaces incorporate a small number of standard ligatures. Most common among these are the f ligatures. These address the problems caused by the overhanging drop of the lowercase f when followed by i, l, or f—fi, fl, ffi, or ffl (sometimes also including the less common fj). These ligatures are included in many serif faces and also in those sans serifs with significant overhang to the f. However, some typefaces do not require ligatures at all because their letterforms have been designed to minimize the problems that make ligatures necessary.

ARCHAIC LIGATURES

Some specialist revival typefaces include a number of additional ligatures that join consonants, such as ct and st (above). These were in common use in printing up to the 18th century and would now normally only be used in instances where reference is being made to an appropriate historical period.

GLOSSARY

Counter The enclosed space within some letters

Kerning Adjustment to the space between particular pairs of letters

Kern pair Any pairing of letters requiring adjustment to the space other than that provided by their normal sidebearings

Letter spacing The overall amount of spacing between letters within a text

Monospace A typeface with no variation of body width, in which all letters are set upon an identical body width

Sidebearing The clearance space on each side of the letter

DISPLAY LIGATURES

Zuzana Licko's Mrs Eaves (above) is inspired by the types of John Baskerville, but includes a unique and inventive set of capital ligatures for display use.

SPECIAL LIGATURES

Some typefaces include a large range of ligatures, in a few instances dedicating entire fonts to them, as in Jonathan Hoefler's Hoefler Requiem (above), in which the italic requires ligatures of three and four letters.

Special features

Professional-quality typefaces are distinguished by the extent of the additional typographic features they offer, beyond the standard glyph set. These may include expert sets containing small caps and non-lining figures, and a range of other specialist glyphs. They may also offer optical sizing or display variants.

COMPARING SMALL CAPS
The comparison between these two examples (right) reveals the shortcomings of "false" small caps. The false version (below) shows less harmonious character spacing and an unacceptable variation in stroke width.

■ SMALL CAPS

The substitution of a smaller size of capital letterform in place of lowercase letters is an established typographic tradition, perhaps most commonly associated with chapter openings. Small-capital letters may be used for emphasis, differentiation, or in subtitles and running heads, where clean horizontals may be preferable to the irregular shapes created by ascenders and descenders.

Many high-quality text typefaces include a small-cap font, created specifically for this purpose. Their weight, color, and stroke width correspond to that of the full caps, while their proportions are usually wider, corresponding more closely to those of the lowercase letter. The sidebearings are more generous, and are designed to give balanced character spacing between capital forms. By comparison, words and phrases set using ordinary capital forms generally require both general letter spacing and specific kerning adjustment to spacing.

Prior to the introduction of OpenType, small caps required a separate font, often described as an expert set and usually also including non-lining figures. Unicode encryption now allows for a full set of small caps to be included within the main font.

■ "FALSE" SMALL CAPS

Professional typesetting software allows the designer automatically to create an inferior version of small-cap setting, through the crude substitution of capitals of a smaller point size. The visual shortcomings of this process serve to demonstrate the importance of a well-designed small-cap font. The false small caps substituted in this way will be lighter in weight and stroke width, and will lack the considerations of set width, letter spacing, and kerning that characterize the well-designed small-cap font.

It must be noted that this is no substitute for a true small-cap font and should not be considered for professional work. If small caps are to be used, it is necessary to select a typeface which provides them.

■ OLD-STYLE NUMERALS

The small-cap font or expert set usually also contains Old-Style numerals, also known as non-lining figures. They might usefully be described as lowercase numerals, because the forms align to the x-height rather than the cap height of the face, and have ascending and descending strokes.

They are particularly valuable in those instances where there is a large amount of numerical information within the running text.

Standard "lining" numerals that correspond to the cap height may create an unintended visual emphasis, equivalent to that which occurs when a word is set in capitals. This interrupts the visual consistency of the text and the ease of reading. By comparison, Old-Style numerals correspond to the profiles and proportions of lowercase letters, and are therefore better integrated within running text.

ORNAMENTS, FLEURONS, AND DINGBATS

Some typefaces also include ornamental or pictorial glyphs, either as additional features or in the form of whole fonts. Many of these are adaptations of historical decorative forms, referred to as "fleurons" or "printers' flowers." These may be used as paragraph markers and for text endings, or as continuous decorative borders or fields of repeated pattern. Fonts are also available that are designed specifically to create borders and frames.

Some non-alphabetic fonts are not specific to any typeface or typographic genre, but are freestanding miscellanies including both functional and ornamental elements. These are commonly known as dingbats or wingdings.

Some non-alphabetical fonts are designed for more specific informational use, including cartographic and scientific functions.

SMALL CAPS

SMALL CAPS

Starts at 18.45 and ends at 21.15

Statistical data
1. 26.01
2. 17.11
3. 10.07
4. 19.52

CHOOSING THE RIGHT SETTING
Proportional setting (upper example, left) gives a balanced distribution of space between numerals, and should be adopted where figures occur in running text. Tabular setting (lower example, left) provides a consistent vertical alignment of figures, which may be required for tables, statistics, and financial data.

■ TABULAR AND PROPORTIONAL SETTING

Professional software allows the designer to specify the manner in which figures (numerals) are spaced. Proportional spacing applies individually specified sidebearings to provide a visually harmonious space between numerals, and should be used whenever numbers occur within running text. Tabular spacing places each figure within a single monospace width. This should be used in all cases where columns of numerals are to be read vertically, such as tables, numerical charts, and statistical and financial information.

■ FRACTIONS

Professional-quality typefaces make specific provision for the setting of fractions. Earlier digital-font technology involved designing a necessarily limited number of specific glyphs for common fractions such as ½, ¼. Improved encryption has allowed for the design of larger numbers of fractions, or for the font to automatically generate visually balanced "arbitrary" fractions from subscript and superscript figures. These are automated, and are inserted by the software in response to the relevant sequence of keystrokes, such as 1 + forward slash 2.

■ SWASH CHARACTERS

Some typefaces include fonts of swash characters, most commonly as variants of the italic font. These are letters of greater decorative extravagance than those of the main face, and are designed for selective use. They may be used in titling and display, or as initial capitals to identify the beginning of a section of text. A swash font may also incorporate alternate lowercase letters such as enders.

MULTIPLE VARIANTS
A selection (above) from the extended range of 58 ampersands that are available in Robert Slimbach's Poetica.

GLOSSARY
Glyph A term used to describe any graphic form within a digital font that can be accessed by specific keystrokes
Latin Term used to describe the Western alphabet
Ligature A composite glyph in which two or more characters are combined in a single form to improve spacing and avoid the overlap of overhanging elements
Script In this context, the term used to describe different alphabets and writing systems

Some fonts can automatically generate unusual fractions as in, for example, 99⅞

AUTOMATED FRACTIONS
Professional-quality typefaces will generate unusual or "arbitrary" fractions (left) in response to keystrokes, substituting small superscript and subscript numerals as required.

SWASH ALTERNATES
Typefaces that are derived from calligraphic forms (above) offer particular scope for the design of swash alternates, adding color and variety and offering the designer an extended range of choices.

OPTICAL SIZING

Prior to the late 19th century, all type was cast from hand-cut punches, and a separate set of punches was created for each size. This allowed the punchcutter to make adjustments of weight and contrast to ensure that the smaller letters were more robust, while ensuring sharp definition and contrast in the smaller sizes. Mechanical composition and, later, photosetting have diminished these distinctions.

The most recent phase of digital type design—in which the storage capacity of OpenType provides for different versions of a face to be designed for use at different sizes—has seen the reintroduction of such adjustments of contrast and weight. These may be defined by use—as caption, subhead, and display fonts—or by recommended size. Optical sizing is particularly valuable in faces with a very high contrast and is beautifully demonstrated in Jonathan Hoefler's HTF Didot or Robert Slimbach's Warnock Pro.

OTHER ALPHABETS

Beyond the Western or "Latin" alphabet, the typographer may well need to set in other alphabets or "scripts." Digital technology has led to major improvements in the availability of compatible alphabets for other languages. In the past, the Greek or Cyrillic versions—or "extensions" of established typefaces—were often designed later and independently of the original design, with varying results.

The development of Unicode and OpenType has created the conditions for a more integrated approach, allowing the incorporation of multiple alphabets or scripts within a single font. The Adobe Pro fonts and the Microsoft Cleartype project provide examples of a growing trend toward designing companion Greek and Cyrillic letters as an integral part of the font design, rather than a retrospective extension.

In addition, some typefaces offer Greek in the more complex polytonic form ("polytonic" refers to a form of Greek type using a more complex system of diacritics to indicate tonal values in pronunciation). Hebrew, Arabic, Japanese, and Chinese types are more distinct in structure and are seldom conceived in terms of direct equivalence to existing Latin faces. If, however, they are to be used alongside Latin types, it will be necessary to consider how well their tonal values harmonize or complement one another.

CONTEXTUAL ALTERNATES

Many key features of professional-quality typefaces are made possible by the principle of contextual alternates. A contextual alternate is a special glyph activated by a particular sequence of keystrokes. This principle is routinely used to automate the insertion of standard and non-standard ligatures; in recent years, however, type designers have begun to explore it as a creative tool. Contextual alternates allow the designer to extend the glyph set to include multiple letter variants, characteristic of calligraphy and display lettering traditions.

Typography
книгопечатание
τυπογραφία

INTEGRATED ALPHABETS

John Hudson's Constantia (above), designed for the Microsoft Cleartype project, is a serif face for use in e-journals. Like all of the Cleartype collection, it includes both Greek and Cyrillic in the main character set.

Caption
Regular
Subhead
Display

RETAINING FORM AND CONTRAST

The four optical sizes of Robert Slimbach's Warnock Pro (above) are designed for use at different sizes, ensuring robust form at the smallest caption size and high contrast in display use.

The typographer's first duty is to the text itself. An intelligent interpretation of the text will not only ensure readability, but will also reflect its tone, its structure and its cultural context. The typographer's analysis illuminates

إن النص هو على الأول والحروف فمنهم دضم بجاو نإ
نفسه. ذ كي وتفسير النص ليس
فقط طقم ضمان سهولة القراءة، ولكن
أيضا تعكس لهجته، اها ويهكلاها
وسياقها الثقافي. فيفاقثلا اةاقايسو
تحليل يني ريـ

CROSS-CULTURAL TYPE

The award-winning Palatino Arabic (above) is the result of a collaboration between the celebrated type designer Hermann Zapf and Arabic type specialist Nadine Chahine.

ASSIGNMENT

Devise a short text that includes the use of small capitals, numerals, and non-standard fractions.

Set this text in at least four different typefaces, then compare the provision of small caps, non-lining figures, arbitrary fractions, and tabular spacing.

Evaluate and grade the quality of provision offered by each typeface.

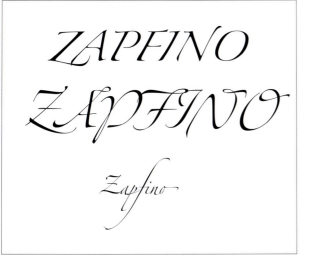

CALLIGRAPHIC VARIATIONS

Herman Zapf's Zapfino includes a wide range of variant letterforms; in the OpenType version, Zapfino Forte (left), these can be automatically activated as contextual alternates.

BEGINNERS AND ENDERS

Robert Slimbach's Brioso (left) includes both "beginner" and "ender" variants for use at the beginning and end of words. In fully automated faces, these are activated by keying the letter in combination with a wordspace.

Swashes are letters of greater decorative extravagance than those of the main face. A swash font may incorporate lower-case 'beginners' and 'enders'

Það
Łodz
Dzięcukję
Piñata
Māori
Măr
Sėkmės!
Skål!
Barça
Felőled
Háček.

DIACRITICS AND SPECIAL GLYPHS

The term "diacritic" refers to any form added to a letter to signal a specific pronunciation peculiar to a language or group of languages. It includes accents and other phonetic marks. Several of the languages that use the European Latin alphabet still employ unique diacritics (accent marks) and additional letters not found in English. Icelandic retains the Thorn and German the Eszett, both of which are standard features of most professional-quality text faces. Polish and Hungarian are notable for using diacritics that do not occur in other languages. In the past, support for some minority languages required different versions of the font. However, improvements in encryption and font capacity have prompted more extensive pan-European glyph sets.

Selecting type

When selecting type for the setting of continuous text it is necessary to look beyond the appearance of individual letters, and consider instead the appearance the face offers when viewed as paragraphs and columns of text. It is also important to consider the extent and functionality of the typeface or type family.

◼ ASSESSING TYPE

Viewing the form of the letters will not tell us how a typeface functions. It tells us how the letters look, but not how they work. Typeface design is the design not only of forms but also of capabilities, and informed typeface choice depends not simply upon how type looks but also on how it can serve the designer's purpose.

The most important question at this stage is not "What kind of letter do I like?" but "What do I want the type to do?"

Numerals If there are to be numerals within running text, the face should include non-lining Old-Style figures.

Italics If italics are to be used extensively, you should consider the quality of the italics and how well they harmonize with the roman.

Fractions For a job that includes fractions, assess the range of designed fractions or the quality with which automated fractions are generated by the font.

Foreign language Text that includes another language requires a face that offers special diacritics or additional glyphs necessary for that language.

Multiple functions For a job that involves multiple kinds of information within the page—titling, text, secondary texts or commentaries, subheads, running heads, captions, footnotes—look at the scope a typeface offers for differentiating these visually, through the use of different weights and widths, italics and small caps, or other means of variation.

All of these are crucial considerations in selecting a text typeface, and are not apparent from simple observation of a single alphabet in the regular weight. Some professional typesetting software includes a glyphs window, which allows the user to view all the glyphs in the font. This facility is invaluable in determining the suitability of a typeface for a particular purpose.

◼ RANGE OF FONTS

Professional-quality text typefaces vary widely in the number of fonts they contain, from a working minimum of four fonts to thirty or more. The bare minimum of a regular, bold, italic, and bold italic font may be perfectly adequate for simple texts, but may require pairing with a well-considered companion face for subhead and titling purposes, or for differentiating textual content. Typefaces with multiple weights, optical sizing, and other forms of variation within their range of fonts offer the designer a wider palette of forms, weight, and contrast.

◼ WEIGHTS

The range of weights within a typeface will have a crucial effect upon both its functionality and the creative possibilities it offers. A typeface with a single weight offers no scope for the use of a bolder form to create emphasis or differentiation. Similarly, a typeface with only a regular and bold still gives only limited scope. A face that includes light, semibold, and extra bold (or black) provides a wider palette of tonal possibility and the scope for the more detailed differentiation of content.

When evaluating a typeface for text setting, it is important to consider the relationship between the regular font and other weights. Different types offer different intervals of contrast between weights—in some the difference is pronounced and dramatic, while in others it is more subtle and restrained.

As the idea of a family of weights is a relatively recent one, any typeface originating before the late 19th century will have had its bold version designed later than the original, with results of varying quality. This is an area where more literal-minded revivals of historic typefaces may be less satisfactory in use than freer contemporary adaptations.

◼ EFFICIENCY AND ECONOMY

The number of readable words that can be set in a given type area will be determined by the legibility of the face. It is important to remember that the legibility of type is determined by character recognition and effective differentiation between characters. For this reason, typefaces that may appear clear or uncomplicated—such as Geometric sans serifs—are actually less efficient for text setting, and serif faces remain the preferred choice for long texts and immersed reading.

Typefaces with a higher x-height give larger lowercase letters and thus appear more legible, but this may also create a wider set that allows fewer letters to the line. High x-heights also have the effect of reducing the amount of white space between lines and diminish the recognition of ascenders and descenders.

◼ LEGIBILITY

The analysis of legibility involves a range of perspectives and methodologies. While any of these may be relevant to particular contexts, it remains a study that resists absolute rules or categorical statements. For most experienced designers, legibility is addressed intuitively or,

WHAT IS LEGIBILITY?

Legibility is probably best viewed as a body of knowledge, research, and opinion to which designers refer selectively, rather than a subject governed by any single unified theory or categorical law. There is a range of provisional truths, but the designer's own response to the text may still be the best point of reference. It is useful, however, to keep the following points in mind:

■ Typefaces with a high x-height have a larger lowercase letter, and will therefore appear larger and more legible for their size.

■ Ascenders and descenders aid character recognition and differentiation, and are therefore a key feature in the legibility of a typeface.

■ Lower and more clearly defined junctions (as in the join of the stem to the curve of a lowercase n) will aid legibility. Open and well-defined counters are a characteristic of the most legible typefaces.

LEGIBILITY AND ECONOMY
Variations in x-height and body clearance (right) mean that some types appear considerably smaller than others when set at the same point size. Weight and contrast will determine the density and readablility of the paragraph or page. The clarity and prominence of each letter's identifying features will determine the legibility of the face for continuous text.

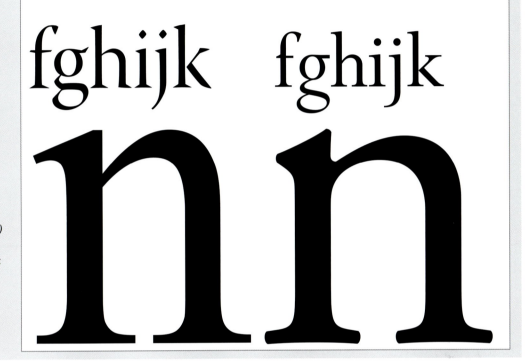

Legibility is probably best viewed as a body of knowledge, research, and opinion to which designers refer selectively, rather than a subject governed by any single unified theory or categorical law.

Legibility is probably best viewed as a body of knowledge, research, and opinion to which designers refer selectively, rather than a subject governed by any single unified theory or categorical law

EXTENDED WEIGHT FAMILIES
The six weights of Helvetica Neue (left) are a latter-day development designed to enhance the original design, providing the designer with an extended palette of tonal possibility for differentiating typographic information and creating visual emphasis.

ritchie

"we must define what is beautiful and what is a work of art."

duchamp

"we aren't dealing with any absolutes, are we, in this life?"

work of art. We are right back where we are started from and we must define what is beautiful and what is a work of art."

WRIGHT: "Then we arrive at the conclusion that the only man who can define it is the man for himself, and not for anybody else."

DUCHAMP: "We aren't dealing with any absolutes, are we, in this life? We are dealing only with that which is in motion, not which is an absolute and fixed..."

MODERATOR BOAS: "Well, of course, even though these things change from age to age, Mr. Wright may be quite right in saying, in each age, the artist is seeking the beautiful."

BATESON: "There are many cultures that classify together the two extreme ends of the sacred-secular scale. The word 'sacer' in Latin, from which we get our word 'sacred', is a word for the extremely beautiful and desirable end of the magical scale. In contrast, there is a middle range of that, which is secular, which is everyday,

which is normal. And at the other extreme, you come again to the 'sacer,' the sacred, which is the supernatural and horrible."

"Now it seems to me that art is very much concerned with both ends of that scale.

"In conversation last night, Mr. Wright, we agreed that love and hate are very closely mixed emotions – or, especially, love and anger, perhaps. Now that means the artist is not, in fact, out to destroy love; he has got to accept the facts of hate as well as the facts of love."

WRIGHT: "... I think the expression of hate, as tragedy, could be beautiful, as Hamlet was."

SCIENCE AND ART
WRIGHT: "May I say here that a scientist *cannot* see this innate thing. That's what sets the scientist apart from the creative artist. Now these twain some day shall meet, but not for centuries... The scientist... is the enemy at

the present time of all the artist would represent... The scientist doesn't mean to be that enemy. He thinks he is benefactor... Religion by way of science has virtually disappeared so far as real vitality is concerned... Artists have all been 'had' by science and education... we have tried to substitute sanitation for civilization. Our redemption does not lie in the hands of scientists, because they can only give us tools in a tool-box; the scientist gives us magnificent tools, but he can't tell us what to do with them or how to do what we most need.

MODERATOR BOAS: "What do you say for your craft, Mr. Bateson, after that?"

BATESON: "I would say, first of all, that I think Mr. Wright is referring to a scientific epoch which was wholly materialistic. It was concerned with causal sequences in straight lines – A sets of B, B sets of C. In such a system, I could manipulate you and you will manipulate somebody else... That scientific epoch is, I think, very rapidly coming to an end.

"Mr. Duchamp's position, for example, is one which recognizes the phenomena of circular causal systems – most of the circle being inaccessible to us. In such a system, there is not the opportunity of manipulation because we are *inside* the system."

WRIGHT: "That is altogether too dramatic a figure... You miss the new romance as a scientist would – as he would himself have to miss it... But he would become a much greater scientist if he *would* get inside and see from the inside outward, rather than from the outside inward. And right there is the difference, I think, very nearly expressed between what I would call the creative artist and the scientist. The creative artist is, by nature, inside the thing and his vision outward. The scientist is outside looking in, trying to take the thing apart to see what makes it click. And he would fail to put it together again, were he to try."

BATESON: "No, the scientist is not outside... The scientist is part of the thing which he studies, as much as the

artist. And it is that move – the discovery that the observer is a significant part of the thing observed – that marks the change of epoch."

ART AND ARTIST

ART IN A CHANGING CULTURE
BATESON: "Looking at these pictures [exhibition of modern art selected for the symposium], I see a culture in a state of change – changing its very deep premises. If you take the Villon... What he has done is to say something like this: 'Cartesian coordinates, perspective – hm' and then he has put this free-flowing line on top of them, to say: 'yes but –, as against those rigid coordinates, the point can still go for a walk.'

"All right, he has stated a protest against the rigidities of twentieth century science which come into the culture via the rectangularity of every room we sit in, and so on. All those coercions are essentially *static* coercions, and the Villon, the Matta, the Surrealist Ernst, the Duchamp 'Nude,' this Mondrian which flickers – all are making statements about process, movement, and dynamics. I think there is an extraordinary uniformity actually in what these people are trying to put down. And it is a strife with a large number of fronts, fighting all sorts of battles in different directions, but with a common theme that we are not going to be coerced in certain forms.

"Now... if you consider a thing like the famous picture of Ophelia – is it Burne-Jones? – with green weeds and flowers on her nose. That picture, or the artist when he makes the picture, says essentially: 'If you have tears to shed, prepare to shed them now!' – To quote Mark Anthony, and Mark Anthony was a sentimental fake too. And the position of the modern artist, as I see it as an anthropologist, is a shift in our notions of human relations in which we refuse to accept that sort of coercion and are reverting to something much closer to Greek tragedy. Greek tragedy does not say: 'If you have tears to shed,

wright

"the creative artist is, by nature, inside the thing and his vision outward."

TWO-COLUMN GRID

A simple two-column page structure is frequently the most appropriate solution in pages of medium format, since it allows for an appropriate and readable measure of words per line at a practical point size. This page spread (left) provides open space for the dramatic use of "pull-quotes" enlarged from the main text.

READABLE LINES

A single column of 10 words in width is easier to read than two columns of 5 words. Fewer line breaks also make for a more economical use of space (below).

The analysis of legibility involves a range of perspectives and methodologies. While any of these may be relevant to particular contexts, it remains a study that resists absolute rules or categorical statements. For most experienced designers, legibility is addressed intuitively or, more accurately, through accumulated knowledge and experience.

Legibility depends upon the ease with which the eye can identify letters, and distinguish them from one another. It therefore depends as much upon the relationship of letters within the font as upon the design of the individual letterforms. An i that might appear perfectly legible when viewed in isolation will be compromised if the j is insufficiently differentiated from it. A Geometric lowercase d appears highly legible until one considers how easily it may be mistaken for an o tight-spaced to an l. An S may be insufficiently differentiated from an 8.

As legibility depends upon recognition, it is also governed by cultural familiarity. For example, Blackletter type remained the norm for long text setting throughout literary publishing in Germany until the 1940s, but would be regarded as barely legible by readers outside the German-speaking counties.

Readability and legibility are interdependent but distinct. Legibility concerns the recognition and differentiation of letters and the resulting

The analysis of legibility involves a range of perspectives and methodologies. While any of these may be relevant to particular contexts, it remains a study that resists absolute rules or categorical statements. For most experienced designers, legibility is addressed intuitively or, more accurately, through accumulated knowledge and experience.

Legibility depends upon the ease with which the eye can identify letters, and distinguish them from one another. It therefore depends as much upon the relationship of letters within the font as upon the design of the individual letterforms. An i that might appear perfectly legible

The analysis of legibility involves a range of perspectives and methodologies. While any of these may be relevant to particular contexts, it remains a study that resists absolute rules or categorical statements. For most experienced designers, legibility is addressed intuitively or, more accurately, through accumulated knowledge and experience.

Legibility depends upon the ease with which the eye can identify letters, and distinguish them from one another. It therefore depends as much upon the relationship of letters within the font as upon the design of the individual letterforms. An i that might appear perfectly legible

more accurately, through accumulated knowledge and experience. Legibility depends upon the ease with which the eye can identify letters, and distinguish them from one another. It therefore depends as much upon the relationship of letters within the font as upon the design of the individual letterforms. An i that might appear perfectly legible when viewed in isolation will be compromised if the j is insufficiently differentiated from it. A Geometric lowercase d appears highly legible until one considers how easily it may be mistaken for an o tight-spaced to an l. An S may be insufficiently differentiated from an 8.

As legibility depends upon recognition, it is also governed by cultural familiarity. For example, Blackletter type remained the norm for long text setting throughout literary publishing in Germany until the 1940s, but would be regarded as barely legible by readers outside the German-speaking counties.

◾ READABILITY

Readability and legibility are interdependent but distinct. Legibility concerns the recognition and differentiation of letters and the resulting word shapes that they form; readability concerns the manner and ease with which the reading eye traces, connects, and absorbs these words as coherent and continuous sentences and paragraphs.

Therefore, while legibility can be seen as an inherent quality in a typeface, the readability of that face is also affected by the way in which it is laid out by the designer. Readability will not depend solely on the nature of the typeface itself but may vary radically depending on the context of the work and the use of negative space, as well as line length, word spacing, and leading.

◾ LINE LENGTH

Short lines create repeated interruptions in the reading process, breaking sentences into dislocated fragments. Unduly long lines require the reader to scan a wider distance, and make it difficult for the eye to track accurately back to the succeeding line. A character count of 60–66 characters per line is widely held to be an optimum. Where longer lines are unavoidable, a designer can compensate to some extent for their effect upon readability by increasing the leading.

◾ WORD SPACING

Word spacing is also a key factor in readability. While too little space between words may make it difficult to distinguish one word from the next, most digital typefaces are designed with generous word spaces. This is compounded in some programs in which the default settings increase this space still further, which causes unnecessary interruption to the readability of the text, as well as introducing excessive white space into the overall texture of the column.

For example, Blackletter type remained the norm for long text setting throughout literary publishing in Germany until the 1940s, but would be regarded as barely legible by readers outside the German-speaking counties.

FAMILIARITY AND READABILITY

Though it appears illegible to the non-German reader (above), Blackletter type continued to be widely used for German book typography into the 20th century, suggesting that legibility owes as much to familiarity as formal structure.

GEOMETRY AND LEGIBILITY

Geometric sans-serif faces are composed of a limited number of geometric forms, providing less differentiation between letters than serif faces (top). Constructed of similar forms, a Geometric lowercase d can be hard to distinguish from the letter pair ol (center), and there can be similar confusion between the capital I and lowercase l (bottom).

GLOSSARY

Alignment The arrangement of lines in a column of running text

Default The standard settings in design software programs

Glyph scaling Adjustment to the width of letters, condensing or extending the form to achieve better letter fit or justification

Rivers The appearance of lines of white space linking the word spaces within a column of text, characteristic of excessive word spacing in justified text

Alignment

Continuous text—also referred to as body text, running text, or long text—may be arranged within columns according to any one of four main forms of alignment. While some are suitable for a wider range of purposes than others, it is important to recognize that no form of alignment is intrinsically better than another; their suitability is determined by the context in which they are to be used.

■ FACTORS AFFECTING ALIGNMENT

Decisions on the arrangement of running type involve the consideration of point size, column width, and alignment. It is the relationship of these three interdependent factors that ultimately determines the appearance of printed text. Type may be set flush or ranged left, centered, flush or ranged right, or justified. Each form of alignment has its characteristic qualities, advantages, and disadvantages.

■ USING FLUSH, OR RANGED, TEXT

Flush type is seen as informal and its asymmetry may be used as a positive element in the design of a page. It may be set in narrow columns of as few as four or five words per line, and the consistent word spaces make flush type more readable and visually harmonious than the variable word spacing of justified type. Hyphenation can be kept to a minimum, or in some cases eliminated altogether. Frequently used in page layouts utilizing two or more columns, and in smaller documents, it is rarely chosen for single-column book pages, though arguments have been made, notably by Eric Gill, for the adoption of flush text in this context.

■ HYPHENATION AND WORD SPACING IN FLUSH TYPE

Flush type should be the preferred option when using basic programs that do not allow for detailed modifications of setting, but it can nevertheless benefit from the adjustments to hyphenation and word spacing provided by professional typographic software.

Since one of the main virtues of flush setting is that it minimizes the need for hyphenation, it is logical to hyphenate only where absolutely necessary. It may also be argued that the more pronounced raggedness of the resulting right-hand edge of the column makes a positive feature of its asymmetry, where a flush text that has been extensively hyphenated may result in nearly even lines.

The majority of typefaces and default settings allow more space than is strictly necessary between words, and the appearance of flush text setting can often be improved by fine-tuning the word spacing. While word spacing is traditionally equivalent to the body width of a lowercase i or the interior space of the n, in practice the designer's eye is the best guide in optimizing word space for ease of reading.

RANGED SETTING
Where text is to be set across a fairly narrow measure, as necessitated by this two-column grid (left), ranged or flush setting maintains even word spacing without hyphenation.

ASYMMETRICAL ALIGNMENTS
Text may be aligned to left or right margins to aid the visual organization of information on the page (above).

JUSTIFICATION AND LINE LENGTH

Justifying type over a measure of four or five words per line will create
marked and intrusive variations of space that will not occur in a measure
of ten to twelve words per line (below).

Justification creates balanced, formal columns of text, giving visual symmetry and clean margins. It remains the accepted form of alignment for traditional single-

Justification creates balanced, formal columns of text, giving visual symmetry and clean margins. It remains the accepted form of alignment for traditional single-column book pages, providing clean inner and outer margins. The feasibility of justified setting will depend on the size of the type and the width of the column. If the job allows for some flexibility over

■ USING JUSTIFIED TEXT

Justification introduces variations in word spacing in order to equalize all lines to a common length. This creates balanced, formal columns of text, providing visual symmetry and clean margins. It remains the accepted form of alignment for traditional single-column book pages, providing clean inner and outer margins. The feasibility of justified setting will depend upon the number of words per line. This is determined by two factors: the size of the type and the width of the column.

If type has to be fitted into a narrow, predetermined column width, this may result in a character count too small for justification to be feasible. If the nature of the job gives some measure of control over the column width, the designer may determine an optimum column width based on considerations of readability.

The nature of the document will determine the optimum type size; questions of economy and the need to achieve a given number of words per page may also affect the choice of size. The lower the character count, the fewer words per line, resulting in an increasingly noticeable variation of word spacing when justified.

■ HYPHENATION AND WORD SPACING IN JUSTIFIED TYPE

Justification should not be attempted unless using a program or setting system that allows for detailed adjustments to hyphenation and justification (H&Js). Some degree of hyphenation is essential in justified setting. It is the designer's role to specify how far hyphenation is applied. Within professional programs it is specified in terms of: the smallest word to be hyphenated, the minimum number of letters before a hyphen, and the minimum number of letters after a hyphen. While some clients may have a predetermined house style covering such questions, it is frequently left to the designer.

As a general rule, hyphenation should follow the phonetic structure of the word, breaking it into syllables. The fine-tuning of H&Js can reflect a general aesthetic preference or it may be used to address specific justification problems.

The relationship between point size, column width, and alignment is what determines the appearance of printed text. When deciding on the arrangement of the text, the designer must take all three factors into account. He or she must also consider which of the four main forms of alignment best suits the context in which it is to be used. No one form is better than another and each has its own characteristics, advantages, and disadvantages.

ADJUSTED WORD SPACING

The appearance and readability of text can often be improved by adjustment to the word spacing, which is usually designed to a default setting far wider than is strictly necessary. Tightening the word spacing can enhance the flow of text and create a more even visual texture, as can be seen by comparing these two examples (above and below).

Therelationshipbetweenpointsize,columnwidth,andalignment iswhatdeterminestheappearanceofprintedtext.Whendeciding onthearrangementofthetext,thedesignermusttakeallthree factorsintoaccount.Heorshemustalsoconsiderwhichofthefour mainformsofalignmentbestsuitsthecontextinwhichitistobe used.Nooneformisbetterthananotherandeachhasitsown characteristics,advantages,anddisadvantages.

Decisions on the arrangement of running type involve the consideration of point size, column width, and alignment. It is the relationship of these three interdependent factors that ultimately determines the appearance of printed text. Type may be set flush or ranged left, centered, flush or ranged right, or justified. Each form of alignment has its characteristic qualities.

DEFAULT JUSTIFICATION

Justification settings allow the designer to specify the minimum, optimum, and maximum spaces between words. This text (left) has been set to default settings of minimum 60%, optimum 80%, and maximum 100%, which may result in a loose pattern of word-spaces and "rivers" of white space in the text.

ADJUSTED JUSTIFICATION

In this example (right) the settings have been reduced to a minimum of 70%, an optimum of 90%, and a maximum of 110%, giving tighter word-spacing and reducing the incidence of rivers.

Decisions on the arrangement of running type involve the consideration of point size, column width, and alignment. It is the relationship of these three interdependent factors that ultimately determines the appearance of printed text. Type may be set flush or ranged left, centered, flush or ranged right, or justified. Each form of alignment has its characteristic qualities.

Decisions on the arrangement of running type involve the consideration of point size, column width, and alignment. It is the relationship of these three interdependent factors that ultimately determines the apperance of printed text. Type may be set flush or ranged left, centered, flush or ranged right, or justified. Each form of alignment has its characteristic qualities.

ADJUSTED LETTER SPACE

Justification settings allow for additional spacing to be introduced between letters (left). This feature should be used sparingly. Even minimal increases in spacing can create an inconsistent texture and density of text.

ADJUSTED GLYPH SCALING

Justification settings also allow for the set width of letters to be extended or condensed (right). This feature should be used sparingly, if at all, because even minimal modifications of form can appear inconsistent with the rest of the text—if either glyph scaling or letter spacing creates a visible difference in appearance between the lines, it has been over-used.

Decisions on the arrangement of running type involve the consideration of point size, column width, and alignment. It is the relationship of these three interdependent factors that ultimately determines the appearance of printed text. Type may be set flush or ranged left, centered, flush or ranged right, or justified. Each form of alignment has its characteristic qualities.

Decisions on the arrangement of running type involve the consideration of point size, column width, and alignment. It is the relationship of these three interdependent factors that ultimately determines the appearance of printed text. Type may be set flush or ranged left, centered, flush or ranged right, or justified. Each form of alignment has its characteristic qualities.

DEFAULT HYPHENATION

This text (left) has been set using default hyphenation settings—hyphenating words of as little as five letters, allowing a minimum of two letters before a hyphen, and a minimum of two letters after it. This can cause breaks that are both visually and phonetically inappropriate.

ADJUSTED HYPHENATION

Here (right), the text has been adjusted to allow for hyphenating words of no less than seven letters, with a minimum of four letters before a hyphen, and a minimum of three letters after it. This adjustment creates breaks that are more visually and phonetically appropriate than the default settings.

Decisions on the arrangement of running type involve the consideration of point size, column width, and alignment. It is the rela-tionship of these three interdependent factors that ultimately determines the appearance of printed text. Type may be set flush or ranged left, centered, flush or ranged right, or justified. Each form of align-ment has its characteristic qualities.

■ USING CENTERED TYPE

Also called ragged left and right, centered type is set on a central axis, with even word spacing and ragged left and right margins. Although seldom used for large quantities of continuous text, the perfect symmetry of centered type can be extremely effective in formal contexts such as title pages. Its main disadvantage is reduced readability—the absence of an even left margin makes it more difficult for the reader's eye to identify the beginning of the next line.

■ USING FLUSH-RIGHT TYPE

Also called ranged right or ragged left, flush-right type is set to an even right margin, giving an uneven or ragged left margin. Rarely used for text of any length, it can, however, be extremely effective for small bodies of text such as captions within asymmetrical layouts, where a ragged left margin may create or resolve dynamic tension within the composition of the page.

ASSIGNMENT

1 Set a column of text flush-left to a narrow column of around six words per line, with default hyphenation. Then set the same text and remove hyphens (automatically if using professional software, manually if not). Compare and contrast the readability and visual impact of the two.

2 Using the hyphenation and justification settings, make a series of columns of justified text, exploring and noting the effect of modifications to hyphenation settings. Re-set the minimum length of word to be hyphenated, and the minimum number of letters before and after hyphens.

3 Using the hyphenation and justification settings, make a series of columns of justified text, exploring and noting the effect of modifications to justification settings. Re-set the minimum, optimum, and maximum word spacing, and determine how far this may be reduced without losing the distinction between the words.

Combine your preferred hyphenation settings and your preferred justification settings into a single paragraph style.

Explore and note the effects of modifications in letter spacing settings.

Explore and note the effects of modifications in glyph scaling.

INTRODUCTION

This book is designed to provide
a foundation for the awareness of
typography, providing a brief outline of the
evolution of type, an introduction to the
language and terminology of type and type
setting, fundamental rules and conventions
of professional practice, and key decisions
on type selection and page layout.

Complete Typographer
A manual for designing with type
WILL HILL

INTRODUCTION

This book is designed to provide
a foundation for the awareness of
typography, providing a brief outline
of the evolution of type, an introduction
to the language and terminology of type
and type setting, fundamental rules and
conventions of professional practice,
and key decisions on type selection
and page layout.

Will Hill
A manual for designing with type
COMPLETE TYPOGRAPHER

PROS AND CONS OF CENTERED TYPE

Centered type provides symmetrical form while maintaining even spacing between words (above). It can be effective for short bodies of text within symmetrical layouts, but the ragged left margin makes it unsuitable for longer texts.

PROS AND CONS OF FLUSH-RIGHT TYPE

While flush-right alignment may be useful in echoing or mirroring flush-left text (above), the absence of an even left margin makes it more difficult for the reader's eye to identify the beginning of the next line, and thus it should only be used for small bodies of text.

Differentiation

Any printed document is likely to contain several different kinds of information. It is an important part of the designer's role to ensure that these are visually differentiated and prioritized, by means of: position, scale, weight, italicization, case, and typeface. These elements work together to establish a hierarchy of information, arranging different kinds of content in order of visual prominence.

▪ POSITION
Different types of information may be identified visually by their position on the page. Running footnotes and recurring elements such as page numbers and running heads will have designated spaces within the page layout. The significance of other categories of text within the hierarchy demands other means of identification. Since we read down the page from the top, where text sits in relation to the top of the page is an indicator of its importance.

▪ SCALE
Changes in content may be indicated through the scale of the type, by increases in point size. A title or subtitle, standfirst or introductory paragraph, or pull-quote would normally be differentiated from the main text by being set in a larger size. In some cases, specific words or phrases within continuous text may be set in larger sizes for emphasis. As a general rule, any such increase should be of at least 2 points; a single-point difference is likely to look like an inconsistency or error rather than a deliberate decision.

▪ WEIGHT
One of the most direct ways a designer can create emphasis or differentiation is by variation of weight. Text typefaces customarily include a choice of weights, from the basic bold to intermediate weights such as book, medium, and demi; and extremes such as light, black, or ultra bold. The interval between weights varies widely from one face to the next and the mixture of weights in one typeface may provide greater contrast than others.

▪ ITALICIZATION
Another method of creating emphasis or differentiation within continuous text is to use italic forms. They can denote the stresses in speech, and indicate the introduction of words from other languages or idioms. The italic form also has a more general association with the spoken word, and may therefore be used for the setting of extended sections of quotation or reported speech.

Using varying weights

One of the most direct ways a designer can create emphasis or differentiation is by using varying weights. Text typefaces customarily include a choice of weights, from the basic regular to intermediate weights such as **semibold**; and extremes such as light, **bold**, or **black**. The interval between weights varies widely from one face to the next and the mixture of weights in one typeface may provide greater contrast than others.

DIFFERENTIATING BY WEIGHT
Different weights—of Myriad Pro in this case (above)—can be used to differentiate content and establish hierarchies, without the need to introduce changes in type size.

MULTIPLE DIFFERENTIATION
The complex demands of a bibliography page require effective differentiation of content. Here (left), only two sizes of type are used, exploiting the contrast between roman, italic, and bold. A deep indent creates a visual emphasis around the authors' names.

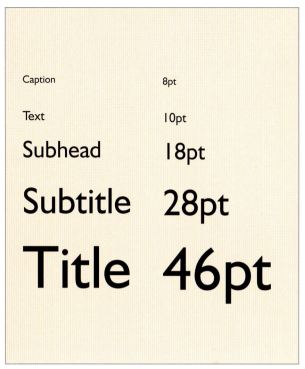

Caption	8pt
Text	10pt
Subhead	18pt
Subtitle	28pt
Title	46pt

The first italics were independent typefaces rather than companion fonts, and italic may be adopted as the main text font for continuous setting, but it must be remembered that this will in turn create the need for some alternative form of differentiation for words that would otherwise have been italicized.

■ CASE

Capital forms may be used within continuous text for visual differentiation or, sparingly, for emphasis. Where capital letters are to be set as "strings" to create whole words or sentences, the designer should consider the use of a small-cap font if one is available. If using the standard capitals from the main text font, particular attention must be given to letter spacing. Strings of capitals almost invariably benefit from general adjustments to letter spacing, and may also require the individual manual kerning of letter pairs at larger sizes.

Bodoni Poster
Bodoni Bold Condensed
Bodoni Book
ONYX

DIFFERENTIATING SUBHEADS

In this prospectus (above left) the subheads are given visual emphasis by the use of a second color and additional leading space above and below. The use of a heavier weight compensates for the reduced contrast between the red type and the white page.

VARYING WEIGHT AND WIDTH

Some type categories lend themselves naturally to variations of weight and width. In particular, the characteristic qualities of Didone types (left), in which there is pronounced contrast between horizontal hairlines and vertical strokes, can be maintained across a wide range of dramatically condensed or extended variants.

NUMBER SERIES

Some typographers determine a hierarchy of sizes (above) by using a Fibonacci series, in which each number is the sum of the preceding two. This may give a sequence such as 8, 10, 18, 28, 46 or 8, 12, 20, 32, 52.

GLOSSARY

Fibonacci Series A number sequence in which each number is the sum of the two numbers preceding it
Hierarchy The arrangement of content into an appropriate order of priority through the control of visual emphasis
Multiple mastering A type-design technology that allows the designer to create new weights of type by interpolating between existing ones
Strings Sequences of capital letters used to set whole words or lines of words

Combining typefaces

Many typefaces or typeface families contain within them a wealth of inbuilt variation, offering a range of features including multiple weights and widths, display variants, and small-cap fonts, allowing the designer to apply many forms of differentiation while using only one face. There will, however, be instances where it is necessary to use more than one typeface or family.

■ EFFECTIVE COMBINATIONS

Different types may be used where different kinds of content appear upon the same page, or to create a more colorful distinction between text and titles than can be achieved with the use of differing fonts from within the text face.

When combining faces, care should be taken to ensure both a well-defined contrast and an underlying affinity between the faces used. It is usually preferable to make positive use of the contrasts between serif and sans serif, rather than using two serif or two sans-serif faces. (It is particularly difficult to combine different categories of sans serif successfully.)

If contrasting typefaces are to be used in such a way that they occur within the same line, care should be taken to ensure that the two faces have a consistent x-height. Sans-serif and serif faces can work together particularly well if there is a similarity in the underlying proportions of the letterforms. For this reason, Humanist Sans typefaces combine particularly happily with the roman serif letters of the Venetian Humanist or Garalde types, because they share a common model of proportion, both being derived from the classic Roman capital and the Carolingian miniscule (see "The development of written forms," page 11).

By comparison, Geometric and Neo-grotesque faces are less suitable for combining with faces from other categories, because their forms and proportions reflect specific, defining phases in the development of type. The historical and stylistic associations of such typefaces may render them unsuitable for combining with others. In particular, Neo-grotesques such as Helvetica or Univers belong to a modernist tradition characterized by the use of a single sans-serif typeface.

■ SUPERFAMILIES

Some typefaces include both serif and sans serif within a single "superfamily." In some cases these will also include an extended range of weights, widths, or optical sizes. Some superfamilies include monospace versions, titling variants, and compatible script faces or "informal" fonts.

MATCHING X-HEIGHTS

If a secondary typeface is to be introduced into running text, care should be taken to ensure that the x-height matches that of the main text face. In the upper example (below), Gill Sans has been introduced into a text set in Adobe Caslon. In the lower example, Impact has been used, creating a marked dissonance of x-height.

Matching x-heights should be maintained.

Matching x-heights should be **maintained**.

COMPLEMENTARY FACES

The work of renowned Dutch designer Gerard Unger is notable for the pairing of complementary but distinct serif and sans faces, designed to be used together (left). Demos (top) is the serif counterpart to sans-serif Praxis (bottom). Unger's sans-serif Argo is designed for use with the newspaper face Swift.

White space is not a mere residue. It is an active force. It is vital in the detail of text

White space is not a mere residue. It is an active force. It is vital in the detail of text

The sans

Create a short paragraph of text in a serif face, in which certain words are to be emphasized by a change of typeface to a sans serif.

Crear un breve párrafo de texto en una cara serif, en el que ciertas palabras se destacó por un cambio de tipo de letra a una sans serif.

The serif

Create a short paragraph of text in a serif face, in which certain words are to be emphasized by a change of typeface to a sans serif.

Crear un breve párrafo de texto en una cara serif, en el que ciertas palabras se destacó por un cambio de tipo de letra a una sans serif.

TheSans ExtraLight	TheMix ExtraLight	TheSerif ExtraLight	TheSansMono ExtraLight
TheSans ExtraLightItalic	TheMix ExtraLightItalic	TheSerif ExtraLightItalic	TheSansMono ExtraLightI
THESANS EXTRALIGHTCAPS	THEMIX EXTRALIGHTCAPS	THESERIF EXTRALIGHTCAPS	TheSansMono Light
THESANS EXTRALIGHTCAPSITALIC	THEMIX EXTRALIGHTCAPSITALIC	THESERIF EXTRALIGHTCAPSITA	TheSansMono LightI
Expert ★ 0123₄₅₆₇→𝒬~	Expert ★ 0123₄₅₆₇→𝒬~	Expert ★ 0123₄₅₆₇→𝒬~	TheSansMono SemiLight
Expertitalic ✶ 0123₄₅₆₇↗ℓↄ~	Expertitalic ✶ 0123₄₅₆↗ℓↄ~	Expertitalic ✶ 0123₄₅₆↗ℓↄ~	TheSansMono SemiLightI
TheSans Light	TheMix Light	TheSerif Light	TheSansMono Normal
TheSans LightItalic	TheMix LightItalic	TheSerif LightItalic	TheSansMono NormalI
THESANS LIGHTCAPS	THEMIX LIGHTCAPS	THESERIF LIGHTCAPS	TheSansMono SemiBold
THESANS LIGHTCAPSITALIC	THEMIX LIGHTCAPSITALIC	THESERIF LIGHTCAPSITALIC	TheSansMono SemiBoldI
Expert ★ 0123₄₅₆₇→𝒬~	Expert ★ 0123₄₅₆₇→𝒬~	Expert ★ 0123₄₅₆₇→𝒬~	TheSansMono Bold
Expertitalic ✶ 0123₄₅₆₇↗ℓↄ~	Expertitalic ✶ 0123₄₅₆₇↗ℓↄ~	Expertitalic ✶ 0123₄₅₆↗ℓↄ~	TheSansMono BoldI
TheSans SemiLight	TheMix SemiLight	TheSerif SemiLight	TheSansMono ExtraBold
TheSans SemiLightItalic	TheMix SemiLightItalic	TheSerif SemiLightItalic	TheSansMono ExtraBoldI
THESANS SEMILIGHTCAPS	THEMIX SEMILIGHTCAPS	THESERIF SEMILIGHTCAPS	TheSansMono Black
THESANS SEMILIGHTCAPSITALIC	THEMIX SEMILIGHTCAPSITALIC	THESERIF SEMILIGHTCAPSITALIC	TheSansMono BlackI
Expert ★ 0123₄₅₆₇→𝒬~	Expert ★ 0123₄₅₆₇→𝒬~	Expert ★ 0123₄₅₆₇→𝒬~	TheSansMonoCon ExtraLight
Expertitalic ✶ 0123₄₅₆₇↗ℓↄ~	Expertitalic ✶ 0123₄₅₆₇↗ℓↄ~	Expertitalic ✶ 0123₄₅₆↗ℓↄ~	TheSansMonoCon ExtraLightI
TheSans Normal	TheMix Normal	TheSerif Normal	TheSansMonoCon Light
TheSans NormalItalic	TheMix NormalItalic	TheSerif NormalItalic	TheSansMonoCon LightI
THESANS NORMALCAPS	THEMIX NORMALCAPS	THESERIF NORMALCAPS	TheSansMonoCon SemiLight
THESANS NORMALCAPSITALIC	THEMIX NORMALCAPSITALIC	THESERIF NORMALCAPSITALIC	TheSansMonoCon SemiLightI
Expert ★ 0123₄₅₆₇→𝒬~	Expert ★ 0123₄₅₆₇→𝒬~	Expert ★ 0123₄₅₆₇→𝒬~	TheSansMonoCon Normal
Expertitalic ✶ 0123₄₅₆₇↗ℓↄ~	Expertitalic ✶ 0123₄₅₆₇↗ℓↄ~	Expertitalic ✶ 0123₄₅₆↗ℓↄ~	TheSansMonoCon NormalI
TheSans SemiBold	TheMix SemiBold	TheSerif SemiBold	TheSansMonoCon SemiBold
TheSans SemiBoldItalic	TheMix SemiBoldItalic	TheSerif SemiBoldItalic	TheSansMonoCon SemiBoldI
THESANS SEMIBOLDCAPS	THEMIX SEMIBOLDCAPS	THESERIF SEMIBOLDCAPS	TheSansMonoCon Bold
THESANS SEMIBOLDCAPSITALIC	THEMIX SEMIBOLDCAPSITALIC	THESERIF SEMIBOLDCAPSITALIC	TheSansMonoCon BoldI
Expert ★ 0123₄₅₆₇→𝒬~	Expert ★ 0123₄₅₆₇→𝒬~	Expert ★ 0123₄₅₆₇→𝒬~	TheSansMonoCon ExtraBold
Expertitalic ✶ 0123₄₅₆₇↗ℓↄ~	Expertitalic ✶ 0123₄₅₆₇↗ℓↄ~	Expertitalic ✶ 0123₄₅₆↗ℓↄ~	TheSansMonoCon ExtraBoldI
TheSans Bold	TheMix Bold	TheSerif Bold	TheSansMonoCon Black
TheSans BoldItalic	TheMix BoldItalic	TheSerif BoldItalic	TheSansMonoCon BlackI
THESANS BOLDCAPS	THEMIX BOLDCAPS	THESERIF BOLDCAPS	TheSansCondensed ExtraLight
THESANS BOLDCAPSITALIC	THEMIX BOLDCAPSITALIC	THESERIF BOLDCAPSITALIC	TheSansCondensed ExtraLightitalic
Expert ★ 0123₄₅₆₇→𝒬~	Expert ★ 0123₄₅₆₇→𝒬~	Expert ★ 0123₄₅₆₇→𝒬~	TheSansCondensed Light
Expertitalic ✶ 0123₄₅₆₇↗ℓↄ~	Expertitalic ✶ 0123₄₅₆₇↗ℓↄ~	Expertitalic ✶ 0123₄₅₆↗ℓↄ~	TheSansCondensed LightItalic
TheSans ExtraBold	TheMix ExtraBold	TheSerif ExtraBold	TheSansCondensed SemiLight
TheSans ExtraBoldItalic	TheMix ExtraBoldItalic	TheSerif ExtraBoldItalic	TheSansCondensed SemiLightitalic
THESANS EXTRABOLDCAPS	THEMIX EXTRABOLDCAPS	THESERIF EXTRABOLDCAPS	TheSansCondensed Normal
THESANS EXTRABOLDCAPSITALIC	THEMIX EXTRABOLDCAPSITALIC	THESERIF EXTRABOLDCAPSITA	TheSansCondensed NormalItalic
Expert ★ 0123₄₅₆₇→𝒬~	Expert ★ 0123₄₅₆₇→𝒬~	Expert ★ 0123₄₅₆₇→𝒬~	TheSansCondensed SemiBold
Expertitalic ✶ 0123₄₅₆₇↗ℓↄ~	Expertitalic ✶ 0123₄₅₆₇↗ℓↄ~	Expertitalic ✶ 0123₄₅₆↗ℓↄ~	TheSansCondensed SemiBolditalic
TheSans Black	TheMix Black	TheSerif Black	TheSansCondensed Bold
TheSans BlackItalic	TheMix BlackItalic	TheSerif BlackItalic	TheSansCondensed BoldItalic
THESANS BLACKCAPS	THEMIX BLACKCAPS	THESERIF BLACKCAPS	TheSansCondensed ExtraBold
THESANS BLACKCAPSITALIC	THEMIX BLACKCAPSITALIC	THESERIF BLACKCAPSITALIC	TheSansCondensed ExtraBolditalic
Expert ★ 0123₄₅₆₇→𝒬~	Expert ★ 0123₄₅₆₇→𝒬~	Expert ★ 0123₄₅₆₇→𝒬~	TheSansCondensed Black
Expertitalic ✶ 0123₄₅₆₇↗ℓↄ~	Expertitalic ✶ 0123₄₅₆₇↗ℓↄ~	Expertitalic ✶ 0123₄₅₆↗ℓↄ~	TheSansCondensed BlackItalic

INTEGRATED SERIF AND SANS

The faces Stone Sans and Stone serif (top left) share a common x-height and affinities of underlying form. As a consequence the serif face has unusually short ascenders, while the sans has a subtle, Humanist variation of stroke width. Though stylistically distinct, they are designed to work together harmoniously.

SERIF–SANS FAMILIES

Luc(as) de Groot's Thesis family (left) comprises a matched serif and sans, and an intermediate or hybrid form titled Themix. All are available in an extended range of weights with many OpenType features.

Page layout

The design of the page involves both the composition of the columns and margins that form the page grid, and the decisions governing the size, weight, and leading of text, subheads, and titling. Page design is likely to involve both practical considerations, such as the amount of text that can be fitted on the page, its legibility and ease of use, and aesthetic or expressive factors, such as impact, compositional dynamism, and visual appeal.

■ LAYOUT AND TYPEFACE
The choice of typeface and the structure of the page involve closely linked and interdependent decisions, each of which may influence or determine the other. For example, an initial decision to compose a page along asymmetrical principles, using short columns of flush, or ranged, type, will in turn suggest certain typefaces as appropriate to this strategy and rule out others as being either historically or visually unsuitable. Conversely, the page design may be driven by the choice of a particular typeface, which then suggests certain characteristics of layout. These will be determined by both the functionality of that typeface and its associations within typographic history.

■ TEXT SETTING
The appearance of a column of type is determined by several distinct but closely interrelated factors. As well as the choice of typeface and alignment already discussed, the size of the type, the width at which it is set, and its leading, must all be considered in relation to one another.

Type size Text for the printed page is usually set at between 9 and 12 points. Types with exceptionally generous x-heights may allow for setting in smaller sizes, while typefaces with low x-height may be set larger than usual.

Line length/column width The width of a column may be determined by the amount of space available within a predetermined page, but wherever possible attention should be given to achieving an optimum number of words per line. Lines that are too short impair readability by constantly interrupting the text; lines that are too long make it difficult for the reader's eye to return to the margin and identify successive lines. A character count of around 60–66 characters is generally accepted as providing an optimum point between these extremes. In some cases, longer lines may be unavoidable, in which case the effect upon readability can be compensated for by an increase in leading.

Leading The amount of leading necessary for a readable and balanced column of type will depend upon the line length and x-height of the typeface. Typefaces with long ascenders and descenders will, as a rule, require less additional leading than those with a greater x-height.

MODERNIST PASTICHE
Many 20th-century serif faces have strong associations with the design philosophies of their time. This poster (below) by Danny Osborne references Carlo Vivarelli's iconic cover design of the 1958 Neue Grafik, a landmark of Swiss typography.

MAINTAINED LEADING

The design of a page may involve different sizes of text. Introductions or standfirsts may typically be several points larger than the main running text; footnotes or captions may be smaller. In such cases, it may not be possible to apply the same leading as used for the main text.

A consistent visual relationship can, however, be maintained by basing the leading of the different sizes upon common multiples. If the text is set on 12pt leading, a larger introductory text may be set upon a leading of 18pt, allowing alignment of every fourth line of text (three lines to four), or 15pt, allowing alignment of every fifth line (four lines to five). For this reason it is useful to base the leadings around easily divisible numbers.

Even in layouts where the strict alignment of text may not be a consideration, recurrent mathematical relationships of this kind serve to reinforce the underlying coherence of the design and the sense that each of the elements belongs to a common scheme.

Introductions or standfirsts may typically be several points larger than the main running text.

In such cases, it may not be possible to apply the same leading as used for the main text. However, by basing the leadings of the different sizes of type on common multiples, it is possible to maintain a consistent visual relationship. For example, running text may be set on 12pt leading and introductory text on a leading of 18pt, allowing alignment of every fourth line of text (three lines to four). Such recurrent mathematical relationships are valuable even where strict alignment is less of a consideration, reinforcing the coherence of the design and contributing to a sense that all elements belong to a common scheme.

X-HEIGHT AND LEADING

The low x-height of Adobe Garamond Pro in the first example (right) will require less additional leading than would be necessary when setting a typeface like Georgia, shown second, which has a higher x-height.

MULTIPLES IN LEADING

The introduction is set in 14 on 16 and the main text in 10 on 12 (above). Setting the leadings to multiples of four points creates recurrent alignments between type set at two different sizes.

The amount of leading necessary for a readable and balanced column of type will depend upon the line length and x-height of the typeface. Typefaces with long ascenders and descenders will, as a rule, require less additional leading than those with a greater x-height.

The amount of leading necessary for a readable and balanced column of type will depend upon the line length and x-height of the typeface. Typefaces with long ascenders and descenders will, as a rule, require less additional leading than those with a greater x-height.

A narrow column will be less likely to require additional leading than a wide one. The amount of space between lines should not exceed the gutter space between columns.

INTRODUCTION STYLES

The point at which a text begins on the opening page of a chapter, or starts the introduction to a magazine feature, may be signposted visually in a number of ways. It may be necessary to make clear to the reader that the text is not a continuation from a previous page, or to bridge the otherwise abrupt transition from a space that may involve images and display typography into the continuum of running text.

Introductory paragraphs may be identified by being set in a larger size, a heavier weight, or even a different typeface from the subsequent text.

STYLING PARAGRAPHS

The designer has a number of typographic options for indicating the beginnings and ends of paragraphs. These both aid readability and introduce some visual relief into large sections of continuous text.
Indent The first line of a new paragraph may be indented—that is, set in from the margin by a fixed measure. While convention sets the optimum indent as one em (giving an indent equivalent to the point size of the type), there are many instances where a deeper indent may be appropriate, particularly if the column itself has an unusually long measure. There are few instances where one would wish to indent by less than an em, since a poorly defined indent can look like an error or inconsistency rather than a deliberate aspect of the design.
Exdent The opening line of the paragraph may be set outside the column margin. Sometimes termed an "outdent," but more properly an exdent or hanging indent, this is effective for highlighting paragraph openings within smaller documents, but would seldom be used throughout a book.
Paragraph spaces The end of paragraphs may, in some cases, be indicated by additional line spacing. This is more common within smaller printed documents than in books, where considerations of page economy and the effect on readability are likely to make this approach inappropriate. If an additional space is to be inserted, the amount of space should be related to the leading of the text, as a line space or half-line space.

However, adding a line space after every paragraph—a custom that is widespread in word-processed documents—is not good design practice and should not be replicated in professionally set texts.

TEXT-SETTING STYLES

Many documents require a number of text-setting styles for the differentiation of distinct types of information or simply for visual variety, such as between different features in a magazine. This may introduce variations in type color, column width, size or weight of type, or the face used. Distinct and consistent styles will also need to be established for captions, footnotes, and other content not included in the running text.

Professional design software allows the attributes of these styles to be stored as named "paragraph styles," which can then be applied consistently to raw text.

APPLYING PARAGRAPH AND CHARACTER STYLES
The range of paragraph and character styles (above) designed to be applied throughout a book or document can be stored under specific names and applied to imported text as required.

COLUMN OPTIONS
In this design journal (below), a six-column grid provides the option for text to be set across either two or three columns, making an effective distinction between two bodies of text.

DROP-CAPS

The visual transition into the main text may be signposted by a drop-cap—an initial set at a larger size than the main text (right). This is recessed into the text to align with the second, third, or fourth line. A drop-cap may be followed by additional words of the first sentence set in small caps.

T HE DESIGNER has a number of typographic options for indicating the beginnings and ends of paragraphs. These are both an aid to readability and a means of introducing some visual variation into large sections of continuous text. The transition to the main text may be signaled by the introduction of a drop-cap.

PARAGRAPH INDENT

The beginning of a paragraph may be indicated by indenting the first line (right). The depth of indent will be determined by type size, line length, and leading.

The designer has a number of typographic options for indicating the beginnings and ends of paragraphs. These both aid readability and are a means of introducing some visual variation into large sections of continuous text. The first line of a paragraph may be indented—that is, set in from the margin by a fixed measure.

PARAGRAPH EXDENT

The opening of a paragraph may be indicated by "hanging" the opening line outside the text margin (right), creating a greater visual emphasis.

The designer has a number of typographic options for indicating the beginnings and ends of paragraphs. These are both an aid to readability and a means of introducing visual variation into large sections of continuous text. Very occasionally, there are instances where the opening of the paragraph is set outside the column margin.

COMBINED ALIGNMENTS

In these page layouts (top and above) a two-column grid is used to manage multiple streams of information in several paragraphing styles. To accommodate illustrations, the main text is reduced to a single column, set justified across two columns. Ranged text is used for the setting of verses. Footnotes are ranged in single columns. The design is further unified by centered running heads and folios.

◼ SUBHEADS

Many documents involve the use of subheads or cross-heads—secondary titles that occur within the column of running text. The weight given to these headings depends both upon editorial and aesthetic considerations. The content of the text itself and the preferences of the author or editor may indicate how much emphasis is appropriate, while the designer's own visual judgment will determine how far the subhead should interrupt the visual continuity of the column. It may be that the subhead can be indicated without any change to type size or leading by using a heavier weight or capital form of the typeface used in the text, or another typeface at equal size.

◼ SUBHEADS AND LEADING

If a subhead involves the use of different sizes of type, necessitating increased space both before and after the subhead, it is important to ensure that the total depth around the subhead relates to the leading of the running text. This ensures that the text following the subhead returns to the maintained leading and thus continues to align with text on adjacent columns. The total leading of the subhead should therefore always use a division of the leading of the text.

Care should be taken to ensure that the lines of type on adjacent pages or columns align properly with one another. Where both columns are uninterrupted by subheads or the intrusion of any other form of additional space, this should occur automatically. The consistent leading of all the text will ensure that, as long as the top lines are correctly aligned, all subsequent lines will also align and each column will end at the same baseline across the double-page spread. If, however, any additional space is to be introduced between lines, this space should be designed so that the position of the following line of text returns to alignment with the lines on the adjacent column.

SUBHEADS WITH MAINTAINED LEADING

The 14pt subhead (below) has been set on 20pt leading with 4pt space below in order that the total of 24 points returns the text to a maintained 12pt leading.

If a subhead involves the use of different sizes of type, necessitating increased space both before and after the subhead, it is important to ensure that the total depth around the subhead relates to the leading of the running text.

Aligning across columns

This ensures that the text following the subhead returns to the maintained leading and thus continues to align with text on adjacent columns. The total leading of the subhead should therefore always use a division of the leading of the text.

USING HYPHENS AND DASHES

Professional typography makes use of three horizontal glyphs: the hyphen, em-dash, and en-dash. Although visually similar, they are semantically distinct, and their correct use is not simply a nicety of typographic style but one of grammatical meaning.

The hyphen

A hyphen is used to indicate breaks in words, or to link words into compound forms as, for example, para-gliding or in double-barreled names, such as Kirsty Seymour-Ure. It is thicker and shorter than the en-dash or em-dash, and is used without additional spacing.

The em-dash

Also known as an em-rule, the em-dash is inserted without additional word space. It may be used to interrupt a sentence, as when indicating an aside or other digression, similar to the way in which parentheses (brackets) are used. This is the common practice in US text. In the UK, however, the choice of the em-dash has increasingly been limited to fine printing or academic contexts; for more popular printed material the spaced en-dash is often substituted.

The en-dash

Also known as an en-rule, the en-dash is longer than a hyphen. One of its main uses is as a substitute for "until," as in 9am–5pm. It may also be used to signify the span between two different units of measurement, as in 3–4 hours. Used in this context the en-dash should not be preceded or followed by a word space.

Fine-tuning the text

After all general points of styling have been established, you may wish to fine-tune the text to correct any inappropriate hyphenations, and to avoid widows and orphans (see below). This may be achieved by making further very minor adjustments to the specification of individual lines or paragraphs, through justification, letter space, or glyph scaling.

The em-dash may be used to interrupt a sentence—as when indicating an aside.

The en-dash may be used to interrupt a sentence – as when indicating an aside.

EM AND EN DASHES

The unspaced em-dash is preferred in the US, as shown in the first example above, while in the UK the spaced en-dash is the widely used choice.

AVOIDING WIDOWS AND ORPHANS

In some cases the last line of a paragraph may comprise a single word. Traditionally known as a "widow," this should be remedied if at all possible by adjustments to the setting of the preceding text. Widows will be less intrusive in a short column, and more problematic in the case of wide columns, particularly if followed by a deep indent.

In other cases the final line of a paragraph falls on the first line of a new column or page. Such lines are called "orphans" and should also be corrected.

THE PARTS OF A BOOK

Although there are variations, the majority of books are structured according to the following conventions:

The prelims

Within the traditionally structured book, there are a number of preliminary pages that precede the main text.

Half-title (1)

This is an initial title page that faces the endpapers (the inside of the front cover). It customarily gives the book title only.

Frontispiece/title page (2)

The full-title page, including title, subtitles, author, and publisher, may fall on the right (recto) page, facing a frontispiece illustration on the left (verso). It may, alternatively, run across the whole double-page spread.

Imprint or biblio page (3)

The verso page following the title normally contains the publishing details of the book: publisher, printer, edition, typeface/foundry, copyright dates, and so on. Alternatively, this information may appear on the verso page preceding the frontispiece or on the last page of the book.

Dedication

If the book is to have a dedication, it customarily falls on the recto, facing the biblio page.

Contents (4)

This customarily falls on the next recto page; in some circumstances, however, there may be reason to run it across the whole spread.

List of illustrations, acknowledgments, preface, introduction

The book may require any or all of these, which commonly fall in the order shown above, although the first two items frequently appear at the end of the book.

Part-titles

Where a book divides into several parts with chapters within them, each part may be preceded by a part-title page. This is a form of page divider between the parts and commonly occurs on the recto page. The preceding verso page may also be incorporated into the design of the part-title page.

Chapter titles (5)

If the parts of the book are subdivided into chapters, the chapter title may occur on the same page as the opening text of the chapter or on the previous page. It may be designed as a single- or double-page spread, referred to as a chapter opener.

Endmatter (6)

Appendices, credits, acknowledgments, and index are usually listed at the end of the book and are commonly referred to as endmatter.

GLOSSARY

Drop-cap Over-sized initial letter set into the text to indicate new chapter or paragraph

Exdent Overhanging line opening that indicates a new paragraph

Em-dash Horizontal glyph one em in length

En-dash Horizontal glyph half an em in length

Frontispiece Illustration at the beginning of a book, usually facing the title page

Gutter More correctly the fold at the center of the page spread, the term "gutter" is now widely used to describe the space between columns

Hyphen Short horizontal glyph, used to indicate breaks in words or to create compound words

Indent Inset line opening, to indicate a new paragraph

Maintained leading A system of leading that ensures that the lines of text continue to align to an underlying baseline grid

Orphan The final line of a paragraph that carries over onto a new column

Page grid The underlying structure of margins and columns that govern the layout of text on the page

Pull-quote A sentence or quotation from the main body of the text, enlarged as a design feature of the page, to give an immediate taster of the content of the text

Standfirst An introductory paragraph or sentence preceding the main body of a text

Widow Single word on the final line of a paragraph

The grid

A grid is the term used to describe the arrangement of verticals and horizontals that determines margins, type area, and the positioning of images. A well-designed grid provides a framework for relationships between all the elements of a layout.

■ THE FUNCTION OF A GRID

Grids vary in complexity according to the particular demands and conditions of the job. The simplest page grid comprises the four lines used to define the left and right margins, the top line, and the baseline of the text area of each page. This is then repeated on the facing page. This structure is an adequate basis for a very basic book page where there is continuous text and no illustrations.

However, many books and other printed documents involve several distinct kinds of typographic content including captions, footnotes, sidebars and secondary texts, as well as photographs or illustrations. These require a more complex grid structure to provide a consistent order to the relationships between the different elements.

The grid also determines and defines the positioning of page numbers, running heads, and any other standard elements that are to recur throughout the document.

■ MULTICOLUMN GRIDS

Magazines, newspapers, and large-format books use complex multicolumn grids, designed to allow flexibility and variation of page layout while maintaining an underlying continuity of structure. Within such a grid, the type may be set across two or more columns, giving the designer a range of column-width options. A six-column grid, for example, allows for a wide range of permutations: two columns of three-column width; three columns of two-column width; one column of four; and one of two. This flexibility of structure also allows for variation in the scale and positioning of illustrations and photographs, which may be set across any width from a single column to the entire text area, while still conforming to the grid structure.

While the concept of a grid may suggest a constraining regularity, a well-designed and complex grid actually provides for great flexibility and visual variety, allowing for a wide range of variations of scale and compositional structure.

ASYMMETRICAL GRIDS

Some pages may use a grid based around two differing widths of column. This asymmetry may then be reflected—keeping the narrower column on the outside of the spread or in the gutter—or duplicated—placing the narrower column at the same side of both recto and verso pages (below).

FLEXIBLE GRIDS

A flexible grid allows the designer to create compositional variation and to introduce a range of image formats into the spread, while maintaining a consistent underlying structure. The eight column grid examples (below) show the flexibility for the designer to create a number of layout options.

THE MODERNIST GRID

The geometric grid structure was a characteristic feature of modernist design from the late 1920s through the 1960s. Echoing modernist architecture in its concern for regular horizontal intervals, the modernist—or "fielded"—grid has a structure characterized by regular horizontal divisions within the text area, creating a grid of smaller rectangular "fields" of consistent proportion. While this may be useful or aesthetically satisfying in some cases, it is not necessary in itself as long as the grid clearly establishes all the recurring horizontal elements within the design.

MODERNIST GRID STRUCTURES

The work of Hamish Muir and 8VO (top right and right) on the design of the journal Octavo uses a detailed modernist grid, in which the page is divided into equal rectangular units.

GLOSSARY

Field Rectangular zone within a grid, created by regular horizontal divisions
Folios Page numbers
Grid The arrangement of vertical and horizontal margins to standardize the position of typographic elements within a page spread
Recto Right-hand page
Running head Recurrent title information appearing at the head of every page
Sidebar Secondary text or commentary set to one side of the main column
Verso Reverse or left-hand page

Display typography

The term "display typography" is generally used to describe typographic work that involves the use of fewer words at larger scale, and to distinguish this work from editorial typography and the setting of continuous text. It includes the typography of corporate identities, book jackets, packaging, fascias, and motion graphics and animation. Display typography may involve the interpretive or illustrative use of letterforms, providing opportunities for the associative values and the formal characteristics of letters to be explored and exploited to deliberate effect.

■ DISPLAY TYPEFACES

Many typefaces are defined as "display faces." This term denotes a face based around particular associative and decorative values, but also indicates that the face would be impractical for use at small scale or in the setting of continuous text. Display typefaces draw upon a wide and colorful range of sources and idioms, and are not constrained by the considerations of legibility and page economy that govern the design of text faces. They are frequently overt statements of creative intent, rather than neutral carriers of content.

The display typeface has its origins in the 19th century, when the developments of the manufacturing industry and the emerging consumer culture created a demand for impact and novelty in a new generation of letters cut in wood for use by jobbing printers. The phenomenon of "artistic printing" is characteristic of the late 19th century in the use of elaborate borders and decorative letterforms.

The accessibility of digital type design media has led to a proliferation of idiosyncratic or eccentric letters, as well as the revival of many historic display faces. Display types reflect a wide range of vernacular sources, including signwriting, wood-letter type, calligraphy, and the many forms of the hand-rendered letter.

It should be noted that many text faces can be effectively used in display contexts, which can serve to draw attention to the intrinsic beauty of individual letterforms more commonly encountered within running text. Some faces based upon Venetian or Aldine models reveal particular elegance of form when viewed at large sizes.

Several recent text faces also include display variants or optically mastered versions designed for titling use.

DELIBERATE INCONSISTENCY

Display typography sometimes deliberately contradicts the precepts of text setting, as in this book jacket design (right) which uses variations of type size and eccentric letter spacing to dramatic effect.

WOODEN DISPLAY TYPES

A range of wooden letters for letterpress printing (above).

DISTRESSED TYPES

A number of digital typefaces (above) have been designed to replicate distorted or distressed finishes, creating type that appears chipped or blurred and evokes a sense of history.

WORDS AS IMAGES

Display typography frequently makes use of a small number of key words. In this poster for the San Francisco Art Institute (above left), three key concepts are juxtaposed against the three dimensional space of an artist's studio.

WOOD LETTERS REVIVED

This title page by Fred Woodward (above right) draws upon the decorative typography of the late 19th century.

ARTISTIC PRINTING

This print union trade card (left) reflects the elaborate decorative mannerisms of the "artistic printing" movement of the late 19th century.

GLOSSARY

Distressed Showing the effect of erosion, wear, and repeated use
Vernacular Local or untutored tradition; a term that has come to encompass a range of craft practices and semi-skilled typography
Wood letter Large-scale display types, typically from the 19th and early 20th century, printed from wood rather than metal types

■ PRIORITIES OF INFORMATION

Variations in scale, tonal value, weight, color, and positioning can be used to establish the relationships between different types of display information. Effective design prioritizes these elements visually within a single unified composition.

Within the design of a book jacket, for example, the elements would typically be: title, author, image, publisher (in the case of high-profile authors, the first two elements may be reversed). Within the design of a poster or other event promotion, the elements would include: title/event, date, time, location, and booking information.

■ TONALITY

Digital media provide for detailed control over the tonal density of type. Used with sensitivity, modulation of tone can extend the depth and visual complexity of a monochrome design.

Percentage screening lightens the tonal value of the type by introducing a fine pattern of white dots into the solid letterform. In this way, the contrast and prominence of a large title may be moderated by printing in a percentage tint rather than a solid. Some care should be taken when applying this process to type, since it may affect the clarity of letterforms. The effect of dot screening upon the clarity and definition of the letter may be imperceptible when used at headline scale, but it should be avoided at smaller sizes. Pale tints and coarse screening will create irregular letter profiles.

The effectiveness of percentage screening is also affected by the quality of paper on which the type is printed. Paper quality determines the size of dot screen that it is feasible for the printer to use; a coarse or absorbent paper requires a coarser screen composed of larger, and therefore more visible, dots. If the budget allows, any moderation in the tonal density of running text should be achieved by running a special color printing rather than a percentage tint.

■ COLOR

Color may be used to create emphasis, heighten contrast, evoke emotional responses, or provide informational color-coding within a complex document. Some of the most effective display typography utilizes a limited range of specific colors rather than the full spectrum. A single additional printing may open up a range of possibilities, allowing the designer to use both positive and negative letterforms, duotone images, and a range of percentage tints in both of the two printed colors.

REVERSED TYPE

Type may be "reversed out" of a background color, resulting in letterforms composed of un-inked rather than inked space. While this may be extremely effective when using robust typefaces at appropriate sizes, it makes particular demands upon the quality of printing, and may in some cases lead to problems in reproduction.

Reversal can lead to loss of definition or detail in some typefaces. Delicate hairlines and finely pointed serifs are prone to breaking or filling-in when reversed, so that the letterform is fractured or blunted; the absorbency and roughness of the paper can also compound these problems. Monoline sans-serif faces and well-defined slab-serif faces will be less prone to a loss of quality than high-contrast Didone or Garalde forms.

While reversed type may create impact and visual variety upon the page, it is measurably less legible. We are accustomed to viewing type as a positive form upon a lighter background. Typefaces are designed as positive inked forms, rather than negative forms to be surrounded by ink. High-contrast reversed lettering may be difficult or even painful to read. This need not be a consideration when setting titling or headlines of a few words, but is a strong argument against using reversed type for substantial amounts of continuous text.

NOTE The higher the contrast of stroke width in a typeface, the more likely this is to cause problems when the type is reversed out of a solid.

SUITABILITY FOR REVERSAL
As this example (above) demonstrates, a monoline sans-serif typeface such as News Gothic (top) is better suited to reversal than the high contrasts and delicate serifs of an inscriptional letter such as Perpetua (center), or the fine hairlines of Didot (bottom).

FOUR-COLOR REPRODUCTION

Four-color process printing uses the four process colors: cyan, magenta, yellow, and black (top right). The initial letters of these colors form the color mode CMYK, which should always be specified when producing digital artwork for print reproduction. A color image such as a photograph or illustration is reproduced through the successive overprinting of dot-screened images in each of these four colors (center right). These are called color separations. Colored type printed by the four-color process is therefore composed of very fine dots in the four process colors.

Although quality printing will render these dots almost imperceptible to the eye, the result does not compare with the evenness of surface and clarity of outline achieved when the type is printed as a special or spot-color—an ink actually mixed to a specified color. Because this requires a separate printing from an additional plate, adding one or more specials to a four-color job has serious cost implications, but is justified where large areas of color or colored type are to be used. Special spot colors are specified using the Pantone system, a universal system of color specification (see below right).

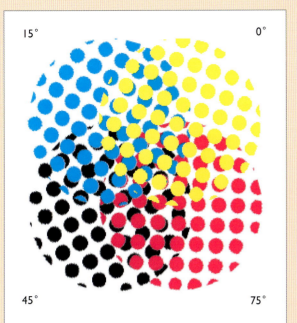

15° 0°

45° 75°

RAW PROCESS COLOR

Though the colors which comprise the four process printings are extremely raw, there are instances where their crudeness may be used to powerful effect. This design (above) utilizes a pure magenta and a pantone green.

THE PANTONE SYSTEM

A universal system of color specification for printers and designers, the Pantone system (right) ensures consistent results though alphanumeric coding of a vast range of individual colors created by the mixing of standard printers' inks.

GLOSSARY

Drop-shadow Digital effect repeating the letterforms as a shadow, usually to the right and below type, to create the illusion that it rests above the surface

Four-color The standard method of commercial color printing, which uses the mode CMYK to overprint four standard inks in varying screen densities

Hairline Fine lines and serifs typically occurring on the horizontal axis of high-contrast faces, notably the Modern or Didone genre

Monoline A typeface with minimal variation in stroke width

Pantone A universal color specification system for designers and printers

Screening The creation of intermediate tones and colors by the photomechanical separation of image or type into a pattern of fine dots for printing

Spot-color The printing of individually mixed special colors, normally specified from the Pantone system

TYPE AND IMAGE

Digital media have given designers increased control over the introduction of type into an image, to the extent that this has become an accepted norm within many design contexts. While this creates unprecedented scope for the integration of word and image, the ease with which type can be introduced into a photographic image or illustration in turn raises a number of potential problems.

To place type upon any tonally varied background either impairs its overall legibility or creates variations of legibility and contrast, making some letters or words more prominent than others and, at worst, rendering some parts illegible. The widespread practice of attempting to correct this by the introduction of drop-shadow is a crude solution to problems that should have been avoided at source. The loss of legibility associated with variations of background tone may in turn necessitate the use of larger or bolder type than would otherwise be necessary, sacrificing subtlety and flexibility in the design.

EFFECTS AND FILTERS

Both raster and vector programs offer a wide range of effects that can be applied to type. Many of these are essentially illusionistic, designed to replicate the effects of light. This may involve casting shadow as though the type were raised (drop-shadow), or creating the effect of three-dimensional embossed or recessed letterforms. Filters and ready-made graphic styles can replicate reflective surfaces such as chrome or glass, or luminous media such as neon.

Such options are of varying use to the serious designer and should be used sparingly and with caution—a novelty effect may be as likely to distract the viewer from the message as it is to enhance it, so needs to be integrated into the overall composition of the design.

SPECIAL FINISHES

Designers have at their disposal a range of specialized print processes and treatments that can enhance and enliven typographic products. Many of the following processes are not handled in-house by commercial printers but put out to more specialized print finishers.

Spot UV varnishes

Varnishes and laminations may be used simply to protect the inked surface, to heighten the richness of color, or to provide a uniformity of gloss or matte texture. Varnish may, however, be more imaginatively used as a graphic medium in itself.

Most varnishes are printed using essentially the same press technology as that used for color printing, and can be viewed as a special print run, much as one might view a "special" or spot color. The varnish may be printed onto the type alone or onto illustrations, or used as a visually independent level of artwork in which some elements are printed in varnish only. Varnishes are available in a wide range of finishes from high gloss to matte, and include colored and metallic variants.

Metallic inks

Wide ranges of metallic inks are available. While the quality of metallic print technology has improved considerably in recent years, it should be kept in mind that metallic inks normally have a fairly flat or granular finish.

TYPE AND BACKGROUND

In this conference program (left), the title has been made slightly transparent to create closer integration with the background image. The subtitle recedes into the background but remains legible due to the robust slab-serif typeface.

TYPE FILLED FROM IMAGE

Some programs allow the designer to fill the type from an image source (right). Provided that the typeface is clear and legible and has sufficient weight, this can be an extremely effective graphic device.

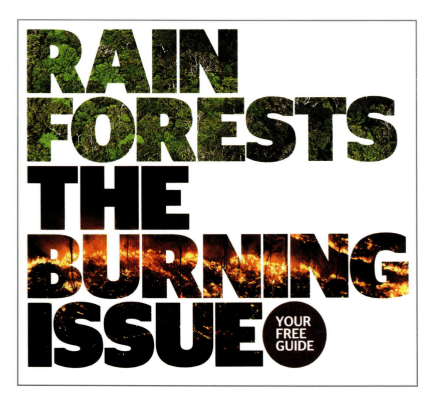

METALLIC IMPRINTS

This exhibition catalog (right) uses metallic foil-blocking to stamp the numeral onto a screen-printed cloth binding.

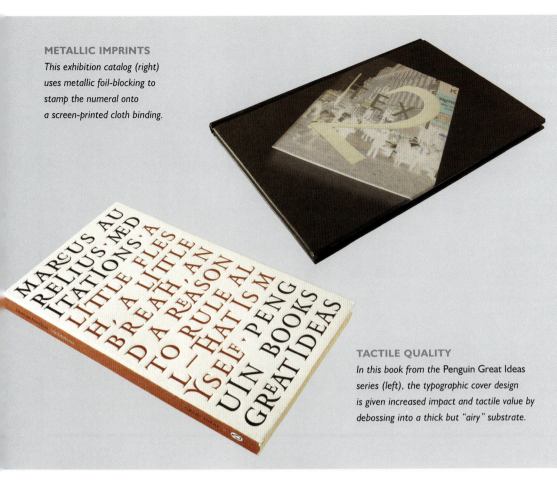

Foil blocking

Reflective metallic finishes are best achieved through foil blocking—a relief printing process in which a very fine layer of pressed metal is fused to the paper surface. Foil blocking can be carried out in a wide range of colored metallic finishes and matte colors, and is frequently combined with an embossing process.

Embossing and debossing

Type may be embossed in a number of different ways. Relief processes using both a positive and negative block can be used to create raised type; cushion embossing creates a gently curved relief surface over larger areas. Type can be impressed into a surface using relief-printing processes in combination with either metal foil or inks. Type may be embossed using no color at all—a process described as "blind embossing." Relief-printing methods are particularly valuable when printing onto rough-textured materials because the pressure of the press impresses the type, flattening the paper surface.

Die cutting and laser cutting

Display typography may make use of cut-away shapes. In the past these required the creation of special metal dies used to mechanically punch out the paper; in the 21st century laser technology has created unprecedented scope for the creative use of cutaway shapes in graphic design and typography.

TACTILE QUALITY

In this book from the Penguin Great Ideas *series (left), the typographic cover design is given increased impact and tactile value by debossing into a thick but "airy" substrate.*

3-D TYPE

In this special case design (left), the type is embossed "blind" without inking, creating a rich tactile surface for the special edition of a book by a leading fashion designer.

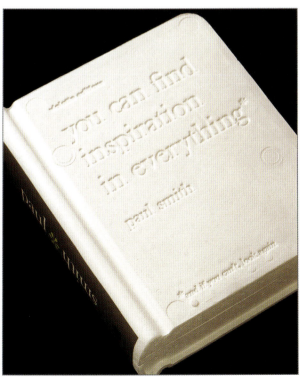

GLOSSARY

Debossing Impressing type or image into the surface of board or other substrate

Die cutting The mechanical punching of preformed shapes into paper or card using metal dies; now increasingly replaced by laser cutting

Embossing Creating raised areas on paper or card pressed between two matched plates.

Foil blocking A relief-printing process in which a very fine layer of pressed metal is fused to the paper surface

Raster Programs based around the manipulation of a bitmapped image area

Spot UV The printing of varnish into selective areas of the print area, either to intensify color in photos or type, or to create independent transparent graphic forms

Vector Programs based around the manipulation of vector paths

LETTER SPACING

Display typography is an illustrative, interpretive form that can draw upon a wide range of nuances and typographic effects. The range of possible approaches to the spacing of letters is therefore far broader and more varied than in editorial typography. In general terms, larger sizes of type often benefit from a tightening of letter spacing and leading, while smaller sizes may gain legibility from having the letter spacing and leading increased. The setting of titles and headlines allows the designer to concentrate more attention on individual letter pairs and manual kerning than would be practical across complex documents.

Display typography may employ extremes of spacing for deliberate typographic effect. Type may be set so close as actually to touch or overlap, creating unexpected graphic forms that the viewer traces and decodes. Extremely open letter spacing may be used to create a sense of deliberation and purpose, implying the gravity of the subject by requiring the reader to slow down and savor the information. Both approaches invite the readers' participation rather than dictating their response through "impact."

Many approaches to type that would be inappropriate in text setting can be utilized as positive qualities in display work. Discordant and fragmented forms may be appropriate in the context of the design; irregular spacing may be used to create fractured rhythms; incompatible typefaces may be deliberately juxtaposed; and legibility itself may be purposely reduced or obscured. We should judge the outcomes not by general typographic conventions, but by their effectiveness as an appropriate response to the content.

ALIGNMENT AND GRID

While the geometric page grid belongs more specifically to editorial typography, display typography also involves detailed consideration of the alignment between different elements. Finding a common vertical axis for two or more elements of the design will bring cohesion and visual continuity, allowing us to make visual connections from larger to smaller sizes of type. Such alignments may develop through the design of the layout to form a kind of organic or asymmetrical grid.

VARYING THE AXIS

The nature of display typography allows for type to be positioned upon more than one axis. This may involve a disciplined use of both horizontal and vertical type, a range of diagonal alignments, or an entirely free-form composition. As well as extending the visual dynamic of a design, the use of more than one axis can be an effective means of differentiating orders of information.

Designers should be aware, however, that, when type is set to a vertical, it is almost always more effective to turn the entire line upon its side than to attempt to stack horizontal letters in a vertical line. The natural variations of letter width are likely to create a vertical line of varying width, which is both visually unsatisfactory and difficult to read. If the design absolutely requires the vertical alignment of letters, the typeface should be broad and of substantial weight.

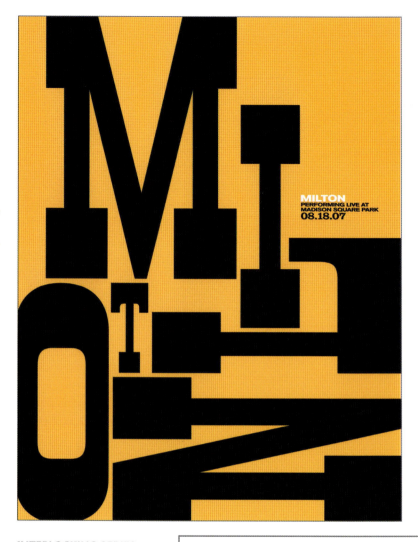

INTERLOCKING SERIFS

The features of a display typeface may provide opportunities for creative manipulation (above). The slab serifs of this Italienne face provide an abstract pattern of interlocking rectangles.

CONDENSED TYPE

In this page spread (right), the strong verticals of a condensed Grotesque type provide a rhythmic complement to the vivid directional graphics.

The Tennis & Rackets Association

Once again we are delighted to join British Land in welcoming you to the British Open Championships. While sadly this is the last year of British Land's Sponsorship of Real Tennis in the UK it is fitting that it coincides with our own Centenary. Fitting, because for the last fourteen years The British Land Company PLC sponsorship and the support of Sir John Ritblat have played a key role in promoting Real Tennis at all levels and has left the game in as good a condition as it has been for many decades.

As we celebrate the last 100 years we can unequivocally say that British Land's involvement has been a major factor in the Association's success. And as we embark on the next 100 years, with new sponsors, it will be from the solid base to which British Land has contributed so significantly.

British Land has supported all facets of the game – Open, Amateur, Club, Junior and Senior – which has been widely recognised and appreciated. It is especially encouraging to see some very promising younger players beginning to emerge from the Junior Open Championships which British Land have sponsored for a number of years. We are particularly indebted to their Honorary President and former Chairman, Sir John Ritblat, Vice President of the Tennis and Rackets Association, who has taken such an active interest at all levels of the game and whose advice will continue to be of enormous help to the Association in the future.

These Championships are the highlight of our season where we will be seeing the world's finest players in action.

The current World Champion, Rob Fahey, is arguably the finest player of all time and it is unfortunate that leading players such as Gunn, Riviere, Wood and Virgona have had to live with his supremacy despite being wonderful Tennis players in their own right.

Once again, we owe a debt of gratitude to Sam Leigh and the staff and volunteers of the T&RA for all the hard work they have put into organising this event.

We look forward to seeing top class competition in both the singles and doubles championships and know that you will join us in expressing our sincere appreciation to Sir John Ritblat and The British Land Company PLC for all they have given to the game throughout the past fourteen years.

Peter Mallinson
Chairman, The Tennis and Rackets Association

4|5

TYPE AS IMAGE

Display typography may involve type used as a physical or environmental medium, subjected to different processes and interventions to express an underlying concept. Restrained sans-serif type (above) provides context and explanation.

TYPOGRAPHIC FIGURES

The abstraction of type and letterform was characteristic of the early 20th-century avant garde. In this tribute to the Dada movement (above), the letters of the word Berlin are aligned to varying baselines and then reflected, to form an abstracted human figure.

SELECTING TYPE FOR DISPLAY SETTING

Display typography frequently focuses upon the associative values of type, and the manner by which it evokes particular responses. At its simplest, the focus may be on subjective or abstract values: the designer's response to the letterforms themselves (as curvaceous or angular, dominant or reticent, loud or soft, formal or informal, animated or static). More significant, however, is the range of associations type can evoke through reference to period, history, and tradition. Complex subtexts can be embedded in a design through the designer's awareness of cultural context and design history.

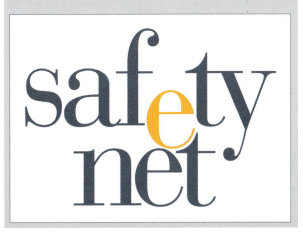

ASSIGNMENT

Choose an artist, author or composer with whom you are familiar. Position the subject's name upon a US letter page. Apply your knowledge of the subject's work:
• to your choice of typeface
• to your use of color

Consider the following:
• the shapes made by the ascenders and descenders in the name
• the relationship between the shape of the name and the shape of the US letter page
• your use of scale, tonality, and positive/negative shapes
• your use of alignment and letterspacing
• your use of transparency and opacity

Typography for the screen

Applications such as web design, games design, interactive CD-ROM, digital books, and other outcomes designed to be viewed on screen involve many considerations that are specific to new media. This does not, however, place them outside the broad principles of typographic practice and information design. Issues of legibility, readability, and a logical navigational structure are as crucial to the screen as to the printed page. However, while the first generation of web design frequently suffered from a lack of understanding of graphic design fundamentals, it is equally misguided to simply impose the conventions of the printed page upon website design.

■ TYPEFACES FOR THE SCREEN

Design for CD-ROM, screen, and broadcast graphics may use any digital typeface, but their clarity upon the screen can vary widely. This will be determined both by the quality of the letterforms and the attention the designer has given to hinting for screen rendering. Certain typefaces have been specifically designed for screen use, and it is best to use these wherever possible, particularly when working at smaller sizes, in order to ensure optimum legibility.

Effective design for the web involves allowing for variations of resolution and typographic definition. This will have a more obviously detrimental effect upon the details of serif faces, which has led to a prevalence of sans-serif faces in web design. The nature of the medium does not normally involve the immersive reading of long texts, and sans-serif faces are therefore a suitable option in most cases.

■ COLOR AND TONALITY

Design for the printed page is based upon the action of reflected light, while the screen operates through radiant light. This involves a very different relationship between the positive forms of the type and the negative space the type occupies. Type on a white page may be visually restful, where type on a white screen will be intrusive and tiring to the eye. The use of color and tonal values is therefore quite different in screen-based design than when designing for print. The well-considered use of contrasting colors is a key feature of readability in screen-based design.

■ TEXT IN WEB PAGE DESIGN

The design of text for the web raises particular problems for the typographer, and offers less control over the appearance of the final outcome than any other area of graphic reproduction. It remains the case that the running text in a web page will appear in the fonts available on the end user's machine, rather than necessarily remaining consistent to the face in which it was designed. This presents the designer with a range of options. The simplest is to use the most widely available fonts for all running text, or to use a preferred font in which the body sizes and proportions correspond reasonably closely to a commonly used default. Web type will be viewed upon monitors of varying size and quality, and should always be designed to function effectively at the lowest resolution at which it is likely to be seen. While this may seem to present an unacceptable set of limitations on the designer and to diminish control over the quality of the final outcome, the best strategy will incorporate these constraints into the overall design rather than working in spite of them.

While it may be possible to embed fonts within the web page, this will have an adverse effect upon download times, and also raises issues over copyright which have not yet been satisfactorily resolved. As with other screen-based applications, particular care should be taken at small sizes to ensure that the alignment of the letters with the pixel screen does not compromise or obscure their form. Well-defined counters, simple and robust structure, and a harmonious balance between stroke width and counter form are characteristics of a legible screen face. Wherever possible, the designer should use a typeface designed for screen use.

VERDANA

ABCDEFGHIJKLMNOPQRSTUVWXYZABCDEF
abcdefghijklmnopqrstuvwxyz1234567890ab
AaBbCcDdEeFfGgHhIiJjKkLlMmNnOo
PpQqRrSsTtUuVvWwXxYyZz1234567
ABCDEFGHIJKLMNOPQRSTUVW
abcdefghijklmnopqrstuvwxyz12
ABCDEFGHIJKLMNOP
abcdefghijklmnopqrst
ABCDEFGHIJKL
VERDANA

CONSTANTIA

ABCDEFGHIJKLMNOPQRSTUVWXYZABCDEFGH
abcdefghijklmnopqrstuvwxyz1234567890abcdefghij
AaBbCcDdEeFfGgHhIiJjKkLlMmNnOoPp
QqRrSsTtUuVvWwXxYyZz1234567890AaB
ABCDEFGHIJKLMNOPQRSTUVWX
abcdefghijklmnopqrstuvwxyz1234567
ABCDEFGHIJKLMNOPQR
abcdefghijklmnopqrstuv
ABCDEFGHIJKLMN
CONSTANTIA

GEORGIA

ABCDEFGHIJKLMNOPQRSTUVWXYZABCDEF
abcdefghijklmnopqrstuvwxyz1234567890abcdefg
AaBbCcDdEeFfGgHhIiJjKkLlMmNnOoP
pQqRrSsTtUuVvWwXxYyZz1234567890
ABCDEFGHIJKLMNOPQRSTUVW
abcdefghijklmnopqrstuvwxyz12345
ABCDEFGHIJKLMNOP
abcdefghijklmnopqrstu
ABCDEFGHIJKL
GEORGIA

CORBEL

ABCDEFGHIJKLMNOPQRSTUVWXYZABCDEFGHIJK
abcdefghijklmnopqrstuvwxyz1234567890abcdefghijkl
AaBbCcDdEeFfGgHhIiJjKkLlMmNnOoPpQq
RrSsTtUuVvWwXxYyZz1234567890AaBbCcD
ABCDEFGHIJKLMNOPQRSTUVWXYZA
abcdefghijklmnopqrstuvwxyz12345678
ABCDEFGHIJKLMNOPQRST
abcdefghijklmnopqrstuvwxy
ABCDEFGHIJKLMNO
CORBEL

THE CLEARTYPE PROJECT
Bill Hill, director of Microsoft Advanced Reading technologies, initiated the Microsoft ClearType project, and the ClearType font collection was developed and managed by Geraldine Wade. The collection was designed to showcase ClearType: a system for increasing the resolution of screen hardware through the manipulation of color subpixels. The project was intended specifically to address the need for new typefaces for screen-based applications including websites and the developing technologies of electronic book production. Six Western types were produced, all designed for screen use, along with a comprehensive Japanese type family with compatible Western fonts. Six leading type designers were involved: Jelle Bosma, Matthew Carter, Luc(as) de Groot, John Hudson, Eiichi Kono Gary Munch and Jeremy Tankard, and specialists Gerry Leonidas and Maxim Zhukov to advise on Greek and Cyrillic.

DESIGNED FOR THE SCREEN
Matthew Carter's Verdana and Georgia, John Hudson's Constantia, and Jeremy Tankard's Corbel (left) are among recent typefaces designed specifically for screen use as well as print.

PREPLANNING WEB DESIGN

Designing for the web involves a greater amount of predetermined formatting and allows for less hands-on intervention than print-based design. In this respect it has greater similarities with typesetting in the pre-digital era, and requires a considerable overview of the visual dynamics of the whole document. Web-design concepts, such as semantic markup, therefore provide a renewed focus upon issues that are actually fundamental to the whole discipline of typography.

WEB FORMATS AND STRUCTURES

Many traditional typographic design principles are equally fundamental to designing for the screen. It should be kept in mind, however, that the page and the multipage document are an essentially linear form with a defined beginning and end. The website, by comparison, is a multidirectional medium—a radial or nodal structure rather than a linear one, which the reader may navigate in several different ways. This informs the manner in which information is organized and connected, making writing for the web a specific discipline, quite different in many respects than writing for the page.

It is important to recognize that the website uses a mixed or purposely incomplete language system, in which written language works alongside images and icons but is not the dominant medium of content. Typography for the screen is therefore likely to be more concise and fragmentary than the typography of the printed page.

Design for navigation The design of a website differs from that of the printed page in that it incorporates interactive elements through which the user can progress, "reading" the document in a number of different directions and according to a range of different priorities. The manner in which the "active" parts of the web page are visually identified is a key aspect of the page design, and calls for clear and consistent typographic differentiation if the site is to be navigable and user-friendly.

Proportion All screen media use a landscape format, as distinct from the portrait proportions of the traditional printed page. This involves re-thinking preconceived approaches to grid structure. The outer limits of the viewable screen area are not consistent, and will vary from one monitor to the next. This requires the designer to abandon some fundamental assumptions of page design, in which relationships to page edge are a defining feature. Instead, the web designer may need to think in terms of the dynamics of radial forms or multiple margins, and to allow for the fact that the surrounding space may expand or contract under different viewing conditions.

Column structure The horizontal format of the screen invites the setting of long lines of text, but it is critical to ensure that comfortable line measures are maintained. Some designers take the view that screen communication requires a narrower column width than would be the norm for print-based design.

Line measure Wherever possible, steps should be taken to ensure that variations of screen rendering do not affect the line measure of the text.

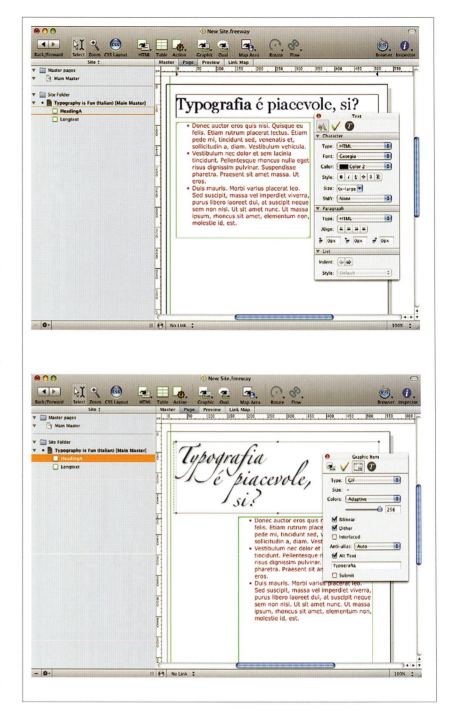

SAVING AS GRAPHICS

In the design of display graphics for the web page (above), the designer can ensure that typographic material retains its intended form by saving headings and titles as graphics. This means that the details of font, color, and any associated effects will remain unchanged; however, the words will not be editable.

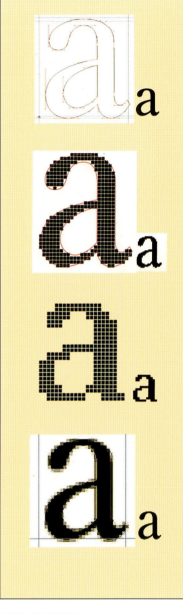

ASSIGNMENT
Test the relative legibility of different typefaces when used on screen.

Set a short paragraph of text in sizes from 9 point to 14 point, and view this on screen in five different typefaces. This selection should include at least one sans-serif and one serif face specifically designed for on-screen use, such as Verdana and Georgia.

Note the differences in performance, in terms of clarity, definition, evenness of rendering.

Note the smallest size at which each typeface gives a satisfactory and readable appearance on screen.

Grade the typefaces in order of suitability for setting continuous text for on-screen viewing

FUNCTION AND MINIMALISM
In this final year project (top), graphic and web design student Carly Smith used a disciplined variation of weight and color to produce a functional and structured site designed to complement a diverse range of design references, while remaining stylistically neutral.

COLOR AND DYNAMISM
In this festival website (above) a dynamic use of color establishes an informal and user-friendly atmosphere in a site which contains a wide variety of graphic content. Palettes of web-safe colors are now an established feature of professional color swatches.

ANTI-ALIASING
The size and position of type may create variations in the alignment between the letterform and the grid of pixels that make up the screen, leading to a visually irregular rendering of letters (above). The process of anti-aliasing is designed to compensate for this loss of clarity, smoothing the contours of the letterform by introducing intermediate tones of gray to selected pixels.

GLOSSARY
Anti-aliasing The process of smoothing the irregular pixelation of the letterform by introducing intermediate tones of gray to selected pixels
Hinting Design adjustment to ensure consistent alignment of the letter to the pixel grid
Nodal Radiating outward from key intersections or "nodes"

Environmental typography

The design of lettering for the built environment has historically drawn upon different traditions, skills, and media than the design of type for print. Although these histories have frequently overlapped or informed one another, the application of lettering to traditional building materials was the craft of the stonemason or the signwriter, much as the layout of type was the craft of the printer. Digital technology has created greater convergence across these areas of practice.

■ ARCHITECTURAL TYPOGRAPHY

Architectural typography needs to function effectively at scale, and to be readable from a range of angles and distances. It must communicate to the moving viewpoint of the pedestrian or motorist, harmonize with the materials and proportions of the building, and reflect the values of both the architect and the institution or organization it houses. Faces designed for print may appear both ill-proportioned and visually crude if they are simply enlarged to the scale necessary for a building or monument.

The designer needs to consider the action of light, and the manner in which the letters interact with the building materials. This may include the possibility of three-dimensionality—type that is raised, incised, or recessed. Further, the conditions may require illuminated signage, presenting a wide range of options for type to be lit from within, behind, above, or below.

In addition, architectural typography requires sensitivity to the idiom and period associations of a typeface, in order to achieve a harmonious relationship to the design philosophy of the architect.

■ PUBLIC ART AND SITE-SPECIFIC TYPOGRAPHY

Many contemporary public art projects make visual use of language and type, placing specially chosen statements, quotations, or pieces of visual poetry in public spaces. The choice of typeface is crucial in such projects, to ensure both readability under varying conditions of light and durability in the face of local weather conditions. The choice of typeface may also make specific reference to aspects of local history and regional culture.

TYPOGRAPHIC LIGHT
Many contemporary environmental projects use the laser projection of type onto buildings and public spaces. This work by Martin Firrell (above) projects a text from Herman Melville, author of Moby-Dick, onto a surface several stories high.

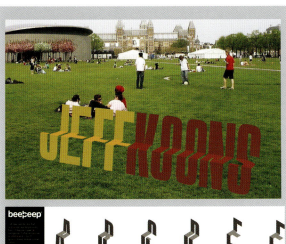

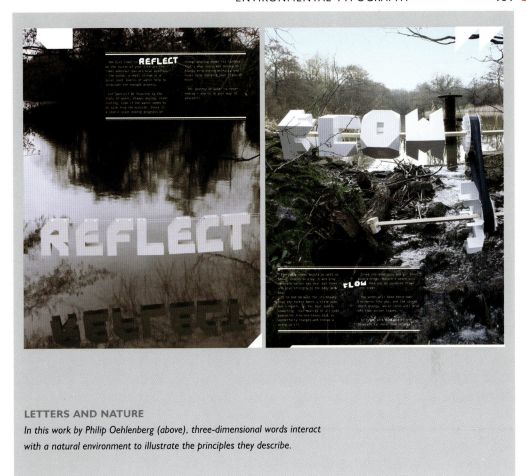

3-D LETTERS

In this proposal for a seating system in Amsterdam's Museum Square (above), the design makes productive use of the three-dimensional forms of André Toet's Wyggle typeface.

LETTERS AND NATURE

In this work by Philip Oehlenberg (above), three-dimensional words interact with a natural environment to illustrate the principles they describe.

SITE-SPECIFIC TYPOGRAPHIES

In Bettina Furnee's installation Lines of Defence *(right), situated on the eroding cliffs of the Suffolk coast in the East of England, 38 flags are positioned to spell out the words SUBMISSION IS ADVANCING AT A FRIGHTFUL SPEED. In her installation* Prisoner of War *(below), texts from wartime reminiscences are set in the window spaces of an abandoned wartime observation post.*

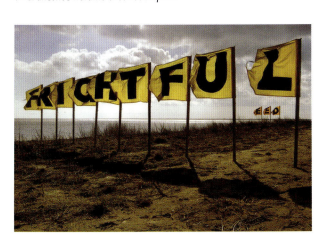

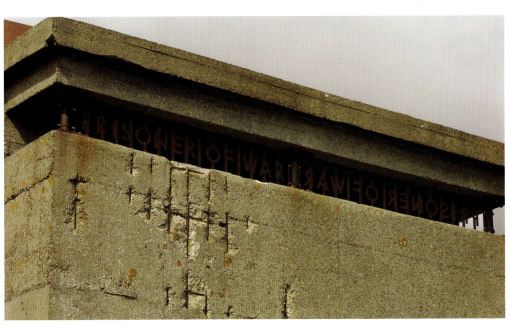

◼ INFORMATIONAL SIGNAGE AND WAYFINDING

In the context of informational signage, legibility is not merely a question of design aesthetics: it may be a matter of life and death. Information on highways, in hospitals, and airports may be crucial to safety and the efficiency of key services, and the legibility of the type is paramount.

As a consequence it is in these areas that some of the most sustained and objective studies of legibility have taken place. In particular, the differentiation of letters within the typeface must be explicit, ensuring that no letter or numeral can be confused with any other. The legibility of letters for use in these contexts depends, in particular, upon well-defined counters and junctions.

Words that may be viewed from an angle or while in motion require greater space between characters than words designed to be viewed at a fixed reading distance. Sufficient space must be allowed between the words and any additional graphic forms, such as directional arrows, symbols, or schematic mapping.

The typography of wayfinding is a complex area of graphic practice, and includes directional signs that direct to a site that is not yet visible to the user; identification signs that identify and confirm a visible destination; warning signs alerting the viewer to potential hazards; and regulatory and prohibitory signs that direct behavior and conduct.

Operational signage may provide more detailed information about an environment and offer different ways in which it can be navigated. This may include maps and charts. Within a wayfinding project, it will be necessary to coordinate all of these forms of graphic information into a single coherent system.

The wayfinding designer will then need to consider a range of site conditions—viewing distances, viewing angles, conditions of light and weather. All of these factors will in turn influence the use of type.

Signage and wayfinding graphics may utilize type illuminated from the front or from behind, raised above a surface or incised into it. Each of these approaches will affect the legibility of the type, and should be considered in detail when selecting or designing the typeface.

Through identification, signs offer some scope for expressive typography; however, the overriding concern of wayfinding design is legibility and a logical semantic structure. A range of weights may be used to differentiate different orders of information; color and tonality may be used to code different zones or activities.

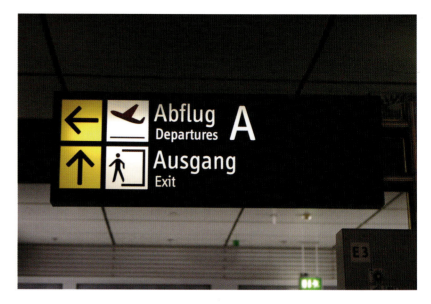

NAVIGATION AND DIRECTION

The design of illuminated signage (above) for public spaces requires type that will function well when back-lit, and has prompted the design of highly legible neo-grotesque types.

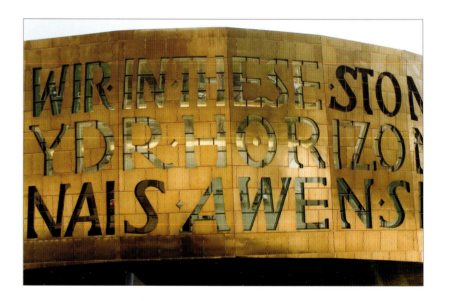

MODERN EPIGRAPHY

The inscription over the entrance of the Wales Millennium Centre (above) makes a reference to the formative influence of Roman culture in the British Isles. The letters which make up the words of Welsh poet Gwyneth Lewis form the windows to the center, and are illuminated from within.

TYPOGRAPHIC ENVIRONMENT

The signage created for the Dana Centre in the Science Museum, London (above) uses the Geometric Futura type to identify a space dedicated to science, technology, and culture.

WAYFINDING GRAPHICS

The system of wayfinding graphics designed by Nicholas Hawksworth (below) uses a contemporary sans-serif face to express directions, destinations, and encourage a deeper understanding of the organization through historic interpretation panels, and graphic awareness of the facilities offered across two connected Edwardian buildings.

3-D WAYFINDING SIGNS

The signage of a converted industrial complex (top and above) makes inventive use of three-dimensional type and vivid color-coding.

ASSIGNMENT

Choose a simple instruction or direction of not more than four words (No entry, Way out, etc.). Then select four different typefaces.

Set the instructional words in each of the typefaces, at as large a size as can fit onto an A3 printout. Take the four printouts to any exterior public space and position them at eye level. Compare and consider the performance of each typeface:

How legible is the instruction when viewed from a distance, from an angle; or from a moving viewpoint?

How well does the typeface harmonize with the surrounding architecture and any other features of the immediate environment?

Evaluate and grade the four typefaces according to these criteria.

GLOSSARY

Schematic mapping Diagrammatic non-literal representation of a zone or environment
Wayfinding Navigation through a built environment aided by graphic signage

Hand-drawn type

Graphic design in the 21st century has seen a very noticeable increase in the use of hand-rendered lettering across a range of commercial graphic applications. This may indicate a reaction to the lack of physicality or tactile value in digital type, reflecting a need to imbue letters with human, material characteristics. Digital technology has redefined the term "handmade" to encompass letters that have been "hand-drawn" with a light pen upon a graphics tablet, while digital type-design technology has allowed for highly gestural, autographic forms to be compiled into installable digital fonts.

■ HANDWRITING AND TYPOGRAPHY

Type design has its origins in the written letter, and has at different points in its history been invigorated by the influence of parallel, autographic traditions—from the Textura manuscript hand that informed Gutenberg's types, the italic scripts of the Renaissance or the copperplate of 18th-century writing masters, through to the influence of the calligraphers Edward Johnston, Rudolf Koch, and Hermann Zapf upon the development of 20th-century types. During the 500 years of metal typefounding, however, this influence was constrained to the production of standardized letterforms, which could not reflect the dynamic variations of the writer's hand that energize actual calligraphy.

■ LETTERING AS A GRAPHIC ART

Throughout the development of the graphic arts in the 19th and 20th centuries, type coexisted with display lettering that had been created by hand. The typography of posters, advertisements, and packaging depended upon the skills of commercial artists able to create fluent and vivid hand-rendered types and scripts.

The advent of photosetting created the demand for and the opportunity to introduce a wide range of display letters, including hand-lettered scripts. Lettering artists whose work had previously focused upon the custom lettering of headlines, titling, or logos were able to translate these skills into a new, more portable medium of type production, economical enough to support a wider range of style and variation than had been feasible in metal type. The work of US designers such as Ed Benguiat and Tony di Spigna crossed these boundaries and introduced a graphic flair and vitality from areas of commercial art that had previously been distinct from type manufacture. Similar opportunities for the design of expressive display faces were created by the development of dry transfer lettering in the 1960s and '70s.

■ POSTMODERNIST TYPE AND REAPPRAISAL OF THE HANDMADE

Reaction against the precepts of modernist design in the 1980s frequently involved handmade lettering, or physical interventions designed to disrupt the formal order of type.

Prior to the digital age, it had been possible to maintain clear distinctions between type design and lettering. Type was by definition a set of fixed and standardized letters, whereas lettering was a fluid and adaptable medium in which a designer could respond to the relationships of particular letter and word combinations, and could distort, modify, shade, and dimensionalize. These latter characteristics entered the field of set type with the development of photosetting, and were developed to a much fuller extent with the advent of digital media.

Now, the profiles of pre-existing type can be digitally crafted into customized forms, while vector drawing programs allow for an increasingly direct engagement between the hand-skills of the lettering artist and the digital environment. This provides scope both for the integration of type and custom lettering within digital artwork, and for the ready translation of the hand-drawn letter into the context of the digital font. The relative economy of digital production and storage allow for a typeface to be designed for a specific and quite limited use. Faces can be readily generated from scans of hand-rendered letters, and used to produce compositions that might appear to be wholly handmade.

■ LETTERING OR TYPE?

Simultaneous with these developments, our definitions of "type" have become more fluid. The vastly increased storage capacity offered by OpenType encryption has enabled the type designer to include multiple variant letterforms and ligatures, rather than singular definitive versions. This capability, combined with creative use of contextual alternates, has

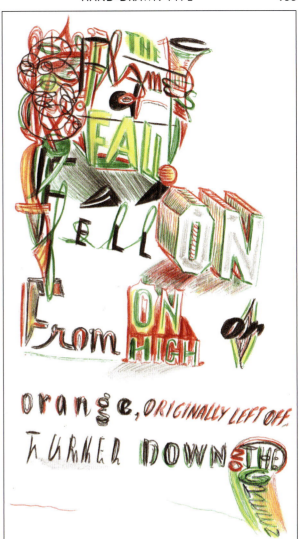

POSTMODERN LETTERING

In this drawing from a sketchbook by Ed Fella (right), the designer's background in commercial lettering forms the basis for a meticulously deconstructed graphic language in which inconsistency is one of the few constants.

CULTURAL ECLECTICISM

In this magazine cover by Margo Chase (left), references to gothic and indic scripts combine in an eclectic, mixed language, transforming typographic forms into abstract symbols that evoke varied cultural associations.

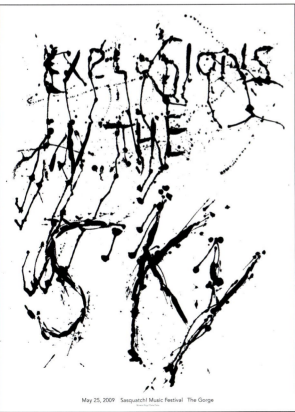

LETTERING AS MARK-MAKING

A commission from an independent music festival offered the creative freedom to employ gestural, expressionistic typography as the sole visual component of Robynne Ray's 2009 poster (left).

DIGITAL RETRO

Custom vector artwork is used to recreate the graphic vernacular of advertising in the early 20th-century in this design by Martin Rijven (right).

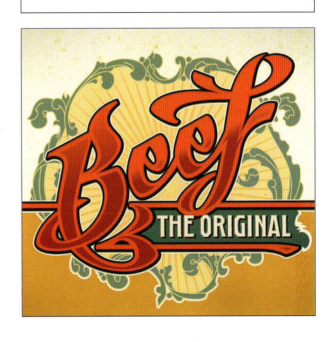

created the conditions for typefaces programmed to respond to different letter combinations with an enhanced range of colorful graphic variation.

DECORATION IN THE DIGITAL AGE

The renewed interest in making letters by hand in the 21st century can be seen both in unique custom designs and in the creation of fonts that have a distinctly gestural, manual quality reflecting the characteristics of brush or pen. Contemporary hand-rendered lettering often reflects an enthusiasm for the decorative and the ornamental. This frequently involves elaboration and embellishment, the decoration of letters with abstract decorative forms, or the manual distortion of existing letterforms.

THE REVIVAL OF ORNAMENT

For much of the 20th century, the influence of modernism led to a rejection of ornament as a design concept, until it was reappraised by postmodernist architects and designers in the 1980s. Since then, extravagant organic forms, curlicues, and typographic swashes have become a familiar component of 21st-century graphics, aided by the capabilities of vector drawing programs such as Adobe Illustrator.

A promotional poster for Jeffrey Keedy's typeface Lushus encapsulated this new approach with the term "artistic printing," an allusion to the parallels between the eclectic methods of the postmodern era and the visual extravagance of the 19th century. Some contemporary lettering artists make specific reference to historic decorative idioms, while others develop an eclectic synthesis combining diverse references and graphic possibilities. Some use physical media and processes including letterpress, screen-printing and stencil, as well as exploring the effects of different drawing tools and surfaces or substrates, while others work largely within the digital environment of vector drawing.

The hand-rendered letter has provided a counterbalance to the revived interest in postwar Swiss typography, offering decorative alternatives to minimalist design philosophies and reintroducing the warmth of the handmade in place of digital precision.

SOURCES AND APPLICATION

Handmade type covers a wide range of stylistic contexts and structural methods. It includes both letters based in the action of writing (from formal calligraphy to graffiti) and those that revisit the form of the typographic letter through manual processes. Much of the renewed interest in hand-rendered lettering has come from outside the mainstream of type design, through the work of illustrators and graphic artists working across a range of contexts and media, and many handmade type projects are essentially "one-off" artworks, created solely for use within specific contexts such as posters, book jackets, or graphic identities. Others are developed into custom digital typefaces, either for exclusive use within a particular commission or project, or for retail distribution.

ASSIGNMENT

Explore the use of a variety of writing tools for making letterforms. These may include ready-made nibs and brushes, but should also include some improvized tools, such as thin strips of wood or card, or any material that can be dipped into ink and used to make a mark.

Consider the manner in which these tools create the thick and thin strokes that determine the stress and ductus of a letter. Some tools, such as broad-nibbed pens or broad, flat brushes, will determine the thickening of the stroke by the angle at which they are held. Others, such as pointed quills, flexible nibs or pointed brushes, will determine the thickening of the stroke by the pressure placed upon them.

AUTOGRAPHIC LETTERING

The spontaneity of hand-rendered lettering (below) has been increasingly adopted by designers in the digital era, offering a range of variation and a human presence that are difficult to replicate in standardized type fonts.

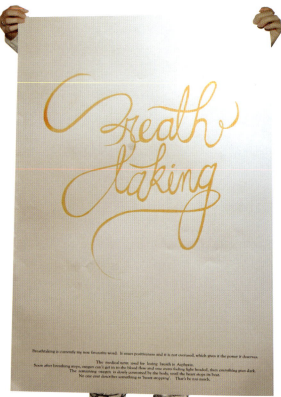

3-D TYPOGRAPHY

A combination of Fat-face Didone and Geometric types constructed in three dimensions by the influential Seattle design studio Modern Dog (above), noted for their innovative use of hand-rendered lettering.

FLUID TYPOGRAPHY

In this poster (right) for an AIGA talk on magazine design, letters are formed in liquid on a water-repellent surface.

THE FONT AS DRAWING

Charles Wilkins' hand-drawn font (below) replicates the direct and irregular qualities of hand-rendered lettering, in the form of a digital typeface.

Building a collection of typefaces

It is preferable to work with a limited number of well-chosen typefaces rather than adopting a different face for every project. Repeated use will develop a deep familiarity with the key characteristics of classic faces and an understanding of their character and capabilities. Many established professionals work with a very small range of typefaces, having refined their preferences to a selection of exceptionally functional styles.

■ WHY COLLECT TYPEFACES?

The 21st century has seen major developments in the range and quality of those typefaces offered as "bundles" with operating systems or software packages. Typefaces with a full range of professional features, produced to high specifications, are included with leading design software. A huge volume of fonts of variable quality is also available on the Internet at minimal cost. Why, then, should we supplement this with additional faces?

Balance and completeness Not all typographic categories or genres are equally well represented within the field of "bundled" fonts. Some of the most innovative new typefaces, and the most sophisticated revivals of classic forms, are produced by independent designers, licensing their work through established foundries or marketing them from their own websites. In order to reflect the quality of current typeface design, the designer or typographer needs to augment the font library with outside purchases. It is useful to consider how well each of the main categories in the Vox system is represented in one's library, and to add to it accordingly.

Range and versatility A designer can gain more use from a typeface with an extended family of weights, expert features, optical sizes, and other variants, than from a number of less comprehensive fonts. Though the prices of extended type families may be intimidating, it is useful to think of the typeface as a palette of typographic color to work with, rather than a limited set of shapes to import into your work.

Quality and distinctiveness A graphic designer's taste and typographic sophistication is measured by his or her choice of typefaces, and it follows that the use of specialized fonts will reflect the designer's particular sensibility and typographic knowledge. Keeping informed on recent developments in type design can provide a commercial edge and ensure that a designer's work continues to be distinctive and individual.

Order and coherence The public appetite for new and innovative forms has been a key factor in the evolution of typography and graphic design. However, an unmediated search for unusual and novel fonts can result in an overloaded font library with little order or coherence.

Availability and value Typefaces are offered free for a number of reasons. A few are offered for altruistic social and cultural purposes, others for self-promotion. Some designers and foundries will offer a limited set of fonts from a larger family as an incentive for the buyer to then purchase the full set. As the designer will expect to make a realistic return for the working time invested in designing a typeface, the axiom that "you get what you pay for" will normally hold true. "Experimental" display faces will not necessarily involve the same exacting standards as are expected in a text face, and these may be distributed free or at low cost.

Cost considerations Fonts cost far less when bought in collections (or indeed entire libraries) than when bought singly, so it may be best to look at the output of the major established foundries first (see Contacts on page 186). You are likely to find it more economical to buy a foundry collection than to purchase separately a large number of individual faces that you have selected.

Legality and professionalism The use of any typeface involves acceptance of the manufacturer's terms and conditions, which normally limit the number of individual sites for which the font is licensed. To copy a font that has been licensed to another user, or to allow another user to copy a font licensed to you, is a breach of copyright. This is not only a matter of law but also of professional ethics: The revenue from the licensing of their fonts enables type designers to continue in their work. Scrupulous observance of copyright is not only a legal necessity, but also a reflection of our professional obligation to support the continued development of type design.

It should not be assumed that the terms under which a typeface has been licensed will support unlimited use. Faces licensed for educational use may not be used for commercial projects. Typefaces are normally licensed for use on a specified number of sites.

Dangers of buying online Some online suppliers offer pirated versions of established faces. Remember that if you make commercial use of an illegally distributed face—or any typeface for which you do not hold an appropriate license—you are in breach of copyright and are breaking the law.

TYPOGRAPHIC FUNDAMENTALS

In this design (right), a selection of the most widely used typefaces is laid out in the format of the Periodic Table of Elements. While online research may establish some widespread preferences and some consensus on "classic" faces, it will also inevitably reveal differences of personal taste.

TYPOGRAPHIC PROMOTION

Though fonts are increasingly marketed and distributed online, the printed specimen remains a key mode of promotion for the type design industry. The production of flyers, booklets, and catalogs (below) enables major foundries and individual designers to establish distinctive identities as well as promoting specific typefaces.

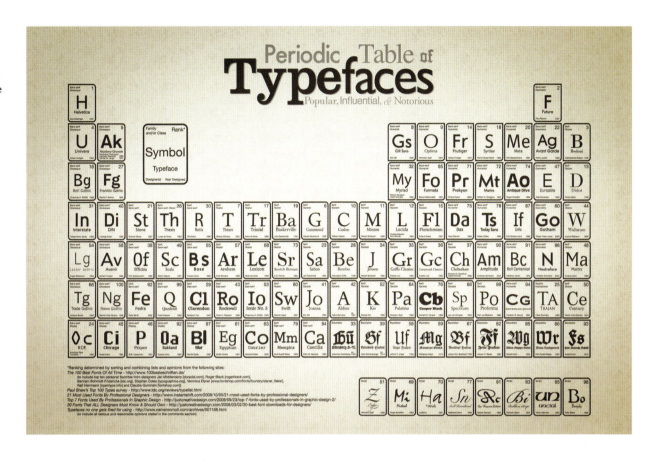

catalog of type

4

All experienced designers have
preferences among the massive
range of typefaces now available,
and the merits of personal lists
of favorites are the subject of
endless online debate. Specialist
typographers will further argue
the qualities of the versions
produced by different foundries.
The subject is too large, and
the range of design contexts too
broad, to hope for a definitive list
of the "best" typefaces. Several
canonical examples have already
been introduced in Chapter 2 as
key examples of defined typeface
categories. This
selection is designed
to augment these, and
to highlight issues of
functionality and detail.

Selected typefaces

The following selection includes text typefaces (Humanist to Modern European, pages 162–172), accompanied by sample text showing each face in use; and display faces (Pre-Typographic to Postmodern, pages 172–179), shown in the form of the word "Hamburgefons," a letter group widely used to demonstrate the key features of the face.

Humanist

Arno

Analysis and interpretation

The typographer's analysis illuminates the text, like the musician's reading of a score.

The typographer's first duty is to the text itself. An intelligent interpretation of the text will not only ensure readability, but will also reflect its *tone*, its *structure*, and its *cultural context*.

Designed by: Robert Slimbach 2007
Classification: Humanist/Aldine
Foundry: Adobe
Number of fonts: 32
Weights: 4
Expert features: Small caps, Old-Style figures, alternates, super and subscript, ordinals, swashes
Special features: 4 optical sizes, ornaments
Language support: Western 2, Central European, Cyrillic, Greek, Polytonic Greek, Vietnamese

Based upon Humanist typefaces of the 15th and 16th centuries, Arno combines characteristics of early Venetian and Aldine book types, themes Slimbach previously explored in typefaces such as Minion and Brioso. It is a multifeatured OpenType family, offering extensive pan-European language support, including Cyrillic and polytonic Greek. The family includes five optical size ranges, extensive swash italic sets, and small capitals for all languages.

Vendetta

Analysis and interpretation

The typographer's analysis illuminates the text, like the musician's reading of a score.

The typographer's first duty is to the text itself. An intelligent interpretation of the text will not only ensure readability, but will also reflect its *tone*, its *structure*, and its *cultural context*.

Designed by: John Downer 1999
Classification: Humanist/Venetian
Foundry: Emigre
Number of fonts: 14
Weights: 3
Expert features: Small caps, petite caps, Old-Style figures, super and subscript, ordinals, swashes
Language support: Standard

Vendetta is an explicitly digital reading of the Humanist form; an interpretation based not upon specific revival but on a synthesis between the work of a range of often neglected Venetian punchcutters and a concern for effective digital rendering. The structure of the letters is informed by historical example, but the sharp, tensile quality of line reflects digital vectors rather than the qualities of foundry type. Its distinctive features include the juxtaposition of the sharp-beaked head serifs with the blunt, slab-like form of the foot serif.

Garalde

Dante

Analysis and interpretation

The typographer's analysis illuminates the text, like the musician's reading of a score.

The typographer's first duty is to the text itself. An intelligent interpretation of the text will not only ensure readability, but will also reflect its *tone*, its *structure*, and its *cultural context*.

Designed by: Giovanni Mardersteig 1954
Classification: Aldine, Garalde
Foundry: Monotype, Adobe
Number of fonts: 19
Weights: 3
Expert features: Small caps, Old-Style figures, alternates, super and subscript, ordinals
Special features: Titling capitals
Language support: Standard

One of the most distinguished 20th-century revivals of the Aldine form, Dante also retains some of the flavor of earlier Venetian types. Adapted for machine composition by Monotype from the 12 pt size in 1957, Mardersteig's face has a stronger weight and more assertive serifs than its closest equivalent, Bembo, and is accompanied by a Chancery italic. Monotype added a semibold weight, enhancing the functionality of the face. It was redrawn by Ron Carpenter in 1993 for digital release in three weights, with a set of titling capitals.

Garalde continued

FF Clifford

Analysis and interpretation
The typographer's analysis illuminates the text, like the musician's reading of a score.

The typographer's first duty is to the text itself. An intelligent interpretation of the text will not only ensure readability, but will also reflect its *tone*, its *structure*, and its *cultural context*.

Designed by: Akira Kobayashi 1999
Classification: Garalde
Foundry: Fontfont
Number of fonts: 28
Weights: 1
Expert features: Small caps, non-lining figures, special and archaic ligatures
Special features: 3 optical sizes, borders
Language support: Standard, Central European

FF Cliford was based upon Alexander Wilson's Long Primer Roman from the 1750s, coupled with an italic based upon Joseph Fry's Pica Italic No.3. The face was designed in three separately drawn optical sizes, Clifford Six, Clifford Nine, and Clifford Eighteen, to retain the differentiation of the metal-type original and to optimize use at both small scale and subhead sizes. The face includes non-lining figures, an extended range of special and archaic ligatures, and a full font of borders.

Stempel Garamond

Analysis and interpretation
The typographer's analysis illuminates the text, like the musician's reading of a score.

The typographer's first duty is to the text itself. An intelligent interpretation of the text will not only ensure readability, but will also reflect its *tone*, its *structure*, and its *cultural context*.

Designed by: Claude Garamond/ Stempel 1592/1924
Classification: Garalde
Foundry: Stempel, Linotype
Number of fonts: 13
Weights: 2
Expert features: Fractions
Language support: Standard, Central European

A "true" Garamond, based upon a Garamond sample sheet of 1592, the Stempel Garamond released in 1924 has an angular, incised appearance which is unlike other Garamond types. It is also slightly heavier in weight and suffers from very short descenders made to fit it on the German standard alignment of the period. It is nevertheless a highly readable text face suitable for book work and other long text applications.

Hoefler Text

Analysis and interpretation
The typographer's analysis illuminates the text, like the musician's reading of a score.

The typographer's first duty is to the text itself. An intelligent interpretation of the text will not only ensure readability, but will also reflect its *tone*, its *structure*, and its *cultural context*.

Designed by: Jonathan Hoefler 1991
Classification: Garalde
Foundry: Hoefler and Frère-Jones
Number of fonts: 27
Weights: 3
Expert features: Small caps, non-lining figures, special and archaic ligatures, swashes, swash small caps, alternates, fractions
Special features: Borders, ornaments, 2 engraved cap fonts
Language support: OpenType version features comprehensive Latin-X

Hoefler Text was inspired by Linotype Garamond No. 3 (based upon type designed by Jean Jannon) and Linotype Janson Text 55 (designed by Miklós Kis). It has subtly curved lines that allude to the warmth and print quality of metal foundry types. It comprises a total of 27 fonts, including small caps, swash italics in all of its three weights, two weights of engraved caps, and a font of fleurons. The letterforms are uniformly balanced and well-considered across all of the weights, making it a highly versatile and colorful text face.

Granjon

Analysis and interpretation
The typographer's analysis illuminates the text, like the musician's reading of a score.

The typographer's first duty is to the text itself. An intelligent interpretation of the text will not only ensure readability, but will also reflect its *tone*, its *structure*, and its *cultural context*.

Designed by: George W. Jones 1928
Classification: Garalde/French
Foundry: Linotype
Number of fonts: 6
Weights: 2
Expert features: Small caps, Old-Style figures, super and subscript, ordinals
Language support: ISO Adobe 2

A "true Garamond" based upon the 1582 letters of the *Historia Ecclesiastica* cut for Garamond by Robert Granjon, Granjon was designed by George W. Jones for the English branch of Linotype in 1928. The bold weight was added by American Chauncey H. Griffith in 1930. Jones' revival is a sharp, highly contrasted and beautifully legible face for long text setting which became an extremely popular book face in the US.

Garalde continued

Janson Text

Analysis and interpretation

The typographer's analysis illuminates the text, like the musician's reading of a score.

The typographer's first duty is to the text itself. An intelligent interpretation of the text will not only ensure readability, but will also reflect its *tone*, its *structure*, and its *cultural context*.

Designed by: Miklós Kis/Robin Nicholas, Patricia Saunders 1690/1985
Classification: Garalde/Dutch
Foundry: Monotype
Number of fonts: 8
Weights: 2
Expert features: Small caps, Old-Style figures, super and subscript, ordinals

Janson Text is based upon a typeface cut by Hungarian punchcutter Miklós Kis in 1685, misattributed to Anton Janson of Leipzig, and revived in 1937 by Chauncey Griffith of Linotype. Linotype Janson was cut in 1954 under the supervision of Hermann Zapf, based on the original Kis punches. The most recent expansion of Janson in 1985 by Horst Heiderhoff created a versatile family, probably the most authentic digitization of the Kis types. Its sturdy forms and strong contrast have made it a popular face for book and magazine work.

Meridien

Analysis and interpretation

The typographer's analysis illuminates the text, like the musician's reading of a score.

The typographer's first duty is to the text itself. An intelligent interpretation of the text will not only ensure readability, but will also reflect its *tone*, its *structure*, and its *cultural context*.

Designed by: Adrian Frutiger 1954
Classification: Garalde
Foundry: Deberny and Peignot, Linotype
Number of fonts: 6
Weights: 3
Language support: Standard

Originally designed for hand composition, Meridien has large triangular serifs, a generous x-height, and a very slight oblique stress. The counters are well-defined and the descenders fairly short, making it an economical face while retaining a high level of legibility. Frutiger's rationale for the form of the serifs was that they create consistent negative shapes between letters; this is borne out by the overall sense of visual continuity. A well-balanced semibold completes the family, which can be effectively partnered with the sans-serif Frutiger.

Minion

Analysis and interpretation

The typographer's analysis illuminates the text, like the musician's reading of a score.

The typographer's first duty is to the text itself. An intelligent interpretation of the text will not only ensure readability, but will also reflect its *tone*, its *structure*, and its *cultural context*.

Designed by: Robert Slimbach 1991
Classification: Garalde
Foundry: Adobe
Number of fonts: 93
Weights: 4
Expert features: Small caps, Old-Style figures, alternates, super and subscript, ordinals, swashes
Special features: 4 optical sizes, condensed fonts, ornaments
Language support: ISO Adobe2 Cyrillic, Greek

Minion was one of the first of Slimbach's faces to feature an integrated design across multiple scripts, initially including a Cyrillic and later a Greek. This has since become the norm for "pro" text faces produced by Adobe. In addition to this extended character set, it includes small caps, multiple weights, ornaments, and swashes. Minion is an economical and versatile typeface suited to a wide range of functions from book work through general text setting.

Miller

Analysis and interpretation

The typographer's analysis illuminates the text, like the musician's reading of a score.

The typographer's first duty is to the text itself. An intelligent interpretation of the text will not only ensure readability, but will also reflect its *tone*, its *structure*, and its *cultural context*.

Designed by: Matthew Carter, Tobias Frère-Jones, Cyrus Highsmith 1997
Classification: Garalde/Scotch
Foundry: Font Bureau/Carter and Cone
Number of fonts: 15
Weights: 4
Expert features: Small caps, Old-Style figures, super and subscript, ordinals
Special features: Companion fonts Miller text, Miller display, Miller headline
Language support: Standard

Miller is based upon the sturdy utilitarian "Scotch Roman" typefaces cut for Glasgow foundries in the early 19th century by Richard Austin. Widely used in the US during the 19th century, these were some of the first typefaces designed with newspapers in mind. Carter's revival is authentic in having both roman and italic small caps, a feature of the originals. The revival's success as a newspaper face led to the design of the narrower headline style Miller Headline.

Garalde continued

Plantin

Analysis and interpretation

The typographer's analysis illuminates the text, like the musician's reading of a score.

The typographer's first duty is to the text itself. An intelligent interpretation of the text will not only ensure readability, but will also reflect its *tone*, its *structure*, and its *cultural context*.

Designed by: Frank Pierpont 1913
Classification: Garalde
Foundry: Monotype
Number of fonts: 37
Weights: 4
Expert features: Small caps, Old-Style figures, super and subscript, ordinals
Special features: Titling Roman caps, condensed fonts, infant version
Language support: Standard, Cyrillic

Plantin is derived from the letters of Robert Granjon, re-cut for machine setting with a separate cursive italic. The strokes were thickened and the ascenders and descenders were shortened for the Monotype machine, giving a larger x-height and resulting in an economical and robust face with strong mass upon the page. The bold weight was designed to optimize contrast, balanced by a slight sharpening to the serifs. Plantin is notable for solid and consistent performance, and was used as the original model and reference in the development of Times New Roman.

Times New Roman

Analysis and interpretation

The typographer's analysis illuminates the text, like the musician's reading of a score.

The typographer's first duty is to the text itself. An intelligent interpretation of the text will not only ensure readability, but will also reflect its *tone*, its *structure*, and its *cultural context*.

Designed by: Stanley Morison, Victor Lardent 1931
Classification: Garalde
Foundry: Monotype
Number of fonts: 68
Weights: 5
Expert features: Small caps, Old-Style figures, super and subscript, ordinals, swashes
Special features: Condensed fonts, small text fonts
Language support: Central European, Cyrillic, Greek, Turkish

Though rendered over-familiar by widespread use, Times New Roman remains a highly efficient and practical typeface, reflecting an unobtrusive synthesis of historical sources and machine manufacture. Sharper and more well-defined than many of its contemporaries, it has been adapted to far wider and more general uses than could have originally been envisaged, including its adoption as a system font for both Macintosh and PC Windows.

Transitional

Swift

Analysis and interpretation

The typographer's analysis illuminates the text, like the musician's reading of a score.

The typographer's first duty is to the text itself. An intelligent interpretation of the text will not only ensure readability, but will also reflect its *tone*, its *structure*, and its *cultural context*.

Designed by: Gerard Unger 1987, 1998
Classification: Garalde/Modern Dutch
Foundry: Gerard Unger, Linotype
Number of fonts: 11
Weights: 6
Expert features: Super and subscript, ordinals
Special features: Ornaments
Language support: ISO Adobe 2, Central European

A newspaper typeface originally released in the 1980s and revised in 1998, Swift is designed to retain its sharpness and definition under the conditions of high-speed web printing. A high x-height and open counters ensure its functionality. Wedge-shaped serifs, composed of straight lines, introduce a lively visual tension and directionality into a highly functional yet elegant face, which reflects the influence of W.A. Dwiggins. It has been adopted by numerous publications for corporate and magazine use.

Bell

Analysis and interpretation

The typographer's analysis illuminates the text, like the musician's reading of a score.

The typographer's first duty is to the text itself. An intelligent interpretation of the text will not only ensure readability, but will also reflect its *tone*, its *structure*, and its *cultural context*.

Designed by: Austin/Monotype 1931
Classification: Transitional
Foundry: Monotype
Number of fonts: 19
Weights: 3
Special features: Small caps, Old-Style figures, alternates, super and subscript, ordinals
Language support: Standard

The types of John Bell continued the tradition of Caslon and Baskerville but were eclipsed by the Moderns, before being revived by Morison in the 1930s to add to the Monotype list. Bell is a reconstruction of Richard Austin's 1788 typeface. Arguably an early Modern or Didone, it is more properly a late Transitional typeface, enlivened by sharp serifs and some variation of stress. Originally used in newspapers, Monotype Bell became well established as popular book type.

Transitional continued

Century Schoolbook

Analysis and interpretation
The typographer's analysis illuminates the text, like the musician's reading of a score.

The typographer's first duty is to the text itself. An intelligent interpretation of the text will not only ensure readability, but will also reflect its *tone*, its *structure*, and its *cultural context*.

Designed by: Morris Fuller Benton 1924
Classification: Transitional
Foundry: Monotype, Adobe
Number of fonts: 6
Weights: 2
Language support: ISO Adobe 2, Central European, Greek, Cyrillic, Turkish

Based on the earlier Century Expanded typeface begun by Linn Boyd Benton for *The Century* magazine, Century Schoolbook reflects early legibility research that confirmed the importance of stroke contrast. Solid bracketed serifs, a wide form, and well-defined counters reinforce the legibility of a face which has become well established for clarity both in informational contexts and children's book publishing. The italics ware added in later revivals by Linotype and ITC.

Electra

Analysis and interpretation
The typographer's analysis illuminates the text, like the musician's reading of a score.

The typographer's first duty is to the text itself. An intelligent interpretation of the text will not only ensure readability, but will also reflect its *tone*, its *structure*, and its *cultural context*.

Designed by: William Addison Dwiggins 1935
Classification: Transitional/Slab Serif
Foundry: Linotype
Number of fonts: 14
Weights: 2
Expert features: Small caps, Old-Style figures, super and subscript, ordinals
Special features: Display fonts
Language support: Standard

Designed by William Addison Dwiggins in 1935, Electra is a distinctive face of considerable character. Sometimes categorized as a Didone, it is better viewed as a hybrid or synthesis reflecting the diversity of sources that informed Dwiggins' work, rather than a single historical model. It has a high contrast, and a slightly inclined stress which recalls Dwiggins' hand-rendered lettering. Designed for metal setting, the regular weight can appear light at text sizes. The bold is more colorful and is practical as a main font for text setting.

Perpetua

Analysis and interpretation
The typographer's analysis illuminates the text, like the musician's reading of a score.

The typographer's first duty is to the text itself. An intelligent interpretation of the text will not only ensure readability, but will also reflect its *tone*, its *structure*, and its *cultural context*.

Designed by: Eric Gill, Charles Malin 1925
Classification: Transitional/Glyphic
Foundry: Monotype
Number of fonts: 16
Weights: 2
Expert features: Small caps, Old-Style figures
Special features: Titling capitals
Language support: Standard

Though cut by Charles Malin to Gill's drawings, Perpetua owes more to a sculptor's understanding of the Roman letter than to the evolution of punchcut forms. It is arguably as much a Glyphic as a Transitional type, but its vertical stress and high contrasts suggest the early modern letter rather than the old face. The light weight of the fine strokes and the tapered fine-pointed serifs are liable to lose definition at small sizes or under adverse printing conditions, while the low x-height limits the economy of setting.

Slab Serif

Rockwell

Analysis and interpretation
The typographer's analysis illuminates the text, like the musician's reading of a score.

The typographer's first duty is to the text itself. An intelligent interpretation of the text will not only ensure readability, but will also reflect its *tone*, its *structure*, and its *cultural context*.

Designed by: Frank Pierpont 1934
Classification: Slab Serif/Geometric
Foundry: Monotype
Number of fonts: 9
Weights: 4
Special features: Condensed fonts
Language support: Standard

Rockwell is a largely geometric face with a well-defined slab serif. The roman weight is monoline, with a serif of equal thickness to the stroke width, while the bold weight has slight contrast, Rockwell has a generous x-height and short descenders. The bar apex of the A and the deep serifs reinforce the linear qualities of the typeface, which is robust and effective in the setting of small amounts of well-leaded text. Its simplicity and legibility have also made it an effective face for web design.

Slab Serif continued

Memphis

Analysis and interpretation
The typographer's analysis illuminates the text, like the musician's reading of a score.

The typographer's first duty is to the text itself. An intelligent interpretation of the text will not only ensure readability, but will also reflect its *tone*, its *structure*, and its *cultural context*.

Designed by: Rudolf Wolf 1930
Classification: Slab Serif
Foundry: Linotype
Number of fonts: 14
Weights: 4
Expert features: Small caps, Old-Style figures, super and subscript, ordinals
Language support: Central European, Cyrillic

One of the earliest 20th-century revivals of the slab serif form, Memphis prefigures modernist tendencies and appears closer to the spirit of the new typography than to the 19th-century display origins of the form. A geometric Slab Serif with a neutral and objective appearance, relieved by the bar apex to the A and an eccentric stroke to the Q, Memphis is a very evenly weighted monoline face suitable for display work and limited text setting.

Sans Serif

Trade Gothic

Analysis and interpretation
The typographer's analysis illuminates the text, like the musician's reading of a score.

The typographer's first duty is to the text itself. An intelligent interpretation of the text will not only ensure readability, but will also reflect its *tone*, its *structure*, and its *cultural context*.

Designed by: Jackson Burke 1948
Classification: Grotesque
Foundry: Ludlow, Linotype
Number of fonts: 14
Weights: 3
Expert features: Small caps, Old-Style figures, super and subscript, ordinals
Special features: Condensed and extended fonts
Language support: Central European

The first cuts of Trade Gothic were designed by Jackson Burke in 1948. and further weights and styles were added until 1960. The family is enlivened by a certain variation of underlying structure across the family of 12 weights and widths with a bold condensed form noticeably more square-sided and mechanistic than the lighter weights. These variants comprise a lively and versatile sans-serif family fit for a wide range of uses. The bold condensed fonts are popular in the newspaper industry for headlines.

Tempo

Analysis and interpretation
The typographer's analysis illuminates the text, like the musician's reading of a score.

The typographer's first duty is to the text itself. An intelligent interpretation of the text will not only ensure readability, but will also reflect its *tone*, its *structure*, and its *cultural context*.

Designed by: Robert Hunter Middleton 1931
Classification: Geometric
Foundry: Ludlow, Linotype
Number of fonts: 2
Weights: 1
Expert features: Super and subscript, ordinals
Language support: Standard

Produced for the Ludlow foundry in 1931, Hunter Middleton's Tempo is one of several American responses to the widespread success of Paul Renners 1927 Futura. Intended for display setting and newspaper work it is a basically Geometric face, moderated by some Humanist influences. The heavy condensed font is excellent for headlines.

Avenir

Analysis and interpretation
The typographer's analysis illuminates the text, like the musician's reading of a score.

The typographer's first duty is to the text itself. An intelligent interpretation of the text will not only ensure readability, but will also reflect its *tone*, its *structure*, and its *cultural context*.

Designed by: Adrian Frutiger 1988
Classification: Geometric/Humanist
Foundry: Linotype
Number of fonts: 24
Weights: 6
Expert features: Super and subscript, ordinals
Special features: Ornaments
Language support: Central European

A linear sans serif in the tradition of Erbar and Futura, Avenir has an x-height higher than these but lower than many later Geometrics. It has broad proportions and open counterforms notably in the C and S. The two-story letter a reflects a Humanist element in an otherwise Geometric face. The light and book weights are unusually close, and suitable for text setting. Bold and extra bold complete the range of weights. Avenir's balanced geometry has made it a popular choice for graphic identities.

Sans Serif continued

Akkurat

Analysis and interpretation

The typographer's analysis illuminates the text, like the musician's reading of a score.

The typographer's first duty is to the text itself. An intelligent interpretation of the text will not only ensure readability, but will also reflect its *tone*, its *structure*, and its *cultural context*.

Designed by: Laurenz Brunner 2004
Classification: Neo-Grotesque
Foundry: Lineto
Number of fonts: 6
Weights: 3
Special features: Monospace version
Language support: Standard, Central European

A highly successful development of the Neo-Grotesque idiom, **Akkurat** is a restrained but fresh typeface which meets the requirements of a revived interest in minimal modernist styles in the 21st century. While it owes much of its basic form to the Helvetica tradition, it has become established as a viable alternative for the discriminating typographer, and offers features characteristic of current digital type production.

Serif/Sans

Stone/Stone Sans

Analysis and interpretation

The typographer's first duty is to the text itself. An intelligent interpretation of the text will not only ensure readability, but will also reflect its *tone*, its *structure*, and its *cultural context*.

Analysis and interpretation

The typographer's first duty is to the text itself. An intelligent interpretation of the text will not only ensure readability, but will also reflect its *tone*, its *structure*, and its *cultural context*.

Designed by: Sumner Stone 1988
Classification: Garalde/Hybrid/ Humanist Sans
Foundry: Linotype
Number of fonts: 20, 29,14
Weights: 3
Expert features: Small caps, Old-Style figures, super and subscript
Language support: Central European

Among serif-sans families, Stone shows the greatest variation of structure and stylistic features between its different faces. The family comprises three faces: Stone, Stone Sans, and a kind of intermediate hybrid, Stone Informal. The serifs are bracketed and tapered, the x-height is generous, and the stress slightly inclined. The sans-serif face has moderate contrasts in stroke width and appears more an unserifed version of an Old-Style letter rather than a face with a distinct identity within the sans-serif genre. It is, however, noticeable that the vertical symmetry of the bowl forms alludes to Grotesque or Modern forms rather than Humanist traditions.

Scala/Scala Sans

Analysis and interpretation

The typographer's first duty is to the text itself. An intelligent interpretation of the text will not only ensure readability, but will also reflect its *tone*, its *structure*, and its *cultural context*.

Analysis and interpretation

The typographer's first duty is to the text itself. An intelligent interpretation of the text will not only ensure readability, but will also reflect its *tone*, its *structure*, and its *cultural context*.

Designed by: Martin Majoor 1990, 1993
Classification: Garalde Slab Serif/ Humanist Sans
Foundry: FontFont
Number of fonts: 16
Weights: 4
Expert features: Small caps, Old-Style figures, contextual alternates, super and subscript, ordinals
Special features: Display "Jewel" faces, condensed fonts
Language support: Standard, Baltic, Central European

Scala typifies the new wave of Dutch types of the late 20th century. It is a text face that functions well under conditions of low resolution. A slab serif on a Humanist structure, it is fairly even in color, with a restrained contrast providing a dramatic comparison to the greater contrasts of the bold. The companion sans serif, Scala Sans, is a balanced and harmonious monoline Humanist Sans that shares the same underlying skeleton or "form principle" as the serif face. The family is completed by a range of condensed fonts and also a set of decorative display variants, Scala Jewel.

Serif/Sans continued

Seria/Seria Sans

Analysis and interpretation
The typographer's first duty is to the text itself. An intelligent interpretation of the text will not only ensure readability, but will also reflect its *tone*, its *structure*, and its *cultural context*.

Analysis and interpretation
The typographer's first duty is to the text itself. An intelligent interpretation of the text will not only ensure readability, but will also reflect its *tone*, its *structure*, and its *cultural context*.

Designed by: Martin Majoor 1993
Classification: Garalde/Slab/ Humanist Sans
Foundry: Fontfont
Number of fonts: 4, 4
Weights: 2
Expert features: Small caps, Old-Style figures, super and subscript
Language support: Standard

A development from the Scala family, Seria is designed specifically for book work and has noticeably deeper descenders and higher ascenders in a tradition established by Jan Van Krimpen. This influence can also be seen in the very restrained slope of the italics, which echoes the Romanee italic of 1949. A second, more sloped italic face, Seria Cursive, will equip the typeface with two distinct italic fonts: a unique differentiation. Seria Sans is a fairly light monoline sans of Humanist proportions, which echoes the characteristics of the serif face. The ascender height results in lining figures far more condensed than the non-lining forms. Both faces are produced in two weights only, with a pronounced contrast between the weights. A close correspondence of x-height and underlying proportion enable the faces to be combined harmoniously.

Celeste/Celeste Sans

Analysis and interpretation
The typographer's first duty is to the text itself. An intelligent interpretation of the text will not only ensure readability, but will also reflect its *tone*, its *structure*, and its *cultural context*.

Analysis and interpretation
 The typographer's first duty is to the text itself. An intelligent interpretation of the text will not only ensure readability, but will also reflect its *tone*, its *structure*, and its *cultural context*.

Designed by: Christopher Burke 1994
Classification: Transitional/Didone/ Grotesque
Foundry: Hiberniatypes, Fontfont
Number of fonts: 68
Weights: 4
Expert features: Small caps, Old-Style figures, contextual alternates, super and subscript, ordinals
Special features: Office and small text fonts
Language support: Standard

Designed as a face for lengthy texts, Celeste is based upon Modern or Didone principles, with a vertical stress and a geometric rather than calligraphic structure, tempered by dynamic features which evoke transitional values. The face does not however have the high contrast associated with these genres, and is characterized by an even weight and rhythm on the page. Capitals smaller than the ascender letters contribute to this sense of visual balance, which is further supported by a restrained italic with few cursive qualities. The variant face Celeste Small Text is designed for setting at sizes of 8pt and below. Extra bold and Black weights were added in 2000. The sans serif form is also a hybrid; a grotesque moderated by some humanist characteristics. The letters share a limited commonality of proportion and outer profile with their serif counterpart, while showing stylistic differences which provide for effective and colorful contrast.

Thesis/Thesans

Analysis and interpretation
The typographer's first duty is to the text itself. An intelligent interpretation of the text will not only ensure readability, but will also reflect its *tone*, its *structure*, and its *cultural context*.

Analysis and interpretation
The typographer's first duty is to the text itself. An intelligent interpretation of the text will not only ensure readability, but will also reflect its *tone*, its *structure*, and its *cultural context*.

Designed by: Luc(as) de Groot 1994
Classification: Slab Serif/Humanist Sans
Foundry: Lucasfonts/Fonthaus
Number of fonts: 144
Weights: 8
Expert features: Small caps, Old-Style figures, alternates, super and subscript
Special features: Intermediate semi-serif style "Themix"
Language support: Standard

Lucas de Groot's Thesis is one of the most extensive typographic "superfamilies." The family is based around three distinct letterforms—Thesans, Theserif and Themix, each of which is produced in eight weights and each weight in six variants (plain, italic, small caps, small caps italic, expert, and expert italic). The italics are distinct fonts in their own right, rather than sloped variants of the roman. The range of weights should be used selectively and with discretion, avoiding either using adjacent weights or too many different weights of the typeface.

Serif/Sans continued

Rotis/Rotis Sans

Analysis and interpretation
The typographer's first duty is to the text itself. An intelligent interpretation of the text will not only ensure readability, but will also reflect its *tone*, its *structure*, and its *cultural context*.

Analysis and interpretation
The typographer's first duty is to the text itself. An intelligent interpretation of the text will not only ensure readability, but will also reflect its *tone*, its *structure*, and its *cultural context*.

Rotis Semi Serif/Rotis Semi Sans

Analysis and interpretation
The typographer's first duty is to the text itself. An intelligent interpretation of the text will not only ensure readability, but will also reflect its *tone*, its *structure*, and its *cultural context*.

Analysis and interpretation
The typographer's first duty is to the text itself. An intelligent interpretation of the text will not only ensure readability, but will also reflect its *tone*, its *structure*, and its *cultural context*.

Designed by: Otl Aicher 1988
Classification: Garalde/ Grotesque
Foundry: Agfa Compugraphic, Monotype
Number of fonts: 9, 6, 6, 18
Weights: 3
Expert features: Super and subscript, Ordinals
Language support: Central European, Cyrillic, Greek

One of the earliest "superfamilies" or type systems, Rotis was designed to combine the key qualities of leading serif and sans types into a single family, with consistent legibility, functionality, and economy, and the capacity for interchangeable use. The form of the C is a visually anomalous feature some find intrusive in an otherwise balanced face. In addition to the regular serif and sans, the family includes two further intermediate styles: Rotis Semi Sans and Rotis Semi Serif. All fonts share the same set width and a matched weight and x-height. Rotis Semi Serif is a de-serifed version of Rotis Serif, Rotis Semi Sans is a Glyphic Grotesque, and Rotis Sans is a traditional Grotesque. The Semi Serif has had some popularity as an eccentric display variant to a functional text family.

Le Monde/Le Monde Sans

Analysis and interpretation
The typographer's first duty is to the text itself. An intelligent interpretation of the text will not only ensure readability, but will also reflect its *tone*, its *structure*, and its *cultural context*.

Analysis and interpretation
The typographer's first duty is to the text itself. An intelligent interpretation of the text will not only ensure readability, but will also reflect its *tone*, its *structure*, and its *cultural context*.

Designed by: Jean-Francois Porchez 1994, 1997
Classification: Garalde/Humanist Sans
Foundry: Porchez Typofonderie
Number of fonts: 3, 3
Weights: 2
Expert features: Small caps, Old-Style figures, alternates, super and subscript, ordinals, swashes
Special features: Related book face, ornaments
Language support: Standard, Central European

The Le Monde family is derived from the face Le Monde Journal, originally designed in 1994 as a custom font for the French newspaper *Le Monde* and intended for newspaper use and at small sizes. It has a similar "color" to Times New Roman, but appears more open, with larger counters and a more fluent continuity on the page. The face is available in three weights; the bold is dramatically contrasted with the roman, while the demi is designed for titling or more specialized applications. The family was dramatically extended with the introduction of three closely related subfamilies: these include Le Monde Livre Classic, a more literary and less utilitarian face offering a wide palette of stylistic effects, including a full set of swash italics; and Le Monde Courrier, an office face designed to reinstate the informal character of typewriting and to function well under conditions of low resolution. Available in seven weights, Le Monde Sans is a lineale type family derived from the serifed types, with a pronounced variation in stroke width. It continues the common structure of the Le Monde family, with a relatively narrow width and oblique axis. It is designed for integrated use with other Le Monde faces.

Serif/Sans continued

Legacy/Legacy Sans

Analysis and interpretation
The typographer's first duty is to the text itself. An intelligent interpretation of the text will not only ensure readability, but will also reflect its *tone*, its *structure*, and its *cultural context*.

Analysis and interpretation
The typographer's first duty is to the text itself. An intelligent interpretation of the text will not only ensure readability, but will also reflect its *tone*, its *structure*, and its *cultural context*.

Designed by: Ronald Arnholm 1992
Classification: Humanist/Humanist Sans
Foundry: ITC, Linotype
Number of fonts: 43
Weights: 4
Expert features: Small caps, Old-Style figures, alternates, super and subscript, ordinals
Special features: Condensed and ultra-condensed fonts, square-serif family
Language support: Standard

The Legacy family comprises a serif and a sans-serif face, both based upon the form and proportions of Jenson's roman. The italic is based upon the italics of Claude Garamond. Legacy Sans is therefore explicitly a Humanist Sans. It is characterized by a delicate modulation of stroke width and a fluid diagonal stroke to the S. It is a broad face with well-defined counters, and benefits from fairly loose character spacing. The italic is a highly legible cursive sans, distinct from the italic alphabet of the serif form, and can be used for text setting. The correspondence of underlying proportion and x-height make Legacy Serif a natural companion face. Legacy Sans is available in four weights.

Quadraat/*Quadraat Sans*

Analysis and interpretation
The typographer's first duty is to the text itself. An intelligent interpretation of the text will not only ensure readability, but will also reflect its tone, its structure, and its cultural context.

Analysis and interpretation
The typographer's first duty is to the text itself. An intelligent interpretation of the text will not only ensure readability, but will also reflect its tone, its structure, and its cultural context.

Designed by: Fred Smeijers 1997–8
Classification: Garalde/Grotesque
Foundry: Fontfont
Number of fonts: 70
Weights: 3
Expert features: Small caps, Old-Style figures, super and subscript, ordinals
Special features: Display, condensed, and headline fonts
Language support: Standard, Central European, Cyrillic

Informed by detailed practical research into the processes and techniques of punchcutting, Quadraat is a book typeface with classical proportions, visually enlivened by some deliberately inconsistent detailing more characteristic of the metal era than the digital age. Rather dark in overall color, it retains legibility well at small sizes. The deep, triangular bracketed serif references Old-Style Dutch types of the 17th century. The face includes small caps and a second set of lining figures to align with them. Originally released in 1992 as a small family of serifed text typefaces, FF Quadraat was developed into a large family of compatible sans and serif subfamilies, including headline, display, and condensed fonts, and a monospace version. Quadraat Sans was released in 1996 and appears stylistically subordinate to the serif letters. Smeijers' concern for differentiation and functional irregularity finds expression in details such as the angled finials. Quadraat is available in 14 styles and weights, with a distinctive italic.

Officina/Officina Sans

Analysis and interpretation
The typographer's first duty is to the text itself. An intelligent interpretation of the text will not only ensure readability, but will also reflect its *tone*, its *structure*, and its *cultural context*.

Analysis and interpretation
The typographer's first duty is to the text itself. An intelligent interpretation of the text will not only ensure readability, but will also reflect its *tone*, its *structure*, and its *cultural context*.

Designed by: Erik Spiekermann, Ole Schafer 1990
Classification: Slab Serif/Neo-Grotesque
Foundry: Fontfont/ITC
Number of fonts: 37
Weights: 5
Expert features: Small caps, Old-Style figures, alternates, super and subscript, ordinals
Special features: Display fonts, bullets, arrows
Language support: Standard

Officina is a highly functional near-monoline face. A condensed slab-serif form, it has four weights, and is also available in a sans-serif version, Officina Sans. The Officina family was originally designed as a functional "office" typeface, but its understated utilitarian qualities were adopted for more widespread use, prompting the design of the extended family of weights. Officina's outwardly rugged structure reveals enlivening subtleties, such as the complex curves of the G and S forms, the half serifs of the m, n, and h, and the stem and descender of the single-story g. It can be readily paired with the sans-serif version, which has identical basic forms at all weights.

Modern European

Trinité

Analysis and interpretation

The typographer's analysis illuminates the text, like the musician's reading of a score.

The typographer's first duty is to the text itself. An intelligent interpretation of the text will not only ensure readability, but will also reflect its *tone*, its *structure*, and its *cultural context*.

Designed by: Bram de Does 1978–81
Classification: Garalde/Modern Dutch
Foundry: Enschede/TEF
Number of fonts: 23
Weights: 3
Expert features: Small caps, Old-Style figures, alternates, super and subscript, ordinals
Special features: Range of 4 heights of ascender/descender, condensed versions
Language support: Standard

Based in the tradition of Dutch type established by Jan Van Krimpen, Trinité is a family of typefaces comprising a wide roman and narrow roman in two weights, as well as two weights of small caps and italics. A very slight slope to the roman letters provides visual momentum and flow. A distinctive and original feature of the family is the fact that both roman and italic are available in three lengths of ascender and descender, equipping the typeface for a range of general text uses and specialized book work.

Dolly

Analysis and interpretation

The typographer's analysis illuminates the text, like the musician's reading of a score.

The typographer's first duty is to the text itself. An intelligent interpretation of the text will not only ensure readability, but will also reflect its *tone*, its *structure*, and its *cultural context*.

Designed by: Bas Jacobs, Akiem Hemling, Sami Kortemaki 2001
Classification: Modern European
Foundry: Underware
Number of fonts: 4
Weights: 2
Expert features: Small caps, Old-Style figures, super and subscript, ordinals
Language support: Standard

A Dutch-style book face of unusually bold weight and low contrast, Dolly is designed to work legibly at very small sizes, while revealing interest at display scale. It has some similarities to Smeijers's Quadraat. The family consist of four fonts: The roman has Old-Style figures as standard, the italic is lighter and narrower for effective differentiation, while the bold is full and rounded. The small caps complete a family designed to meet all text requirements without requiring a lavish range of fonts.

Pre-Typographic Archaic/Classical

SOPHIA

HAMBURGEFONS

Designed by: Matthew Carter 1993
Classification: Incised/Historical
Foundry: Carter and Cone
Number of fonts: 1
Weights: 1
Special features: Alternates, linking glyphs
Language support: Standard

Based upon incised hybrid letterforms from 6th-century Constantinople, Sophia reflects the cosmopolitan mixture of stylistic influences which informed this period. The typeface is notable for a complex system of joining letters which can be used to create a range of ligatures. Designed as a single font with no italic or subsidiary weights, the face includes a colorful range of variant letters.

HERCULANUM

HAMBURGEFONS

Designed by: Adrian Frutiger 1990
Classification: Inscriptional/Classical
Foundry: Linotype
Number of fonts: 3
Weights: 2
Expert features: Alternates, super and subscript, ordinals
Special features: Outline font
Language support: Standard

Based upon Roman painted letters of the 1st and 2nd centuries BCE, the face takes its name from Herculaneum, one of the Roman cities destroyed by the eruption of Vesuvius in 79 CE. The typeface is based on cursive capitals found on papyri from this period. Narrow capitals are combined with wide ones and the single case offers a wide range of alternate letters. The face comprises two weights and an outline version.

Pre-Typographic Medieval

VERE DIGNUM

HAMBURGEFONT

Designed by: Phil Baines 2002
Classification: Medieval
Foundry: Linotype
Number of fonts: 3
Weights: 1
Expert features: Alternates, super and subscript, ordinals
Special features: Three interchangeable fonts
Language support: Standard

A monoline face incorporating experimental letterforms with both modern and medieval characteristics, Vere Dignum comprises six alphabets, compiled into a family of three typefaces. Vere Dignum Regular contains two different interpretations of the uppercase alphabet; Vere Dignum Alternates contains another two alphabets, which may be used in combination. Vere Dignum Decorative contains the last two alphabets of this series, which are rounder and more curvilinear.

Goudy Medieval

hamburgefons

Designed by: Frederic Goudy/ Lisa Wade 1993
Classification: Medieval/Blackletter
Foundry: Mentor
Number of fonts: 1
Weights: 1
Language support: Basic Latin

This typeface was based on a 12th-century South German manuscript hand, from which Goudy preserved the gothic spirit while romanizing individual characters. Like much of his historically inspired work, the interpretation of sources is a loose and inconsistent one, the typeface an evocative but quite general evocation of medieval characteristics refracted through an early 20th-century perception.

aLcHeMY

HAMBURGEFONS

Designed by: Jeremy Tankard 1993
Classification: Inscriptional/Medieval
Foundry: Jeremy Tankard Typography
Number of fonts: 2
Weights: 1
Expert features: Superiors, inferiors, special ligatures
Special features: Plug-in characters and finials
Language support: Standard

Based upon medieval lettering from a wide variety of sources, Alchemy is a synthesis of many variant letterforms which predate the development of printed type. The character set is augmented with a large number of alternate forms, special ligatures, and superscript letters, allowing the user a wide range of options and permutations to work with. The face is in one weight with no italics.

Renaissance

CRESCI

HAMBURGEFONS

Designed by: Garrett Boge, Paul Shaw 1996–7
Classification: Inscriptional/Humanist
Foundry: Letter Perfect
Number of fonts: 1
Weights: 1
Language support: Standard

Based upon the lettering of Giovanni Francesco Cresci, the pre-eminent Vatican scribe of the late 15th century, the refined capitals of the Cresci face exemplify the aesthetic of the Renaissance in a display face that evokes both scribal letters and the inscriptional forms that informed them. The face is characterized by the classically narrow proportions of the E and F, and has a very slightly smaller size of small cap in place of a lowercase.

Garalde Companions

Big Caslon

Hamburgefons

Designed by: Matthew Carter 1994
Classification: Garalde
Foundry: Carter and Cone/Adobe
Number of fonts: 4
Weights: 1
Expert features: Small caps, Old-Style figures, alternates, super and subscript
Language support: Standard

Based upon the larger sizes of the Caslon foundry types, Big Caslon is a display typeface with a noticeably greater contrast of stroke width than is found in faces modeled on the text sizes. The result is a vivid and animated face in which the idiosyncrasies which enliven Caslon's letters become a visible feature.

MANTINIA

HAMBURGEFONS

Designed by: Matthew Carter 1993
Classification: Garalde/inscriptional
Foundry: Carter and Cone
Number of fonts: 1
Weights: 1
Expert features: Small caps, Old-Style figures, alternates
Special features: Special ligatures
Language support: Standard

Mantinia is a display face inspired by the letterforms of the Renaissance artist and engraver Andrea Mantegna, one of the first to study and revive the monumental lettering of imperial Rome. It contains several distinctive ligatures, raised small capitals, and tall capitals that are also inscriptional in origin. It is an effective display companion for Carter's Galliard.

Rationalist

Ambroise

Hamburgefons

Designed by: Jean-Francois Porchez 2001
Classification: Didone
Foundry: Porchez Typofonderie
Number of fonts: 5
Weights: 5
Expert features: Small caps, Old-Style figures, semi-Old-Style figures, alternates, super and subscript
Special features: Ornaments, borders
Language support: Standard

Designed by Jean François Porchez in 2001, Ambroise is a contemporary interpretation of Didot's late style, cut by the punchcutter Vibert. The black weight was the basis for the conception of the family, which reinstates the distinctive g, y, and k letterforms which other revivals have standardized. Every variation of the typeface is named after a member of the Didot dynasty. The condensed variant is called Ambroise Firmin. The extra-condensed is called Ambroise Francois.

Industrial

Giza

Hamburgefons

Designed by: David Berlow 1994
Classification: Slab Serif
Foundry: Font Bureau
Number of fonts: 16
Weights: Non-standard
Special features: Range of unique weights/widths
Language support: Standard

Based upon Vincent Figgins' specimen of 1845, Giza is a bold "Egyptian" and possibly the closest digital equivalent to Vincent Figgins' Antique Roman, the first example of Slab Serif or Egyptian type. This exemplified a style that was to be widely adopted through the 19th century. Figgins' types had not been adapted to subsequent print technologies, and Giza provides a vivid digital revival of the idiom. It comprises a series of 16 styles, across a range of nine weights and nine widths.

Industrial continued

Gotham

Hamburgefons

Designed by: Tobias Frère-Jones 2000
Classification: Grotesque/Geometric
Foundry: Hoefler and Frère-Jones
Number of fonts: 66
Weights: 8
Expert features: Non-lining figures
Special features: Narrow, extra narrow, and condensed fonts, related "rounded" fonts
Language support: OpenType version features comprehensive Latin-X

Derived from the lettering on the New York Port Authority bus terminal, Gotham has been developed into a comprehensive range of weights and widths which have made it a popular choice for display and text setting. A vernacular sans serif, it has been refined and extended to address a variety of stylistic possibilities. In 2009 the family was augmented by Gotham Narrow, a compact variation on the style specially engineered for text sizes.

Interstate

Hamburgefons

Designed by: Tobias Frère-Jones/ Cyrus Highsmith 1993–4
Classification: Grotesque
Foundry: Font Bureau
Number of fonts: 40
Weights: 7
Special features: Condensed and compressed fonts, Pi font, Monospace version
Language support: Standard

Derived from the signage of US highway signage alphabets of the Federal Highway administration, and adapted and developed for magazine and advertising use, Interstate combines a rugged and utilitarian ambience with high legibility. Its popularity has prompted the development of an extended range of 40 fonts including compressed, condensed, and regular widths, and weights from hairline to ultra black. The family also includes a series of fonts featuring symbols inspired by traffic signs.

Ornamental/Decorated/Open

Arnold Bocklin

Hamburgefons

Designed by: Otto Weisert 1904
Classification: Art Nouveau
Foundry: Mecanorma, Adobe
Number of fonts: 1
Weights: 1
Language support: Standard

Named after the Swiss symbolist painter Arnold Boecklin, Weisert's typeface evokes the book design of the Jugendstil movement through a vocabulary of florid organic forms. The typeface saw a renewed popularity in the late 1960s. It comprises a basic set of capitals in a single weight.

Modernist/Geometric

Neuzeit Grotesk

Hamburgefons

Designed by: Wilhelm Pischner 1928
Classification: Geometric
Foundry: Linotype
Number of fonts: 2
Weights: 2
Special features: Companion condensed fonts
Language support: ISO2

First released by Stempel in 1928 Neuzeit Grotesk was adopted by the German Standards Committee in the 1970s for official signage and traffic directional systems, after which the abbreviation DIN (*Deutsches Institut für Normung*, The German Institute for Industrial Standards) was added to the name. Widely used in the German printing industry, it is a largely utilitarian typeface, with a few distinguishing features including the crossbar J and the curved foot of the l.

Modernist/Geometric continued

Spartan

Hamburgefons

Designed by: Rick Cusick 1951
Classification: Geometric
Foundry: Linotype
Number of fonts: 2
Weights: 2
Special features: Complementary "classified" version
Language support: ISO Adobe 2

Released by American Type Founders as an American response to Futura, Spartan has more of the characteristics of the Grotesque. An exceptionally high x-height and wide proportions make it a legible and functional face which functions well at small sizes. The optical variant Spartan Classified was designed specifically for use at 5.5-point in classified advertising.

Avant Garde

Hamburgefons

Designed by: Herb Lubalin, Tom Carnase 1967
Classification: Geometric
Foundry: ITC/Adobe
Number of fonts: 14
Weights: 5
Expert features: Alternates, super and subscript, ordinals
Special features: Condensed fonts
Language support: Central European

Developed from the titling designed for Avant Garde magazine, the current digital form does not include the ligatures and alternates that enlivened Lubalin's original. Avant Garde was originally designed to be set very tight, and variant forms were devised to maintain an even rhythm of letter spacing The typographic expression of an abstract idea best resolved in its capital letters, Avant Garde Gothic is at its most effective when used as a titling face. The repetition of Geometric forms can impede differentiation between letters, and the circular counters are visually intrusive.

ITC Bauhaus

Hamburgefons

Designed by: Ed Benguiat, Victor Caruso 1975
Classification: Geometric
Foundry: ITC/Adobe
Number of fonts: 5
Weights: 5
Expert features: Super and subscript, ordinals
Language support: Standard

A very loose adaptation of Herbert Bayer's prototype letters of 1925 for the Dessau Bauhaus, ITC Bauhaus was designed in 1975 by Ed Benguiat and Victor Caruso. Much of the simplistic rigor of Bayer's original has been moderated to produce a typeface across five weights—light, medium, demi, bold, and heavy. The typeface tends now to evoke the 1970s more than the 1920s.

p22 bayer

hamburgefons

Designed by: Herbert Bayer, Denis Kegler, Richard Kegler 1925/1997
Classification: Geometric
Foundry: P22
Number of fonts: 1
Weights: 1
Language support: Standard

A more faithful revival of Bayer's letters than ITC Bauhaus, P22 Bayer is part of a font set including two other Bayer faces and a collection of 72 graphic elements inspired by various Bauhaus works. The inconsistencies that result from a wholly Geometric approach are rigorously maintained, resulting in a colorful period reconstruction in a single weight.

Chalet

Hamburgefons

Designed by: Rene Chalet/ House Industries 2000
Classification: Geometric/ Neo-Grotesque
Foundry: House Industries
Number of fonts: 27
Weights: 3
Language support: Extended Latin, Central European

House Industries Chalet type family originally comprised ten faces in three distinct styles, and a wholly fictitious provenance as a project supposedly inspired by the fashion designer René Albert Chalet. The designs are broadly modernist and monoline, with a range of stylistic variations between Geometric and Neo-Grotesque features. The collection also includes over 100 silhouette images. Subsequent development has increased the number of styles to 27. Chalet includes a cyrillic and extended language support.

Modernist/Geometric continued

Super Grotesk

Hamburgefons

Designed by: Christian Schwartz 2002
Classification: Geometric/
Humanist Sans
Foundry: House Industries
Number of fonts: 38
Weights: 5
Expert features: Old-Style figures
Special features: Display and text,
slab and inline versions
Language support: Extended Latin,
Central European

Based on the face originally developed in the 1930s as a substitute for Futura in East Germany, Super Grotesk has a low x-height and a balanced Geometric form. The capitals are very slightly condensed when compared to the fully Geometric proportions of the lowercase letters. The face features non-lining figures and is also available in condensed versions.

Manual Calligraphic

Calflisch Script

Hamburgefons

Designed by: Robert Slimbach 1993
Classification: Script
Foundry: Adobe
Number of fonts: 4
Weights: 4
Expert features: Alternates, super
and subscript, ordinals, swashes
Language support: Central European

Robert Slimbach's design is based on the handwriting of Max Caflisch, a teacher of graphic arts in Zurich. The fluid yet disciplined character of this writing is retained in an informal linked script, which adapts the subtleties and natural letter joins of Caflisch's original handwriting into a highly functional typeface. The typeface was designed in four weights and maintains legibility at a full range of point sizes. Caflisch Script is suited to small amounts of running text, as well as titling and display work in books and advertisements.

Poetica Chancery

Hamburgefons

Designed by: Robert Slimbach 1992
Classification: Script/ Chancery
Foundry: Adobe
Number of fonts: 21
Weights: 1
Expert features: Small caps,
Old-Style figures, alternates, super
and subscript, swashes
Special features: Multiple
swash variants
Language support: Standard

In Poetica, the italic form is the basis for an extensive independent type family, rather than a companion to a roman font. Based upon the Humanist Lettera Cancellaresca, the family consists of 21 fonts providing an unusual variety of design possibilities within one typeface. It includes numerous swash letters, ornaments and ligatures, beginnings and endings, ampersands, and ornaments.

Matura

Hamburgefons

Designed by: Imre Reiner 1938
Classification: Script
Foundry: Monotype
Number of fonts: 2
Weights: 1
Expert features: Super and subscript,
ordinals, swashes, alternates, ordinals
Special features: Scriptorial capitals
Language support: ISO Adobe 2

Designed by the Hungarian wood engraver and type designer Imre Reiner in 1938 and released by the Monotype Corporation, Matura is a bold upright script with vibrant scriptorial capitals and the characteristics of broad-edged pen lettering.

Manual/Calligraphic continued

ITC Silvermoon

Hamburgefons

Designed by: Akira Kobayashi 1998
Classification: Art Deco Script
Foundry: ITC, Fontfont
Number of fonts: 2
Weights: 2
Expert features: Super and subscript, alternates, ordinals
Special features: Ornaments
Language support: ISO Adobe 2, Central European

ITC Silvermoon is a condensed and fluid face which combines geometric and calligraphic characteristics to evoke the Art Deco style of the 1920s. Kobayashi designed the face in two contrasting weights. The regular weight is essentially monoline, while the bold has a pronounced contrast of stroke width, suggesting the action of a broad-nibbed pen.

Donaldson Hand

Hamburgefons

Designed by: Timothy Donaldson 2003
Classification: Handwritten Script
Foundry: Letraset
Number of fonts: 1
Weights: 1
Special features: Dingbats and symbols
Language support: Standard

A collaboration between Letraset and letterworker Timothy Donaldson, based upon his own exuberant handwriting style, Donaldson Hand is an informal script of considerable immediacy and dynamism. The rough edges of the strokes evoke the action of the nib upon a rough textured paper, and variations in alignment to the baseline serve to animate the face despite its fairly basic character set.

Brush Script

Hamburgefons

Designed by: Robert E. Smith 1942
Classification: Brush script
Foundry: ATF
Number of fonts: 1
Weights: 1
Expert features: Super and subscript, ordinals
Language support: Standard

Designed by Robert E. Smith in 1942 for American Type Founders, Brush Script remained in widespread popular use through the successive technological changes of the 1960s and 1970s. Characterized by confidence and verve rather than formal elegance, it provided the assertive qualities necessary in a commercial typeface. Informal, spontaneous, and direct, it reflects the craft skills of the jobbing lettering artists of the pre-digital age.

WATERS TITLING

HAMBURGEFONS

Designed by: Julian Waters 1997
Classification: Calligraphic/Classical
Foundry: Linotype
Number of fonts: 12
Weights: 4
Expert features: Alternates, super and subscript, ordinals
Special features: 3 widths (regular, condensed, semicondensed)
Language support: Standard, Central European

Waters Titling was designed by calligrapher and lettering artist Julian Waters. Based in letterforms created with the broad-nibbed pen, the design is related to other historically based titling alphabets but offers a wider range of weights and widths. The structure and proportions are based on the Roman monumental inscription forms of the first and second centuries CE but expressed through the vitality of the calligraphic letter. The face is notable for its flowing, subtly bracketed serifs.

PONTIF

HAMBURGEFONS

Designed by: Garrett Boge 1996
Classification: Inscriptional/Baroque
Foundry: Letter Perfect
Number of fonts: 1
Weights: 1
Language support: Standard

Pontif is a Baroque script typeface based on the inscriptional lettering work of Luca Horfei, the Vatican scribe who designed the major inscriptions for Pope Sixtus V's Rome in the 16th century.

Informational/Wayfinding

Parisine PTF

Hamburgefons

Designed by: Jean-Francois Porchez 1996
Classification: Neo-Grotesque
Foundry: Porchez Typofonderie
Number of fonts: 4
Weights: 2
Expert features: Small caps, Old-Style figures, semi-Old-Style figures, super and subscript, ordinals, swashes
Language support: Standard, Central European

Designed in 1996 to replace the use of Helvetica across the Parisian transport service RATP, the Parisine family was revised and extended for use in maps and external communication. A synthesis of the Germanic Neo-Grotesque and a more organic Latin style, it is more economical and legible than Helvetica. The set of more than 700 glyphs supports numerous Latin-script European languages. Small caps are available in all weights, and the face includes miniscule lowercase and figures for automated fractions.

FF Info Display

Hamburgefons

Designed by: Erik Spiekermann, Ole Shafer 1996
Classification: Neo-Grotesque
Foundry: Fontfont
Number of fonts: 20
Weights: 5
Expert features: Super and subscript, ordinals
Language support: Standard

Part of a very extensive family that includes Info Text and Info Office, Info Display comprises 15 styles. It is a robust and legible condensed sans serif with a subtle rounding at the terminals and a tapering of its nearly monoline strokes at junctions. Detailed hinting means that the Info types are particularly well adapted to web and other screen contexts.

Digital

Lithium

Hamburgefons

Designed by: Akira Kobayashi 2002
Classification: Beyond Classification
Foundry: Typebox
Number of fonts: 10
Weights: 3
Special features: Additional Ray fonts
Language support: Western European

Unusual among the work of a designer largely associated with traditional forms, Lithium is a consciously technological, electronic design with a blur-like rounding to its forms. The suggestion of electronic display letters is developed in the "Ray" versions. The range of weights and display variants provides a colorful and visually harmonious face for the information age.

Postmodern/Amorphous

Matrix

Hamburgefons

Designed by: Zuzana Licko 1986
Classification: Digital/postmodern
Foundry: Emigre
Number of fonts: 9
Weights: 3
Expert features: Small caps

The early Emigre faces were designed to retain their form, consistency, and legibility under conditions of very low resolution, while showing greater detail at higher resolutions. Matrix was the first of these designed for postscript. While this allowed for more detailed drawing, Matrix was intended to save memory space by using simple ratios. This was the basis for the distinctive triangular serifs, which gave the smoothest result at low resolution. In addition to representing a key point in the evolution of digital type design, Matrix remains highly functional as a screen font.

Usage and styling

This section is a guide to some common points of correct typographic usage. Most of these are matters of convention and will be governed by the house style of an organization or publication. In several cases, accepted usage differs from one country to another. Technically, many of these are editorial matters or questions of good linguistic practice rather than design choices, and in many cases they would be addressed by a sub- or copy-editor, or resolved by reference to the style guide used by the client or publisher. However, it is increasingly common for designers to be required to input text with minimal editorial support, and it is therefore important for the designer to be aware of good practice in the detailing of text.

Abbreviations such as Inc, Co, and common contractions such as Ltd, Mr, Dr, do not require a full point: Murder Inc Mrs Dalloway Dr John Dee	**The abbreviations i.e. and e.g.** for "that is" and "for example" should be set with full points and no additional space. However, full points may be omitted in the interest of visual coherence: The figures, i.e. the numerals A modern face, e.g. Walbaum
Abbreviations for weights and measures may be set without a preceding space, do not require a full point, and should not be expressed in the plural: 11pt Bauer Bodoni on 120gsm blade paper	**Abbreviations in lowercase** such as plc and mph are written without full points: He slowed to 30mph outside the offices of Rolls Royce plc
Abbreviations for volume, page, circa should have a full point without a following space: Updike's Printing Types Vol.1 p.1 c.1922	**The abbreviation St.** for "street" is normally given a full point to distinguish it from St, used as an abbreviation of "saint": As a student I lived in St John's St., Winchester He used a Gibson SG for "St Stephen" but a Fender Strat for "Shakedown St."

Academic qualifications such as MA or PhD are written without full points:

Will Hill MA

Ian Horton PhD

Acronyms should normally be set in capitals. The US style uses full points without additional spaces, while the UK style is to set these without without any full points:

C.I.A. (US style)

MI5 (UK style)

• Acronyms that are in common use may sometimes be expressed as a normal name with an initial cap only:

Unicef, Nato, Unesco

Ampersands indicate a formal pairing of names within organizations. They should be preceded and followed by character spaces unless the graphic identity of the organization requires otherwise:

Marks & Spencer

• They may also be used where a pairing of words or initials has a recognized meaning. Initials may be set without additional spacing:

He likes Drum & Bass better than R&B

Ellipses, indicated by ellipsis points comprising three full points with a space before and after, are used to denote omissions in a text. There is a specific glyph for this purpose that should be used rather than a succession of full points.

An ellipsis … … created by a single keystroke

Apostrophes indicate that a word is possessive:

Will's typeface

• They may also indicate a contraction or omission:

Sou'wester

• Abbreviations that have become accepted words in their own right do not require an apostrophe:

On the phone he heard the cello over the noise of the plane

• Care should always be taken to use the correct left-facing punctuation mark (equivalent to the "smart quote") rather than the prime (see Primes, overleaf):

The good typographer's apostrophes are smart.

The bad typographer's "primes" are not.

Rock 'n' roll not rock 'n' roll

The indent on the opening line of a new paragraph should be set to a specific measure; this may be matched to the leading of the text. It should be created as a formatting instruction; the tab key should not be used for this purpose. Never use the space bar to indent by adding character spaces as this may lead to irregular vertical alignment.

Decimal points have a glyph consisting of a dot at median height. This should be used instead of a full point. French usage substitutes a comma.

98·4 (English language)

98,4 (French)

Dates are treated in two ways, depending on whether the text is US or UK. The US style is month, date with contraction, comma, year; the UK style for setting date information is number, month, year:

May 1st, 1997 (US style)
1 May 1997 (UK style)

The full point at the end of a sentence should be followed by no more than a single word-space. The common typing practice of inserting a double space should be corrected by the typographer.

Dashes are treated differently in the US and UK. In the US, an em-dash with no additional spacing is used; in the UK a spaced en-dash is preferred:

The dash—a useful punctuation mark—should be used with discretion. (US style)

The dash – a useful punctuation mark – should be used with discretion. (UK style)

• When substituting a dash for the word "to" in a span of times, dates, or measurements, an en-dash should be used, with no additional spacing:

1940–1963

4–5 metres

21–25 January

Figures (numerals) within text faces may be lining or ranging, corresponding to the capital height; or non-lining figures, that align to the x-height and have ascenders or descenders. Where available, non-lining figures should be used where numerical information occurs within the body of lowercase running text. They should not, however, be used in combination with strings of capitals.

He was born in 1946, and when only 23 years old was voted 2nd-greatest guitarist in Rolling Stone.

WORST INFLATION SINCE 1930

• Numerals from 1,000 upward should be punctuated, in UK and US usage, by inserting a comma to indicate each thousand; French usage substitutes a full point:

1,000,000 Dollars

1.000.000 Euros

Paragraphs, in common typing practice, are often indicated by the insertion of an additional line space at the end. This should be corrected by the typographer. The opening of a new paragraph may be indicated by an indent.

Ordinals will be converted into superscript contextual alternates by professional typographic software:

1st 2nd 3rd

• US and UK usage tends to avoid the use of ordinal numbers in running text, spelling the word out in full:

Second left off 2nd Street

Italics are used to indicate the titles of published works and compositions:

In his third novel *Gravity's Rainbow* (1973)

• To indicate foreign words and phrases:

It was *de riguer* among the *auteurs* of the *nouvelle vague*

• To denote vocal emphasis:

I don't *believe* it!

Primes, vertical punctuation marks that come in single and double forms, were designed for use in typewriters to serve as both apostrophes and quote marks. Their correct use is now limited to expressing feet and inches; they should never be used in place of the appropriate directional "smart" glyphs for quotes or apostrophes:

"I am 6' 7" tall," he said.

Quotation marks are contextually activated, as typographically correct "smart" quotes, to face away from word-spaces and thus to face toward the quoted text. US style uses double quotes as the norm, with single quotes where a further quote occurs within a quoted passage. UK preference is for single quotes, with double quotes for further quotes within quoted passages; it also uses single quotes for quotations and to denote the usage of particular words:

"He said 'you can't do that in New York.'" (US)

'I said "you can't do that in London."' (UK)

Initials that precede a surname do not need full points (unless house style dictates otherwise); they should, however, be spaced:

B B King, F T Marinetti, H P Lovecraft, S H de Roos

A hyphen indicates broken or compound words. It should never be used in place of a dash (see Dashes, previous page)

Antoine de Saint-Exupery (1900–1944)

The solidus, forward slash, oblique, or virgule expresses a relationship between two alternatives or polarities:

male/female

on/off switch

• It is used in some abbreviations:

a/c

c/o

• It can also indicate a line break where successive lines of poetry are run on as a single line:

On Ponte Sisto/ an alto saxophone note/ echoes off water

Parentheses, brackets, and braces, though similar, perform different jobs.

• Commonly and incorrectly described as brackets, parentheses may be used to indicate an afterthought, a subordinate clause, or a reference:

(except in the south)

He said (with something approaching certainty) that he knew the route.

(Bringhurst p.120)

• A complete sentence set within parentheses should end in a full point within the parenthesis, while a subordinate clause should have the point outside:

(It was the last time he would say this.)

He walked the high wire (and without a safety net).

• Square brackets are used chiefly for comments, corrections, or translations by a subsequent author or editor, to denote an omission or a clarification within a quotation:

The transitional [typefaces], including Baskerville

• Braces are used in specialist texts in mathematics, computing, and music, and have different functions within each field. A brace may be used as a vertical link between two or more lines:

{ brace }

Glossary

Aldine Types derived from the types used by Aldus Manutius from punches by Francesco Griffo at the end of the 15th century

Alignment The arrangement of lines of continuous text to a fixed margin or axis: flush (ranged), justified, or centered

Ampersand Glyph used in place of the word "and," derived from a contraction of the French *et*

Anglo-American system American system of point measurement determined by the American Typefounders Association in 1886 at 72.27000072 to the inch

Anti-aliasing The process of "smoothing" irregular pixelation by the use of intermediate tones

Application A computer program that performs a specific function, such as layout, image manipulation, and font design

Arabic numerals The figures 0 through 9, as distinct from Roman numerals

Ascender The part of some lowercase letters that extends above the x-height

Asymmetrical type Type arranged to multiple margins or alignments, producing an irregular composition on the page

Baseline The notional horizontal line upon which the base of the letters is positioned

Bezier A form of curve established by computer-determined control points, used in defining outlines in digital type

Binary code The basis for digital data, made up of two distinct characters: 0 and 1

Bit A contraction of "binary" and "digit"; the primary unit of digital information

Bitmap The image on the monitor in which each pixel is mapped to a specific bit in the computer memory

Black A term used to denote an extra bold weight of type

Blackletter Germanic script based upon manuscript forms; variants include Textura, Rotunda, Bastarda, and Fraktur

Bleed Any part of a design that extends beyond the cropped edge of the page

Body Originally the metal block on which the print surface of the type letter was positioned, now understood as the overall area within which each digital letter or glyph is contained

Body height The overall height of the type including descenders and ascenders expressed in points

Body type Type of a size suitable for the setting of continuous text, normally between 8 and 14 points

Bold The heavier weight variant of a regular typeface; also demibold, ultrabold

Borders Solid, multiple, or broken lines used to separate, enclose, or underline type

Bracketing The curve from the letter stem or main stroke to the serif. Serifs that join at a sharp angle are described as unbracketed

Calligraphic type Type based upon hand-rendered script letterforms

Caps A common abbreviation of capital or uppercase letters

Case The tray or drawer containing metal type that gave the name to upper- and lowercase letters.

Casting Typesetting by the mechanical casting of individual letters or lines of type from molten metal

Centered Lines of type set with equal ragged margins left and right, to a central axis

Chapter head Title and/or number set on the opening page of a chapter

Chase Rectangular metal frame into which hand-set type and illustrations are locked for printing

Cicero A European term of measurement for a 12-point unit equivalent to a pica em

Composition A traditional term for the arrangement and assembly of type for print

Condensed Narrow type, normally a reduced variant of a regular width

Copy The original raw text to be typeset

Counter The enclosed spaces within letters, such as the bowls of b, p, and o

Crosshead A heading that crosses more than one column

Cursive Sloped type, normally based upon handwriting but not linked

Dagger/double dagger Additional footnote reference marks, used in a similar manner to asterisks

Debossing Impressing type or image into the surface of board or other substrate

Default The standard settings in design-software programs

Descender The descending stroke, tail, or loop that falls below the baseline of some lowercase letters

Didot system The European system of point measurement originated around 1770 by Firmin Didot at 67.55818249 to the inch

Die cutting The mechanical punching of preformed shapes into paper or card using metal dies; now increasingly replaced by laser cutting

Display type Type designed for use at larger sizes for titling and headlining, which may not contain all the glyphs or font variants found in a text face

Distressed Showing the effect of wear and repeated use

Drop-cap Over-sized initial letter set into the text to indicate new chapter or paragraph

Drop-shadow Digital effect repeating the letterforms as a shadow, usually to the right and below type, to create the illusion that the type rests above the surface

Egyptian Originally a term used to denote the antique qualities of sans serif; later adopted to denote an unbracketed slab serif

Ellipsis A glyph comprising three dots denoting an omission

Em A relative or proportional horizontal measure of a width equal to the body height of the type, also described as an em-quad in metal setting

Embossing Creating raised areas on paper or card pressed between two matched plates

Em-dash A dash of one em in width

Em-space Intercharacter space of one em in width

En A measure of width equal to half an em; half the body height of the type

En-dash A dash of one en in width

En-space Intercharacter space of one en in width

Exdent Overhanging line opening that indicates a new paragraph

Expanded/extended Wide type, normally a wider variant of a regular width

Face The print surface of metal type; also abbreviation of "typeface." See *Typeface*

Family A group of related typefaces, sometimes including condensed and extended versions, titling sizes, and additional alphabets

Fibonacci Series A number sequence in which each number is the sum of the two numbers preceding it

Field Rectangular zone within a grid, created by regular horizontal divisions

Film setting Photosetting onto photographic film or paper for reproduction

Flush The alignment of type to a single straight margin, also known as ranged

Foil blocking A relief-printing process in which a very fine layer of pressed metal is fused to the paper surface

Folios The name traditionally given to page numbers

Font/fount A full set of characters of one particular typeface in one style

Foot The base of the letterform, which normally sits on the baseline

Foundry type Metal type cast for hand-setting and repeated use

Four-color The standard method of commercial color printing, which uses the mode CMYK to overprint four standard inks in varying screen densities

Frontispiece Illustration at the beginning of a book, usually facing the title page

Galley A metal tray in which metal type was held prior to locking in chases for printing

Galley proofs Type set from metal or photosetting, for checking prior to final assembly

Glyph A term used to describe any graphic form within a digital font that can be accessed by specific keystrokes

Glyph scaling Adjustment to the width of letters, condensing or extending the form to improve letter fit or justification

Gothic A descriptive term for Blackletter types in Europe and sans serifs in the US

Grid The arrangement of vertical and horizontal margins to standardize the position of elements within a page spread

Grotesque Term used in Britain for the description of early sans-serif typefaces

Gutter More correctly the fold at the center of the page spread, the term "gutter" is now widely used to describe the space between columns

Hairline Fine lines and serifs, typically on the horizontal axis of high-contrast faces

Hand casting The casting by hand of individual letters of type from matrices

H&J Hyphenation and justification: the adjustment and specification of hyphenation and word spacing for justified type

Hanging indent Style in which the first line of a paragraph is set outside the margin used for the remainder of the copy. See *Exdent*

Hierarchy The arrangement of content into an appropriate order of priority through the control of visual emphasis

Hinting Design adjustment to ensure consistent alignment of the letter to the pixel grid

Hot metal The casting of type from molten metal

Humanist Early types, also known as Venetian, which mark the introduction of roman type

Humanist Sans Sans-serif types based upon classical proportions

Hung initial Display initial letter set outside the margin used for the remaining copy

Hyphen Short horizontal glyph, used to indicate breaks in words or to create compound words

Imposition The arrangement of multiple pages for commercial printing from large plates

Incunabula A term used for examples of early printing, particularly books from the 15th century

Indent The practice of indicating the beginning of a new paragraph by insetting the first word

Initial Opening letter of a chapter or paragraph, sometimes set in a larger contrasting face for decoration or emphasis

Italic Sloping letters, originally typefaces based upon Renaissance handwritten forms, later paired with roman fonts

Justification The adjustment of word space to create regular left and right margins in running text

Kern Originally the parts of some metal letters that overhung the body, typically the loop of the f

Kerning The adjustment of space between individual pairs of characters, incorporated in the design of the font

Kern pair Any pairing of letters requiring adjustment to the space other than that provided by their normal sidebearings

Latin script The Western European alphabet

Leading The space between lines of type, specified as the measurement in points from one baseline to the next

Letterpress Relief printing from metal or wood types; the principal method of printing from the 15th to the mid-20th century

Letter spacing The amount of space between letters in a text, adjusted unilaterally

Ligature A compound form combining two letters to improve spacing and overcome visual problems such as occur in the letter pairs fi and fl

Line measure The width of a column, determining the number of characters to the line

Linotype A mechanical composition system designed to cast whole lines, or slugs, of metal type

Lithography Printing process using chemical separation to create inked areas on a metal plate or stone. See also *Offset lithography*

Lowercase The small letters derived from minuscule written forms, as distinct from the capital uppercase letters

Maintained leading A system of leading that ensures that the lines of text continue to align to an underlying baseline grid

Majuscule The handwritten or calligraphic basis for uppercase letters

Margin The negative space between the type and the page edge. The term margin is also used to describe the line that defines the outer edge of the type area

Matrix The mold from which metal type was cast, created by the impression made from a steel punch; also the photographic negative images of type used in photosetting

Measure The length of a line or column of type

Mechanical typecasting The production of type from the late 19th century using Monotype or Linotype systems

Minuscule The handwritten or calligraphic basis for lowercase letters

Modern Term used to describe the Didone faces of the late 18th century

Monoline A typeface with minimal variation in stroke width

Monospace A typeface in which all letters are centered upon an identical body width

Monotype Mechanical composition system designed to cast each letter as a separate unit or sort

Multiple mastering A type-design technology that allows the designer to create new weights or variants of type by interpolating between existing designs

Non-lining figures Also known as Old-Style figures, these correspond to the lowercase letters and have ascenders and descenders, rather than being aligned to the height of the capitals.

Oblique Characters slanted to the right. The term oblique is sometimes used to distinguish sloped letters from true cursive or italic forms

Offset lithography Commercial printing from a photosensitized lithographic plate. The printed areas are created by a process of chemical separation and transferred (offset) to a printing roller

OpenType A new font format based on the Unicode standard that allows for dramatically increased glyph sets

Orphan The final line of a paragraph when allowed to carry over to a new column

Outline face Typeface with only outline printing

Page grid The underlying structure that governs the layout of text on the page

Pagination The numbering of pages in consecutive order

Pantone A universal color specification system for designers and printers

Paragraph mark The use of a typographic element or symbol to indicate the beginning of a new paragraph

Photosetting The setting of type by mechanically exposing photographic paper or film to a light projected through a sequence of letterforms

Pica/pica em A horizontal measure of 12 points

Pixel An abbreviation of "picture element," used to describe a single square of the computer screen

Point The unit for measurement of type, now standardized at $1/72$in

PostScript A page description language developed by Adobe

Printer font The digital font containing the information that determines the form of the printed letter

Pull-quote A sentence or quotation from the main body of the text, enlarged as a design feature of the page

Punch The original forms from which the casting matrices were struck

Punchcutting The traditional means of crafting type from the 15th to late 19th century

Ragged Term used to describe the irregular margin created by unjustified or flush type

Ranged See *Flush*

Raster Programs based around the manipulation of a bitmapped image area

Recto The right-hand page of a page spread

Resolution The accuracy of visual definition, determined by the number of pixels on either monitor or output device

Reversed copy Type set to print out wrong-reading

Reversed type Type set to read in white or a lighter color out of a printed surround

Rivers The appearance of lines of white space linking the word spaces within a column of text, characteristic of excessive word spacing in justified text

Roman Upright letterform as distinct from italic, also used to describe the serif letter

Roman numerals Numerals set using the Roman system based on the use of I, V, L, X, C

Rules Printed lines used to decorate or differentiate areas of type and image

Running head Recurrent title and chapter information at the head of every page

Running text Text set as a continuous sequence of words

Sans serif Type without serifs

Schematic mapping Diagrammatic non-literal representation of a zone or environment

Screen font The digital font that determines the display of type on the screen

Screening The creation of intermediate tones and colors by the separation of image or type into a pattern of fine dots for printing

Script The term script is used to describe different alphabets such as Latin, Cyrillic, or Greek

Script typefaces Based upon handwritten letterforms that may be either formal or informal and usually denoting linked letters rather than unlinked cursive letters

Serif The broadening of triangular forms at the terminals of letters, derived from Roman inscriptional lettering

Set width The width of the body of the letter

Sidebar Secondary text or commentary set to one side of the main column

Sidebearing The clearance space on either side of the letter

Slab serif Broad serifs with a squared end, either unbracketed or bracketed

Slugs Solid lines of type cast by the Linotype mechanical composition system

Small caps The use of a smaller size of capital forms in place of lowercase

Sorts Originally individual pieces of cast type, but later denoting special characters outside the standard alphabet, such as symbols and dingbats

Spot-color The printing of individually mixed special colors, normally specified from the Pantone system

Spot UV The printing of varnish into selective areas of the print area, either to intensify color in photos or type, or to create independent transparent graphic forms

Standfirst An introductory paragraph or sentence preceding the main text

Strings Sequences of capital letters used to set whole words or lines of words

Swash Decorative letters with long flourishes, tails, and ascenders

Text The main body of continuous copy on the page

Text typeface Typeface suitable for setting continuous text at sizes from 6 to 14 points

Textura A form of Blackletter characterized by a condensed lowercase and angular form

Tiff Tagged image file: a method of storing images as bitmaps

Tracking A term used to describe general letter spacing of a text or sentence

Transitional A category of type marking the transition from Old-Style or Garalde forms to Modern or Didone

TrueType A page description language introduced for use on the Macintosh computer

Typeface A set of standardized letters designed for mechanical or digital reproduction

Unicode An international character set proposed in 1997 to contain all the world's languages, which forms the basis for OpenType encryption

Unit A variable measurement, based on the division of the em into equal increments, to describe the widths of letters, sidebearings, and word spacing

Unit value The width of individual characters expressed in units

Unjustified type Type in which the word spacing has not been adjusted to produce even margins. See also *Flush*

Uppercase Capital letters, originally kept in a separate drawer or "case" of metal type

Vector Programs based around the manipulation of digital paths

Venetian See *Humanist*

Verso The left-hand page, facing the recto

Vox classification System for classifying typefaces

Weight The density and stroke width of the letters within a typeface

Widow A single word or unacceptably short line at the end of a column or paragraph

Wood letter Large-scale display letters, typically from the 19th and early 20th century, printed from wood types

Word spacing The space between words, ideally equivalent to the width of a lowercase i

Wrong-reading Type reading in reverse mirror image, as found on punches, metal type, or negatives

X-height The height of lowercase letters within a typeface, specifically the height of the lowercase x

Contacts & bibliography

Recommended reading:

Baines, P and Haslam (2002), A.: *Type and Typography*, London: Laurence King

Blackwell, L.(1998), *Twentieth Century Type: Remix*, London: Laurence King

Gordon, B.(2001), *Making Digital Type Look Good*, London: Thames and Hudson

Lupton, E. (2001), *Thinking with Type: A critical guide*, New York: Princeton Architectural Press

Spiekermann, E and Ginger, E.M. (2002), *Stop Stealing Sheep and Find Out How Type Works*, London. Adobe

Dodd, R. (2006) *Gutenberg to Open Type*, Lewes: Ilex

Bringhurst, R.(1997) *The Elements of Typographic Style*, Vancouver: Hartley and Marks

Lawson, A.(1990) *Anatomy of a Typeface*, Boston: Godine

Tracy, W. 1986 *Letters of Credit*, Boston: Godine

Mitchell, M. and Wightman, S. (2009) *Book Typography*, Marlborough: Libanus

Some useful websites on typefaces and typography:

www.typeculture.com

www.typophile.com

www.webtypography.net

www.baselinemagazine

www.atypi.org

www.typesociety.org

www.klingspor-museum.de

www.stbrides.com

www.publiclettering.org.uk

Web typography:

http://www.alistapart.com/articles/settingtypeontheweb

www.markboultondesign.com

Foundry websites including useful factual and contextual information, interviews, etc

www.adobe.com

www.bitstream.com

www.devicefonts.co.uk

www.dutchtypelibrary.nl

www.emigre.com/fonts

www.fontbureau.com

www.fonts.com (Monotype)

www.fontshop.com

www.fontsmith.com

www.letterror.com

www.linotype.com

www.lucasfonts.com

www.myfonts.com

www.stormtype.com

www.teff.nl (Enschede)

www.typedesign.com

www.typofonderie.com

www.typography.com

www.typography.net

www.t26.com

www.underware.com

www.unostiposduros.com

www.virusfonts.com

www.itcfonts.com

www.alphabets.com

www.p22.com

www.typeco.com

www.typotheque.com

www.thetypestudio.com

Index

Credits

Quarto would like to thank the following agencies for kindly supplying images for inclusion in this book:

Font foundries

Quarto would like to thank the foundries who supplied fonts. Foundries are individually credited in the Catalogue of Type section; foundries whose fonts appear in the Categories of Type section are listed below.

Adobe
Bitstream
Emigre
Font Bureau
Fontfont
Hoefler & Frere-Jones
JT Type Ltd
Linotype
Mecarnorma Collection
Monotype Imaging
Tilde
Typerepublic
(URW)++
Virus